A Gift of Light

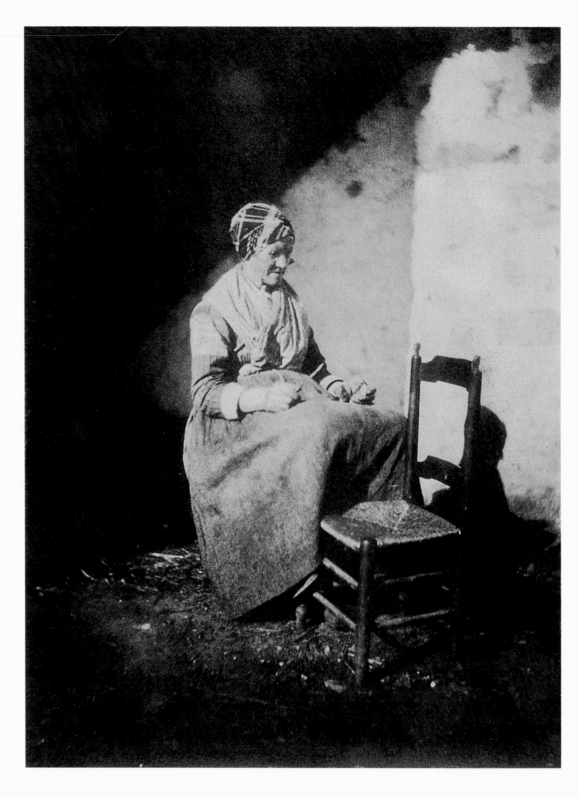

UNIDENTIFIED PHOTOGRAPHER *Woman Seated, Peeling Vegetables* 1853 salt print

A Gift of Light

Photographs in the
Janos Scholz Collection

Edited by

Stephen Roger Moriarty

with Morna O'Neill

Foreword by Charles R. Loving

Published in conjunction with an exhibition of photographs
from the Janos Scholz Collection of
Nineteenth-Century European Photographs at the
Snite Museum of Art, University of Notre Dame
8 September – 10 November 2002

UNIVERSITY OF NOTRE DAME PRESS
NOTRE DAME · INDIANA

We gratefully acknowledge the Snite Museum of Art for permission
to reproduce all of the photographs in this book,
copyright © by Snite Museum of Art, University of Notre Dame.

A Gift of Light was designed and set in type by Will Powers, Birchwood, Minnesota.
The typefaces are Clifford for the text, designed by Akira Kobayashi,
and Voluta Script, designed by Viktor Solt.

A Gift of Light was printed by King's Time Printing Press, Hong Kong.

This book was printed on acid-free paper.

Library of Congress Cataloging-in-Publication Data

Snite Museum of Art.
A gift of light : photographs in the Janos Scholz collection /
Edited by Stephen Roger Moriarty with Morna O'Neill ; foreword by Charles R. Loving.
 p. cm.
"Published in conjunction with an exhibition of photographs, the Snite Museum of Art,
University of Notre Dame, September–November 2002." Includes bibliographical references.
 ISBN 0-268-02953-9 (cloth : alk. paper)
 1. Snite Museum of Art—Photograph collections—Exhibitions.
 2. Photography—History—19th century—Exhibitions.
 3. Photograph collections—Indiana—Notre Dame—Exhibitions.
 4. Scholz, Janos—Photograph collections—Exhibitions.
 I. Moriarty, Stephen Roger.
 II. O'Neill, Morna.
 III. Title.
 TR6.U62 N687 2002
 779′.074772′89--dc21

 2002007374

"Examine. If of no use, discard."

JANOS SCHOLZ
written on the paper wrapped around
photographs given to the Snite Museum

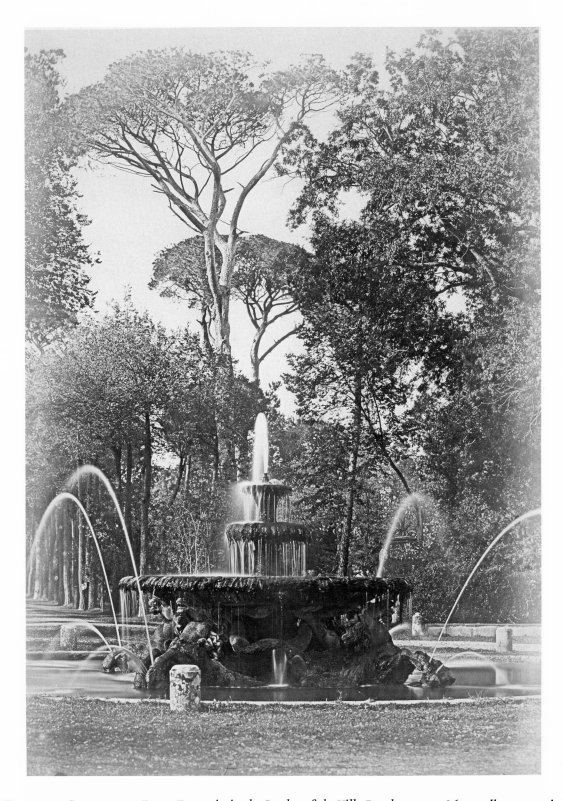

Tommaso Cuccioni *Rome, Fountain in the Garden of the Villa Borghese* c. 1860 albumen print

A Gift of Light

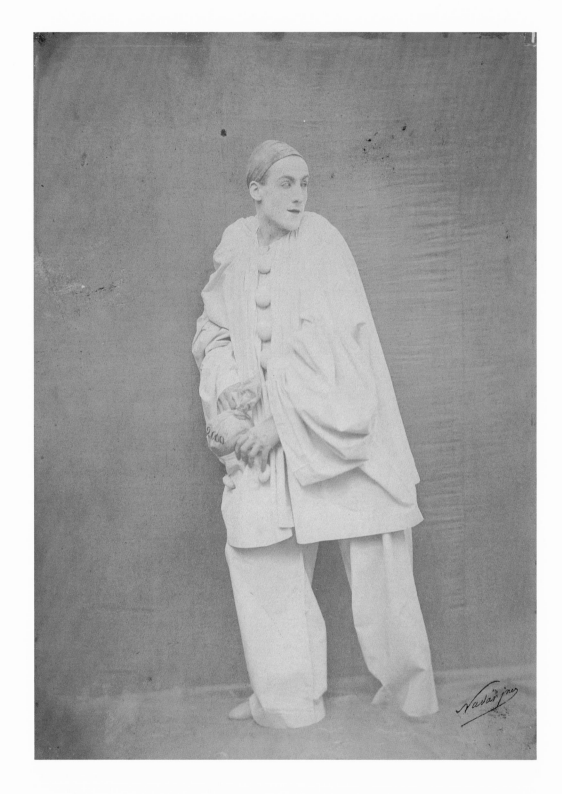

NADAR AND ADRIEN TOURNACHON *Pierrot the Thief* 1854–55 salt print

Foreword

THE SNITE MUSEUM OF ART TAKES GREAT PRIDE IN PRESENTING this selection of photographs from the Janos Scholz Collection of Nineteenth-Century European Photographs. The works reproduced in this book represent the quality and range of the collection but barely begin to reveal the extraordinary riches of its more than five thousand photographs.

When photography scholar and author Eugenia Parry visited Notre Dame to review the Scholz collection, she observed:

> I was impressed, at times amazed. [Steve Moriarty] showed me Scholz's early calotypes by Talbot, Adamson and Hill, and the great French painter-photographers, Edouard-Denis Baldus, Henri Le Secq, and Gustave Le Gray; commercial portraits, architectural and urban views, landscapes; the beauty and quality were staggering. These pictures are of exceptional importance in forming a collection that reflects the history of photographic seeing. Many universities have spent decades attempting such richness. How fortunate Notre Dame is to have received such an important gift.

The university is indeed fortunate to have this valuable resource, not only for teaching, research, exhibitions, and publications at Notre Dame, but also for use outside the university, where the photographs appear in exhibitions and are reproduced in publications.

The collection's relevance is by no means limited to students and scholars of art and art history. As Parry noted, the history of photography has relevance to all students, who, although "computer literate . . . are also visually illiterate"; in their daily lives "they see masses of pictures but have no idea why or how these pictures influence them." The photographic image became the twentieth-century standard for visual realism, and "photographic seeing" shows no evidence of relinquishing its hold. Becoming aware of the

history, technology, and limitations of camera-generated images is essential for realizing that visual perception has been, and continues to be, profoundly affected by these images' overwhelming presence in our culture.

This publication and exhibition would not exist today—and the collection would not be at the Snite Museum—but for the friendship formed many decades ago between the museum's Director Emeritus Dean A. Porter and his mentor, Janos Scholz. In addition to generous gifts of art, Janos also gave of his time, serving as a member of the Snite Museum of Art's national advisory council; many colleagues remember him with affection and admiration. His widow Helen provides generous support for the museum's photography collection, and their son Christopher continues the family tradition of service as a current member of the Snite advisory council. We are deeply indebted to the Scholz family, not only for their extraordinary gift of rare photographs, but also for their genuine friendship and wise counsel.

I offer special thanks to Curator of Photography Stephen Roger Moriarty. His keen eye for photography, broad understanding of its history and practice, and special talent for interpreting it for the layperson have served the museum well. Likewise we are indebted to Notre Dame graduate Morna O'Neill for her thought-provoking essay on Victorian photography. We are grateful to the University of Notre Dame Press and to Jeannette Morgenroth for overseeing the book's publication and shepherding it through many critical stages. Working again with designer Will Powers was a pleasure. His elegant and understated page designs are ideal for art publications. Finally, I am pleased to recognize the museum's exhibition team—especially Greg Denby, Ramiro Rodrigeuz, and John Phegley—for their successful efforts to install these very fragile works of art safely and tastefully.

CHARLES R. LOVING
Director and Curator of Sculpture, Snite Museum of Art

"The essence of luxury":
Janos Scholz as Collector

STEPHEN ROGER MORIARTY

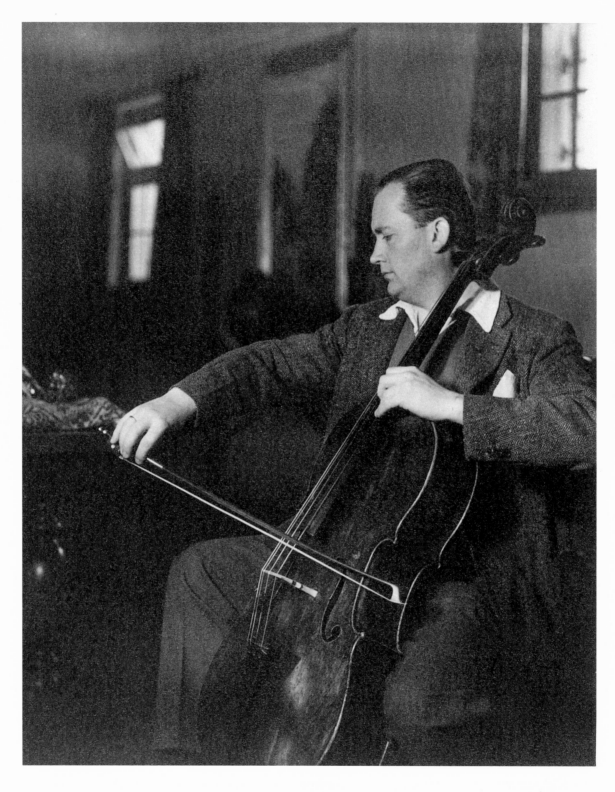

ARNOLD GENTHE *Portrait of Janos Scholz* 1937 silver gelatin print, toned

IN 1980, JANOS SCHOLZ OFFERED THE FOLLOWING REFLECTION:

Collecting is in a certain sense a very selfish activity. To start with, it can lead, as everything in life, to harmful excesses. The urge to possess something totally is a very dangerous malady. The sooner the collector sheds himself of it, the better off he is. Sharing an idea or an object gives great satisfaction and also, in my opinion, is a great luxury. The opportunity to own something for awhile and then offering it to others by explaining the beauty and meaning it reveals to us, or by actually giving it to others, is what I consider the essence of luxury. Thus, a person who is able to do this during his lifetime reaps a benefit and a satisfaction which is denied to those who cling to possessions.[1]

Throughout his life, the parallel impulses to acquire and to give away shaped and directed Scholz's two great passions: music and collecting. The rich cultural and educational milieu of his youth helped develop the intellectual interests behind his passions and acted upon them in a refined and unified way. Both Scholz's high level of musical accomplishment and his very accomplished artistic connoisseurship were geared to generosity and a spirit of sharing. The two passions, moreover, acted upon one another, and his passion for music may have informed his generosity as a connoisseur. If, on the one hand, the collector's impulse accompanied Scholz's passion for music—he memorized (personally acquired, so to speak) all of Joseph Haydn's string quartets, he played a 1731 Stradivarius cello and violas da gamba from 1696 and 1699, he amassed over seven hundred musical scores of cello music, and he owned a large collection of viola da gamba and cello bows—the musician's impulse to share may in turn have shaped his notion of "the essence of luxury"; music exists to be played, to be given, the player "offering it to others by explaining the beauty and meaning it reveals to us, or by actually giving it to others."

Scholz's passion for collecting things emerged early in his youth, when, as a child growing up in Hungary, he picked up Roman coins

and pieces of ancient glass and pottery in the fields. Curiosity soon led to a collection of books on local history, augmented by chipped figurines and ragged manuscripts found on excursions into the family attics. As the boy grew into adulthood, he replaced the chipped figurines with porcelain, tapestries, bronze figurines, cellos and cello bows, musical scores, medieval objects, and early European prints and drawings. As the decades passed, the drawing collection occupied more and more of Scholz's time and energy, and by the 1970s he had assembled what was described as "the finest private collection of Italian drawings in America and one of the finest in the world."[2] Finally, almost as an afterthought, Scholz turned his attention to a little-known field, the earliest years of European paper photography. Before age and illness finally curtailed his collecting drive, he had acquired over five thousand photographs dating from 1839 to the turn of the century. The images in this book comprise a small sampling of that last collection.

Scholz grew up in a world that valued learning and beauty. Born in 1903 in Sopron, Hungary, near the border with Austria, Scholz came from a distinguished family with a rich musical heritage. The composers Franz Schubert and Franz Liszt were family friends. Janos was a fifth-generation cellist, beginning his studies at age seven. Although his mother insisted that he obtain a certificate in agronomy from the Royal Hungarian College of Agriculture and Janos dutifully completed his degree, he left soon after for Budapest to pursue his real love, the cello. His admission to the Hungarian Academy of Music was assured when Scholz demonstrated that he had memorized all of the Haydn string quartets. A strong memory would prove valuable later in Scholz's collecting career, as he researched his various collections.

After studying at the academy, Janos Scholz was named first cellist of the Budapest Symphony Orchestra, and he played with the Budapest Symphony, the Budapest Opera, and various chamber ensembles throughout Europe. In 1932 he joined the Roth Quartet, which left Hungary to tour the United States in 1933. Because of the rise of fascism in Europe, all four members applied for American citizenship,[3] and Scholz made his new home in New York City, falling in love with the numerous museums, bookstores, and

restaurants. He mastered English, adding it to his "collection" of languages—German, French, Hungarian, Italian, and Latin. Throughout the 1930s he continued his concert tours.

During a 1935 tour to Mexico, he began collecting prints and drawings,[4] which he continued when he returned home. New York in the late 1930s was the perfect place to collect old master works on paper. Scholz became friends with William Ivins and A. Hyatt Mayor at the Metropolitan Museum of Art, who advised him on his collection, and he searched art galleries and used bookstores for his acquisitions. The economy was still depressed from the stock market failure of 1929, and many American and European families with art collections were desperate for cash. In addition, Scholz's frequent international concert tours allowed him to meet and socialize with people who were also collectors, another source of material. He liked to buy large batches of prints and drawings, often in portfolios or scrapbooks, negotiating the best price. After returning home, he would retire to his study to consult his personal library and meet with his friends in the art world to identify the best images from the lot. Scholz would then keep the key pieces and reserve the rest for future trades.

One result of this activity was an extensive collection of early European prints, including complete sets by Claude, Ostade, Everdingen, Waterloo, and the van der Veldes. While he was concentrating on Dutch landscapes, including prints by Rembrandt and Ruysdael, Scholz gathered impressions by Pieter Brueghel the Elder, Hans Holbein, and Albrecht Dürer, as well as works from Italian, German, and French printmakers. Scholz's print collection was acquired by the Philadelphia Museum of Art in the 1940s, when he decided to narrow the focus of his collecting to old master drawings, with a special concentration on the artists of Italy.

Ironically, part of the challenge of collecting during this period was that such a vast amount of art was available on the market. Collectors continually had to make choices, narrowing or expanding their fields of interest. Most serious collectors were interested in paintings and sculpture, while old master drawings were under-appreciated and undervalued. John Russell, an art critic for the *New York Times*, wrote in 1977 that Scholz had "begun to collect at a time

5

when a Dürer drawing could turn up in a bookstore and be offered to him (so he tells us) for the price of a good dinner."[5] Scholz later recalled, "When the giant American collectors began amassing their loot, drawings played only a minor role, although material was readily available at the time. It was easy to get a good Giambattista Tiepolo drawing on Fifty-Seventh Street for much less than a hundred dollars, while a G. D. Tiepolo sheet changed hands on Third Avenue for thirty-five dollars."[6] Scholz also collected drawings by Pisanello, da Vinci, Titian, Raphael, Correggio, Parmigianino, Tintoretto, Veronese, Zuccari, and Domenichino. To these Italian masters he added works by Rubens, Van Dyck, Rembrandt, and Goya.

Scholz's assiduous activities as a collector become especially remarkable when one remembers that during this period they were worked in around the grueling rehearsal, performance, recording, and teaching schedule of a professional musician. Scholz toured as a soloist and with different ensembles throughout the United States, Mexico, Canada, and Europe, and he recorded for numerous labels, including RCA Victor, Columbia, Vox, and Phillips. He was the first musician to record the Bach viola da gamba sonatas (Columbia Recordings, 1938), long before performing early music on original instruments became common, and in 1941 was the viola da gamba soloist with the New York Philharmonic under Bruno Walter in ten performances of Bach's St. Matthew Passion.

In addition to Scholz's work as a performer, he also taught many young cellists, and he served as a juror for scores of music competitions in North America and Europe. In 1990 the Eva Janzer Memorial 'Cello Center at Indiana University honored Scholz's distinguished performing and teaching career by bestowing on him the *Chevalier du violoncelle* award.[7] Best known among Scholz's students is Yo-Yo Ma, who studied with Scholz before attending the Juilliard School of Music.

Scholz edited music for viola da gamba by George Frideric Handel (1685–1759) and Benedetto Marcello (1686–1739), as well as eighteenth-century music for cello. He gave his editions and the rest of his extensive collection of cello music to the Walter Clinton Jackson Library at the University of North Carolina at Greensboro, where the music is gathered along with the collections of several other

cellists. In addition to being "what is certainly the world's largest single repository of cello music,"[8] the collection serves musicians and scholars interested in the history of cello performance; one of the principal uses of the scores and sets of parts is to make comparisons of bowings and other performance indications made by the original owners. Scholz's musical career, as well as his activities as a collector, turned around what he called "the essence of luxury": he habitually shared the beauty and meaning that music had revealed to him. At the same time, his learning and research refined what he had to share.

Similarly, as Scholz's art collections deepened and grew, so did his scholarship and research. He taught classes in connoisseurship and draughtsmanship at Columbia University and New York University. He served on a number of advisory councils, including that of the Snite Museum of Art at the University of Notre Dame. As the fame of his collection grew, Scholz became known as someone who would lend generously from his holdings, eventually providing individual drawings or groups of them to more than 150 exhibitions, often in small museums.

Decades of collecting finally came to a dramatic conclusion one night just before Christmas in 1973. Scholz gave a cello recital to a select audience at the Pierpont Morgan Library and at the conclusion of the concert announced that he was naming the library as the recipient of his Italian drawing collection. The announcement made the front page of the *New York Times*, which added that the British Museum, the National Gallery in Washington, the Albertina in Vienna, and the Metropolitan Museum in New York had all vied for the collection. Scholz explained that one of the main reasons he had chosen the Morgan Library was that it was especially friendly to students and scholars, and it had agreed to keep the collection intact.[9]

After almost forty years as a collector, Scholz found himself without one of the two great labors of his life. "Many people asked, 'Are you sorry to see the drawings go?' I honestly said no. I decided to do that long ago, and for me it was an honor to know that these things will be preserved, studied, and enjoyed by other people after me. After all, that was the idea behind why I collected."[10] However, his friends knew him well, and they persisted in asking him when he

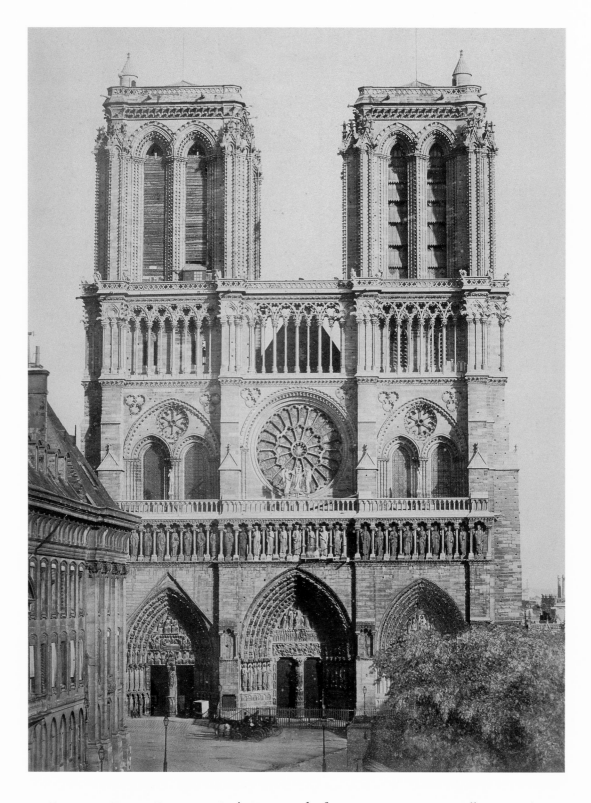

EDOUARD-DENIS BALDUS *Paris, West Façade of Notre Dame* c. 1857 albumen print

would launch into a new field of collecting. "I would answer that something would come along. Then I went through the family archives and sorted out quite a few of the early photographs."[11] Scholz knew a young woman who had studied photographic history and asked her to look over the family material. "We started to look at photographs," he said, "and somehow I thought that would be something new in my life. And here at home were those parcels of photographs that I didn't have to buy. They were there for the taking, and this is how it started."[12]

Around 1975 Scholz began collecting photographs in much the same way that he had collected drawings: he bought large lots of images, sometimes in albums, and searched through them in hopes of finding a core of important material. He quickly accumulated several thousand photographs, most from the genre of late nineteenth-century European travel pictures, and most of average quality. At the same time, he was acquiring and reading books, attending exhibitions, and talking with museum curators. His critical eye had been trained on drawings, and it took some time for him to realize that he was dealing with a completely different medium, with its own syntax, history, and connoisseurship. He decided to focus his collecting on the early years of European photography on paper, thereby turning his back on the other two great fields of nineteenth-century photography, the daguerreotype and American western landscape images (which Scholz called "Vista Americana").

The family photographs that had first drawn Scholz's attention to the field had been acquired by his wife Helen's ancestor, Clarence Dinsmore, while taking the Grand Tour through Europe in the 1860s and again in the 1870s.[13] At the same time, Scholz began to seek out old photographs and photographic albums while browsing in bookstores and antique shops. He visited some of the established photography dealers but was discouraged that prices were starting to rise quickly in a field that other collectors were also discovering. "I had to go somewhere to find photographs where they were either unrecognized or just neglected, where people would almost give them to me," Scholz recalled; "I always went to nonspecialists in photographs and these are the places where I bought my best things."[14]

In reality, however, Scholz came to rely on two photography dealers for most of his finest images: Daniel Wolf and Alain Paviot. Wolf later became known in the photography world as the broker for the series of purchases that allowed the J. Paul Getty Museum in Malibu, California, to become, almost overnight, a serious collector of photographs. But when Janos Scholz began buying from Wolf in the mid-1970s, he was selling photographs from a pushcart on the sidewalk in front of the Metropolitan Museum. Wolf was buying albums and portfolios of nineteenth-century images and selling the individual photographs on simple mounts, wrapped in plastic. As he established himself, he opened a gallery and began to acquire material from dealers in England and France. Wolf was the source of some of Scholz's finest British material, such as the Talbots and the Hill and Adamsons.

Daniel Wolf was also beginning to sell material that was coming out of Paris, such as the fine group of photographs by Gustave Le Gray that are reproduced in this book (pages 76, 92, and 93). Scholz was eager to obtain more of this French material, for he had begun to realize, as had other collectors, that the photographs produced in France in the 1850s and into the 1860s were some of the finest and rarest in the history of the medium. Scholz discovered that Daniel Wolf was obtaining some of his best French material from Alain Paviot, a Parisian dealer who worked out of the second floor of an old eight-sided wooden building, which he called the Galerie Octant. Paviot, like Janos Scholz, was a relentless searcher who scoured bookstores, antique shops, and estate sales for neglected and underappreciated photographs that had managed to survive the wars, fires, floods, dampness, and ignorance that had been the death of so many early fragile paper images. Paviot assembled exhibits and published catalogues of photographs by Marville, Nègre, Poitevin, Le Blondel, and Vignes, from which Scholz purchased examples. During one particularly fruitful visit to Paris in 1983, Scholz obtained thirty-one photographs from Paviot, of which fourteen have been judged important enough to be included in this book.[15]

At the same time as Scholz was collecting, he was also giving away. He had become an influential member of the advisory council of the Snite Museum of Art at the University of Notre Dame in 1968

and was attracted by the museum's commitment to exhibit and teach from works of art in an atmosphere of faith. He soon became a close friend of the director at that time, Dean A. Porter, and began lending items from various collections for exhibitions. In 1980 the Snite assembled *Janos Scholz: Musician and Collector,* an eclectic mixture of objects which included a number of his more important Italian drawings, as well as fifty-two recently acquired photographs. By 1984, Scholz had enough new material to present *Nineteenth-Century European Photographs: Selections from the Janos Scholz Collection.* Always fond of the dramatic moment, Scholz announced at the opening that he was giving his entire photography collection to Notre Dame.

Actually, he had already been sending bundles of hundreds of photographs and dozens of albums to the Snite Museum at Notre Dame since 1978. Packages of photographs arrived regularly until 1987, when health problems finally began to put an end to Scholz's lifelong collecting. Janos Scholz died in New York on 3 June 1993. After his death, his wife and son found hundreds more photographs stored in a closet in his apartment and generously donated them to Notre Dame. The Scholz photography collection is now complete and is located where it can be exhibited, studied, and enjoyed by scholars and students.

"The agency of light":
Early Photography in England and France

STEPHEN ROGER MORIARTY

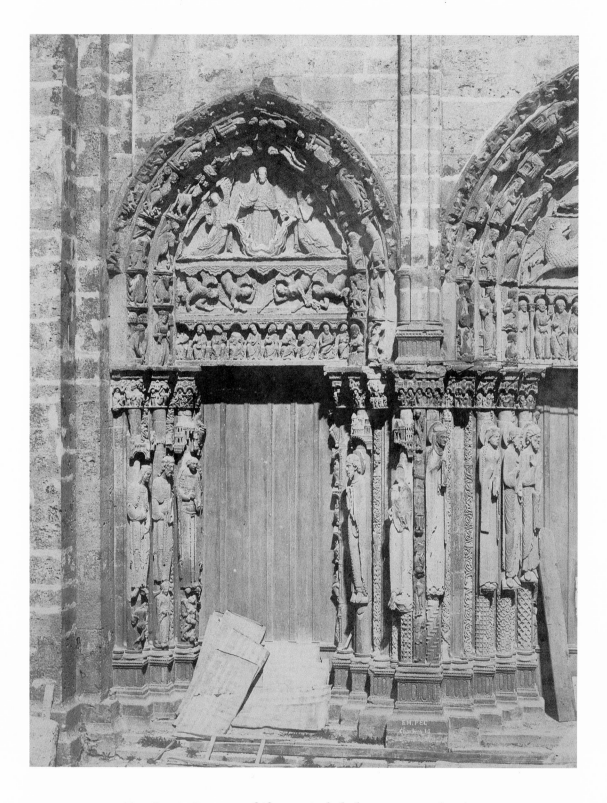

Em. Pec *Doorway of Chartres Cathedral* c. 1852 salt print

TO THE FIRST PHOTOGRAPHERS, THE PROCESS MUST HAVE SEEMED almost miraculous. A piece of paper, coated with table salt and silver nitrate, was set out in the sun with an object laid on top of it, often a leaf or the stem and flower of a plant. The uncovered parts of the paper began slowly to darken, leaving a ghostly pale shadow on the surface where the object had rested. This most basic of photographic images, called a *photogenic drawing* by its inventor, William Henry Fox Talbot, has always fascinated photographers, and over the decades many of them have returned to the process, as if on a pilgrimage to the spring at the source of a river (see this page). [1]

But, for all their simple beauty, Talbot saw these images primarily as the first steps toward a more elusive and lofty goal.

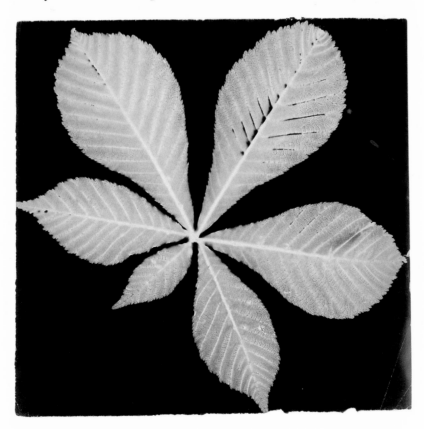

UNIDENTIFIED PHOTOGRAPHER *Photogram of a Leaf* 1860 albumen print

Talbot dreamed of capturing whole pictures on paper, images of the world as they are seen by the eye, or, more precisely, as they are projected by a lens onto a flat surface. Years later, Talbot claimed that the whole idea of photography had come to him in 1833 while on his honeymoon at Italy's Lake Como. Like many other sophisticated travelers of his time, Talbot had carried with him a *camera lucida*, a device that allowed a viewer to look through a prism and see a distant view apparently projected down upon a piece of drawing paper. In theory, with a little practice the user could outline the image with a pencil, producing a rough sketch of the landscape. Talbot was unable to produce a drawing he liked, and in his frustration he wondered if there might be an easier way to capture a picture on paper:

> *I then thought of trying again a method which I had tried many years before. This method was, to take a* camera obscura *and to throw the image of the objects on a piece of paper in its focus—fairy pictures, creations of a moment, and destined as rapidly to fade away. It was during these thoughts that the idea occurred to me—how charming it would be if it were possible to cause these natural images to imprint themselves durably, and remain fixed upon the paper.*[2]

Talbot was a brilliant man, not unlike his Victorian contemporary Charles Darwin in his systematic scientific search for the solution of problems. Talbot realized that the first step in his quest was to invent some way to sensitize paper so that it would be affected by the sunlight shining upon it. His photogenic drawings proved that such a paper could be produced, and he then began placing the sensitized sheets in the back of tiny wooden cameras, where the rays of the projected image would slowly burn the image into the surface of the paper. These little boxes were smaller versions of another device that artists used, the *camera obscura*, a box with a lens on one end that cast an image on a piece of ground glass at the other end. A skillful user of such a device would place a thin piece of tissue paper on the glass, and the image, still faintly visible through the paper, could be sketched over with pen or pencil. Talbot's plan was to let the sunlight itself do the drawing, and he suc-

ceeded in capturing a camera image during the brilliant summer of 1835.

The results were strange and curious, since the lighter areas, such as the sky, became dark, while dark shadows in the original scene left the paper unchanged, or white (see pages 68, 72, and 88). The eminent British astronomer John Frederick William Herschel coined the word *negative* to describe these images, whose only precedent in visual history may be the human figure mysteriously imprinted on the Shroud of Turin.

As pleased as he was with these early results, Talbot still had not been able to make a print with the tones reversed back to their normal values, or what Herschel called a *positive*. Talbot quickly realized that he could put one of his negatives on top of a fresh piece of sensitized paper, and in theory the dark skies would block the light, resulting in a white area, while the plain white shadows would let the light through, thus producing dark. The problem was that Talbot's first negatives were pale and weak, and produced only muddy and unreadable prints. Discouraged, Talbot put away his photographic equipment and paper images, and turned his attention to managing his estate and solving mathematical problems.

In January of 1839 Talbot heard a report through the scientific grapevine that impelled him to reopen his experiments. It was rumored that a Frenchman, Louis-Jacques-Mandé Daguerre, had also been able to capture images in a camera obscura and was preparing to make his discoveries public.[3] Fearing that his years of work were about to be eclipsed, Talbot brought out his 1835 experimental images and hastily arranged a showing at the Royal Institution in London on 25 January 1839. On 31 January, Talbot delivered a paper on his project to the Royal Society of London, and in February he finally revealed the details of his chemical procedures.

What Talbot did not yet know was that Daguerre's process, which produced images called daguerreotypes, was very different from his. Daguerreotypes were photographs captured on the surface of a copper plate that had been coated with silver, polished to a mirror brilliance, rendered light-sensitive by fumes of iodine, exposed in a camera, and developed in a darkroom by fumes of heated mercury. Each daguerreotype is unique, and the resulting image so

fragile that it has to be protected under glass. The Janos Scholz collection, which is almost exclusively composed of paper photographs, contains one important daguerreotype, a rare outdoor view of Rome from the early 1840s showing the equestrian statue at the top of Michelangelo's Campidoglio steps in Rome, taken by the Parisian photographer Pierre-Ambrose Richebourg (see this page).

Comparing the daguerreotype below with one of Talbot's images made around the same time, such as his *Loch Katrine, Scotland* (page 73), one can see why most of the public preferred daguerreotypes: they possess a sharpness and clarity missing from the first paper photographs, partly because the image on the paper prints was diffused by the light's passing through the fibers of the paper negative. Moreover, Talbot struggled for years to overcome the disastrous tendency of his images to fade away, sometimes immediately after they were produced. The daguerreotype process, on the other hand, was so commercially successful that within a few years studios were active in all the major cities of the world, even in remote and rural areas. The public's demand for the daguerreotype, so intense that it was humorously called *daguerreotypomania,* was frustrating for pho-

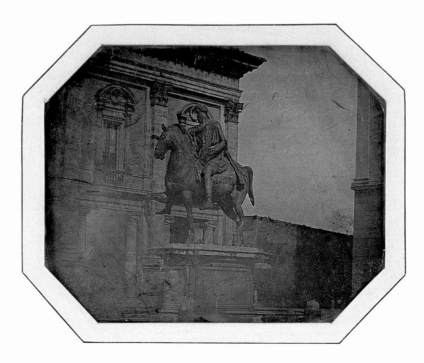

PIERRE-AMBROSE RICHEBOURG *The Campidoglio, Rome* c. 1842 daguerreotype

tographers who chose to work in paper. To them, the superiority of paper photography seemed obvious. The negative-positive process allowed, theoretically, for an unlimited number of prints to be reproduced from a single negative. In addition, paper was much less expensive, and the thinness of the prints made it possible to paste them into books, thus allowing the publication of volumes of photographs, such as Talbot's pioneering *Pencil of Nature*, in 1844–46.

Talbot's continual experimentation eventually led him to discover a more efficient procedure. One day in the fall of 1840 he found that a piece of sensitized paper, left in the camera for a much shorter time, would still yield a rich negative if it were placed later in a chemical called a *developer*. The processed and dried negative was pressed against a fresh piece of sensitized paper in a frame under glass and set out in the sun until the positive print appeared. It was finally "fixed" to stop the light sensitivity, washed, and dried. Now that Talbot could produce a negative with a much shorter exposure time, he began photographing more people, such as his assistant Nicolaas Henneman (page 68), or the group at the battery at Mt. Edgcumbe, Plymouth (page 69). Talbot called the resulting photographs *calotypes,* meaning "beautiful images."

After the 1840s Talbot stopped taking his own photographs and eventually lost money on his photographic business ventures. He still fretted, however, over the fading of his prints and so invented an ingenious technique for reproducing photographs with ink on a press. Announced in 1858, his *photoglyphic engraving* process anticipated the technologies still used today to reproduce photographs in books and magazines (page 74). Before his death in 1877, Talbot finally began to receive some of the recognition he deserved for such an immensely important discovery. By 1900, however, the centenary of his birth, little interest was shown in commemorating his life and accomplishments, and for decades only a few historians of photography understood his importance. In recent years interest in Talbot has been renewed; he is now admired not only as a pioneering scientist but also as a determined and accomplished photographer.

Even though paper photography had been commercially eclipsed through the 1840s by the crystalline clarity of the daguerreotype, the soft, delicate, elusive quality of Talbot's paper images continued to

fascinate and attract a significant group of early photographers who kept the process alive.[4] Morna O'Neill explores the development of the paper photograph in Britain in another essay in this book. Here we will cross the Channel to France, where talented photographers began producing pictures of such strength, beauty, and diversity that this period is now widely regarded as one of the golden ages of photography.

French paper photographs from the 1840s are very rare, since few photographers dared to stray from the overwhelming commercial popularity of the daguerreotype. The Scholz collection contains one fascinating example from 1849, a small view from a second-story window of a farmhouse. Not just the early date distinguishes the image, but also the fact that the photographer, Alphonse Louis Poitevin, printed into the picture a handwritten label with his name, the date, and, prominently at the top, the word *photographe* (see detail, this page, and the full photograph on page 79). Poitevin was apparently very aware that he was learning a distinctly new medium and was among a small group of French experimenters who were rediscovering the beauty and practicality of paper photographs.

Photography flourished in France during the 1850s and 1860s. One reason for the success of the medium was that the country had industries that could produce the necessary chemicals, paper, and cameras with lenses. A relatively prosperous middle class frequented the galleries and studios, eager to purchase portraits, views of exotic places, and even an occasional "artistic" photograph, such as Gustave Le Gray's *Forest of Fountainebleau* (page 76). Also, an elaborate structure already existed to support the arts, with museums, salons, exhibits, academies and ateliers for students, and magazines and newspapers where critics published reviews and essays. Like their counterparts in the traditional arts, photographers came together in professional associations, first the Société Héliographique, then, in

ALPHONSE LOUIS POITEVIN detail, *Salt Works at Gouhemans* 1849 salt print

1854, the influential Société Française de Photographie, which still exists.

This period of photographic growth coincides with the reign of Napoleon III, who was elected president in 1850 and after a coup d'état ruled as emperor from 1852 to 1870. While his rule was autocratic and repressive, a relatively stable social and economic environment encouraged commerce to flourish, as well as the arts, including photography. Various offices of Napoleon III's government commissioned photographers to produce works such as documentary images of the restoration of the crumbling cathedrals around France (page 14). Similarly, Edouard-Denis Baldus completed an extensive study of French architecture and railways (pages 82 and 83), and Charles Nègre documented the imperial hospital at Vincennes (page 78). Gustave Le Gray completed a prestigious commission to depict the French army maneuvers at the Camp de Châlons; several of his photographs show the pavilion constructed for a solemn mass celebrated for the emperor (page 92), and in one unusual view the service is shown in progress, with the emperor and his court seated in front of the pavilion (page 93).

The flood of images produced in the 1850s was made possible by an experimenter from Lille, Louis-Désiré Blanquart-Evrard. The publisher Blanquart-Evrard refined the calotype process so well that he began issuing portfolios of photographs, often of famous works of art, such as the picture of a Luca Della Robbia sculpture by Charles Marville (page 104). Blanquart-Evrard further streamlined the printing process by exposing the prints briefly to light and then developing them in a darkroom, just as Talbot had done with his negatives. Now hundreds of prints could be made in a day, thus beginning the industry of photographic publishing. These published photographs of works of art would transform and energize the study of art history by offering affordable reproductions to a wide audience, and the photographic images were more accurate than earlier woodcuts or engravings.

In many ways, Charles Marville's career is typical of these early master photographers. He began as a painter and printmaker, illustrating travel books and socialist publications. Besides producing negatives for Blanquart-Evrard to publish, Marville was able to

support himself by obtaining commissions from the French government. His most memorable project was his photographic record of the 1860s Parisian neighborhoods that were about to be demolished to clear space for Baron Hausmann's new wide boulevards; Marville's project was similar to later documentary photographs produced by Eugène Atget. Marville was still taking assignments from the city of Paris in 1875, when he photographed the rebuilding of the Vendôme column (page 101). The column had been toppled by rebels in the heady days of the Paris Commune, and the painter Courbet, who had carelessly allowed himself to be photographed astride the ruins, fled to Switzerland when the government attempted to bill him for the huge cost of the repairs.

Marville was also a technical experimenter, apparently dissatisfied with the fact that it was extremely difficult to capture clouds in early photographs. Because photographic emulsions of the time were oversensitive to the blue end of the spectrum, the sky, which is full of ultraviolet light, burned out. Shooting out the window of his studio on the Rue Saint-Dominique, Marville produced a technical wonder, a dramatic formation of clouds silhouetting the dome of the Invalides (page 87), but at the cost of letting the cityscape below remain somewhat underexposed. Unlike Marville, most nineteenth-century photographers begrudgingly accepted the whiteness of the sky in their prints; some even used the negative shape as a formal part of the composition.[5]

Other French photographers came from the ranks of professional artists. As a result, their work was often informed by a greater sensitivity to composition and design. For example, four of the best photographers of the 1850s studied together in the same atelier in Paris: Gustave Le Gray, Henri Le Secq, Charles Nègre, and the Englishman Roger Fenton all attended sessions in drawing and painting at the studio of the successful academic painter Paul Delaroche.

The earliest French paper photographers produced images using techniques derived from Talbot's original experiments. These photographs are called *salted paper prints,* or *salt prints,* because one of the earliest ingredients of the light-sensitive coating was common table salt, or sodium chloride. The use of paper for a negative continued in France, especially after Gustave Le Gray developed his popu-

lar dry waxed paper process, which allowed the photographer to pre-
pare negatives ahead of time, returning to the darkroom later to de-
velop them. The waxing of the negative also made it more transpar-
ent, resulting in a somewhat sharper print. Le Gray's *Forest of
Fontainebleau* (page 76) is an example of a salt print from a waxed
paper negative.

Since the chemicals on the surface are absorbed into the fibers of
the paper, salt prints have none of the shiny glossiness usually associ-
ated with photographic images. Salt prints can reveal a delicacy and
grace that have rarely been matched, almost as if the light were ema-
nating from the photograph rather than being reflected from it. The
Scholz collection contains several such salt prints, such as Jean-
Jacques Heilmann's *Chateau and Town of Pau* (page 80), E. Nicolas's
Senlis, the Ruins of the Old Chateau and the Cathedral (page 94), Alphonse
Le Blondel's *Family Group in Garden* (page 116), the anonymous *Trees
and House, Rural France* (page 77), and *Woman Seated, Peeling Vegetables*
(page 117). Even such an unpromising subject as an earthen bank—the
battered rampart from the Crimean War photographed by Colonel
Jean-Charles Langlois (page 90)—achieves an extraordinary tactile
quality, as if the dirt itself had been rubbed into the surface of the
paper. In the *Forest of Fontainebleau* (page 76) the rich golden tones
perfectly evoke the feeling of bright sunlight filtering through the
leaves on a hot summer day; a soft breeze rustled some of the upper
branches, swaying them slowly during the long exposure, resulting in
vague, cloudlike shapes floating above the forest floor.

Salt prints were greatly admired by many professional artists,
such as Eugène Delacroix. In 1859 he argued for the qualities of the
calotype: "The most striking photographs are those in which certain
gaps are left, owing to the failure of the process itself to give a com-
plete rendering. Such gaps bring relief to the eyes, which are thereby
concentrated on only a limited number of objects. Photography
would be unbearable if our eyes were as accurate as a magnifying
glass."[6] Some photographers, such as Le Gray, were extremely fond
of their softer, more "artistic" images. He even developed an esthetic
argument, the "theory of sacrifices," suggesting that the sacrifice of
fine detail to a softer, more "artistic" feeling actually produced an
image of greater power.[7]

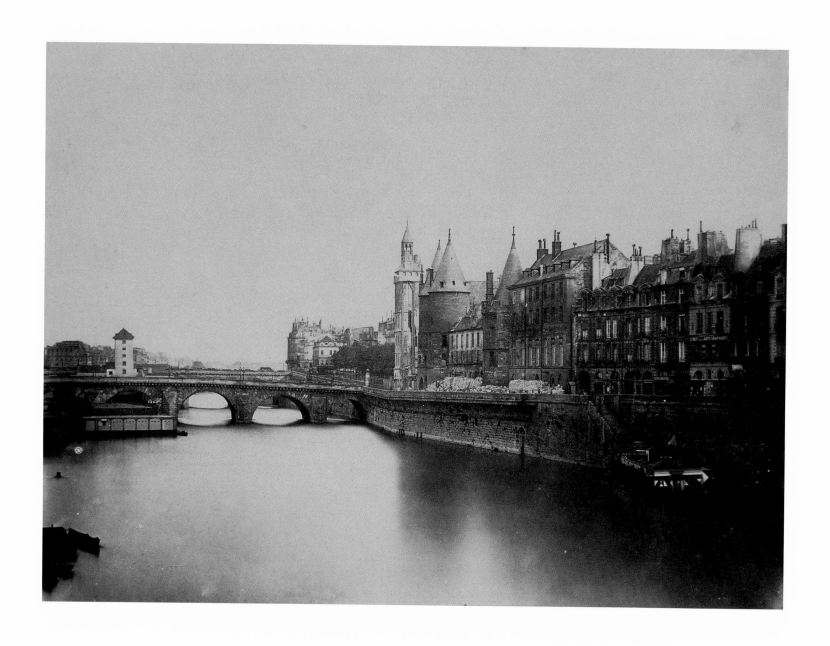

François-Auguste Renard *Paris, Quai de l'Horloge* c. 1852 albumen print from albumen on glass negative

In driving the evolution of photography, the forces of the marketplace have proven to be more powerful, however, than abstract theories. With the exception of a few independently wealthy amateurs, such as Emmanuel, Duc de Noailles (page 95), photographers have always been compelled to meet the demands of the buying public, who seem obsessed by one particular photographic quality above all others: the faithful reproduction of fine detail. This was especially true in portraiture, which then, as today, was the bread and butter of most commercial photography studios. The buying public had the last word, and photographers, sometimes reluctantly, sometimes with great determination, began to search for new ways to sharpen their images.

One obvious solution was to find a substitute for the paper negative, which diffused the print, even when it was waxed to make it more transparent. One possible alternative was to use a sheet of glass for the negative; different coatings were tried that would both stick to the smooth surface and absorb a light-sensitive emulsion. One of the first successful coatings was made in 1847 from an ingredient found in egg whites, albumen. Two early views of Paris printed from albumen glass negatives by François-Auguste Renard clearly illustrate the sharp clarity possible with this new process (pages 24 and 89). Every detail in the Gare de Strasbourg (page 89) is present, from the bricks in the street and the spikes of the fence to the architectural details of the building, even the stripes on the canvas window awnings. But these images also demonstrate a weakness of albumen glass negatives—their relative insensitivity to light. The exposure times were so long, ranging from six to eighteen minutes, that the bustling traffic in front of the station did not register on the plate, leaving as evidence of human presence only a few seated vendors and idlers by the front gate.

A similar effect is apparent in Renard's view of the river Seine (page 24). The ripples and waves of the flowing water have smoothed out, blurring the reflections of the buildings along the quays and giving an impression of a frozen lake. While such effects may have a certain charm, the slowness of albumen negatives made it extremely difficult to photograph what has been the most popular subject of almost every photographer: the human image. Every

portrait photographer knows how difficult it would be to get even a calm adult subject to sit perfectly still for six to eighteen minutes, much less a restless child or a pet animal.

Frederick Scott Archer published an alternative method of using glass for a negative in England in 1850. Archer had developed a glass negative of much greater sensitivity, using collodion rather than albumen to coat his plates. Collodion is made by dissolving cellulose nitrate, called guncotton, in ether and alcohol, producing a milky white liquid. Once the collodion was spread across the surface of the glass, but had not completely dried, it was dipped into a bath of light-sensitive chemicals and, while still wet, was exposed in the back of the camera. Before it could dry out, the negative was developed, fixed to remove its light sensitivity, washed in clean water, and finally dried. Many photographers would add a coat of varnish to protect the delicate surface until it could be printed.

These *wet plates,* or *wet collodion negatives,* introduced an enormous complexity into the photographic process. Since the whole procedure had to be completed before the coating dried, photographers who worked outdoors had to take an entire darkroom along. Even a small "portable" outfit could weigh forty or fifty pounds, and prior to the actual taking of the picture a small light-tight tent had to be erected, chemicals prepared, and a source of water located nearby for the washing. Simply producing a good printable negative was quite an accomplishment; that many of the images were also well composed and even beautiful is a tribute to the photographers' determination and talent. Examples of this process, the plates on pages 98 and 99 are photographs by Louis Vignes, a young French naval lieutenant who was trained as a photographer so he could accompany an expedition to the Middle East led by the Duc de Luynes. The images of the landscape in Lebanon (page 98) and the ruins at Petra (page 99) were taken under primitive field conditions, but Lieutenant Vignes succeeded in capturing graphically arresting records of the sights he encountered. Other fine examples may be found in this book in the selection of travel photographs.

Some photographers—for example, Jean-Jacques Heilmann, who had a studio in the southern French city of Pau, near the Pyrenees—

were content to print these new glass negatives on salted paper. Heilmann's studies of the chateau and city combine the clarity of glass with the delicate tonality of the salt print (pages 80 and 81). They are atmospheric and delicate, yet a magnifying glass reveals such subtle details as laundry hanging out to dry and a glassed-in balcony that may be part of Heilmann's own studio (page 80). The determination to achieve even greater clarity continued, however, as did the search for a printing paper that did not allow the chemicals to diffuse into the fibers. The albumen print, introduced in the 1850s, became the standard for the next thirty years. The paper was coated first with a smooth, cream-colored layer made from albumen; the chemicals stayed on the surface of the coated paper, and the resulting images rivaled the daguerreotype in detail while costing less and reproducing easily.

To some extent, the technical evolution of photography also explains the changes in imagery from period to period.[8] Long exposures of extremely slow negative materials result in quiet, empty streets, while fast emulsions can freeze the jagged motions of an energetic crowd (pages 34 and 89). Captured on a daguerreotype plate, with a paper negative on salted paper, and with a glass negative printed on smooth albumen paper, the same landscape will have a completely different "feel" to it. Historically, the process of printing a glass negative on albumen paper rendered both daguerreotypes and salt prints obsolete by combining the clarity of the first with the economy and ease of reproduction of the second. Why did the buying public so avidly pursue these particular qualities in a photograph? Does the medium have inherent qualities that the general public found sufficiently attractive or intriguing to spend money willingly, even eagerly, in order to enjoy?

Since photographs are mechanically produced at an exact time and a precise place, by light reflected from the subject itself, photographs are seen to be a kind of surrogate for the original subject. A good example is a treasured picture of a departed spouse or an absent loved one. We know it is only a piece of paper, yet we feel that the photograph in some way represents more than just the person's appearance. Likewise, we all have had the experience of a faded memory being refreshed or corrected by seeing a snapshot. Such

experiences convince us that photographs are in a sense repositories of truth, custodians of the past, and we often enter them as evidence in courtrooms, or rely on them as "proof" that we really did attend a cousin's wedding.

In the nineteenth century, the age of industrial invention and utility, people also found photographs extremely useful and therefore desirable. An astute nineteenth-century critic who examined the uses of photography, Lady Elizabeth Eastlake, wife of Sir Charles Eastlake, the director of the National Gallery of Art in London, wrote in 1858:

> *Photography has become a household word and a household want; it is used alike by art and science, by love, business, and justice; is found in the most sumptuous salon and in the dingiest attic— in the solitude of the Highland cottage, and in the glare of the London gin-palace—in the pocket of the detective, in the cell of the convict, in the folio of the painter and architect, among the papers and patterns of the mill owner and manufacturer, and on the cold brave breast on the battlefield.*[9]

Presumably Lady Eastlake's reference to a photograph found on a dead soldier refers to a portrait of a loved one, and certainly the most common use of photography throughout its entire history has been to record the human face. John Szarkowski, for many years the curator of photography at the Museum of Modern Art, has pointed out that before photography, only the rich could afford portraits, but suddenly that changed with the advent of the new medium: "By the end of the century, for the first time in history, even the poor man knew what his ancestors looked like."[10] People could collect not only photographs of their own friends and family but also portraits of famous (or infamous) people. These images were often gathered into albums, especially after the development of the immensely popular *carte-de-visite*, a small image mounted on a thin piece of cardboard (see page 61). The importance of family albums to their owners can be seen today in news accounts of fires, floods, and other disasters. Survivors frequently report that after assuring the safety of their children and pets, they then rescued their photo albums.

Photographic portraits were also useful to scientists and schol-

ars. For example, an inscription on the back of the handsome pair of images of a young Vietnamese man taken by Philippe Jacques Potteau in Paris in 1863 (pages 118 and 119) tells us that the subject is Simon Cu'a, that he is eighteen years old, and that he accompanied a diplomatic delegation from Vietnam to Paris. In addition, we learn that he is from the ancient province of Annam in southern Vietnam and that he is a student in the school of a Monsieur Dadan. The images become rich with possible interpretations, perhaps as anthropological records, or, to one critic, as "an excellent example of youthful pride facing up to the photographer, a fruitful confrontation resulting in a strong portrait."[11] From our vantage point, we also know that twenty years later, when Simon was thirty-eight years old, the French would absorb Vietnam as a colony and start a bloody chain of events that is still being played out today. From that perspective, the portraits obtain dark political significance as early documents of colonialism, money, and power.

Portraits sometimes surprise or shock us with a ruthless adherence to reality that does not always coincide with the mental image we carry of our own appearance. Retouching negatives to remove wrinkles and blemishes was very common in the nineteenth century, as it is today. Some conditions, however, were too striking to be retouched. Portraits of an American woman, Rebecca Earp, exist both in a smaller, less detailed version in carte-de-visite format and a larger, more expensive print (this page) that shows her toothless image in exquisite detail.

SAMUEL BROADBENT
Mrs. Rebecca Earp, Seated
c. 1855 salt print

When Lady Eastlake mentioned that photographs were to be found "in the folio of the painter," she could very well have been describing a set of images commissioned by François-Victor Jeannenet (1832–1885), a provincial painter active in Vesoul and Besançon in eastern France. The Scholz collection contains a set of photographs of models in various poses executed by J. N. Truchelut (pages 106, 107, 108, and 109), who had a studio in Besançon. Unfortunately, no painting has yet been found that corresponds to the wonderful figures in Truchelut's photographs. Artists began using photographs as sources as early as 1839, but Eugène Delacroix (page 110) was the first prominent painter to commission an extensive series of photographs of models in specific poses.[12] Someone, presumably Jeannenet, has drawn numbered lines across the photographs to make it easier to transfer the images to a canvas. The forced, awkward poses of the models, coupled with the overlaid grids, give the images a contemporary quality, a cross between science and surrealism.

A little-known American painter, Milton Bancroft (1867–1947), also made extensive use of photographs, gluing scores of them into a pair of albums. Bancroft traveled to Europe from 1894 through 1899, where he obtained photographs of paintings and drawings from the National Gallery in London and from the Louvre in Paris. He was one of the earliest artists to purchase prints from Eugène Atget, who began photographing around 1898. The smaller size of a print of a tree indicates it was taken with Atget's first camera (page 123, *Willow Tree*), which he soon traded for a larger one.[13]

Ironically, photography's air of truthfulness has made it especially useful in producing a type of image based on fantasy, the erotic photograph. Photographers quickly discovered that there was a huge demand for images of attractive models (usually female), ranging from blatantly pornographic to traditional academic model poses. The Scholz collection contains only one such image, a tame photograph of a model reclining in tall grass (page 121). What makes this picture unusual is that it is a salt print stereoscopic format, meant to be seen through a viewer that would make it appear three-dimensional. Nude stereoviews were much more common in the daguerreotype format, as it greatly enhanced the illusion of reality. Throughout the nineteenth century, stereo photographs, often travel views of exotic

places, were produced by the millions and, after the portrait, were one of the most common forms of photography.

Another quality that has permeated photography from its beginning and enhances its claim to veracity is its relationship to time. A photograph is traditionally taken by a person with a camera who has to be in the presence of the subject photographed at exactly the same time as the subject. The past or the future cannot be photographed, only the "now." As John Szarkowski has pointed out,

> *There is in fact no such thing as an instantaneous photograph. All photographs are time exposures, of shorter or longer duration, and each describes a discreet parcel of time. The time is always the present. Uniquely in the history of pictures, a photograph describes only that time in which it was made. Photography alludes to the past and the future only insofar as they exist in the present, the past through its surviving relics, the future through prophecy visible in the present.* [14]

The awareness of time in the photographs in this book is even stronger because we are looking at photographs that date from the earliest days of the medium. Subjects of portraits are long dead, landscapes have been transformed, and buildings no longer exist.

Susan Sontag has described the feelings that can be generated when we meditate on photographs, especially those from a more distant past:

> *It is a nostalgic time right now, and photographs actively promote nostalgia. Photography is an elegiac art, a twilight art.... An ugly or grotesque subject may be moving because it has been dignified by the attention of the photographer. A beautiful subject can be the object of rueful feelings, because it has aged, or decayed, or no longer exists. All photographs are* memento mori. *To take a photograph is to participate in another person's or thing's mortality, vulnerability, mutability. Precisely by slicing out this moment and freezing it, all photographs testify to time's relentless melt....*
>
> *Cameras began duplicating the world at that moment when the human landscape started to undergo a vertiginous rate of change:*

while an untold number of forms of biological and social life are being destroyed in a brief span of time, a device is available to record what is disappearing. The moody, intricately textured Paris of Atget and Brassaï is mostly gone. Like the dead relatives and friends preserved in the family album, whose presence in photographs exorcises some of the anxiety and remorse prompted by their disappearance, so the photographs of neighborhoods now torn down, rural places disfigured and now made barren, supply our pocket relation to the past. . . .

Like a wood fire in a room, photographs—especially those of people, of distant landscapes and faraway cities, of the vanquished past—are incitements to reverie.[15]

Ultimately, these photographs are things of mystery. We can approach them with the sophisticated analysis of Susan Sontag, or with the insights of Marx and Freud. The same photograph may say entirely different things to an anthropologist, a feminist, an art historian, or a painter. Nimbly dancing away from any one interpretation, these images pass before us like tricks in a magic show. We can try to debunk, demystify, and explain them. We can also sit back and be dazzled, humbled, puzzled, angered, and entertained.

"Kingdom of darkness," Kingdom of Light: Photography in Victorian Britain

MORNA O'NEILL

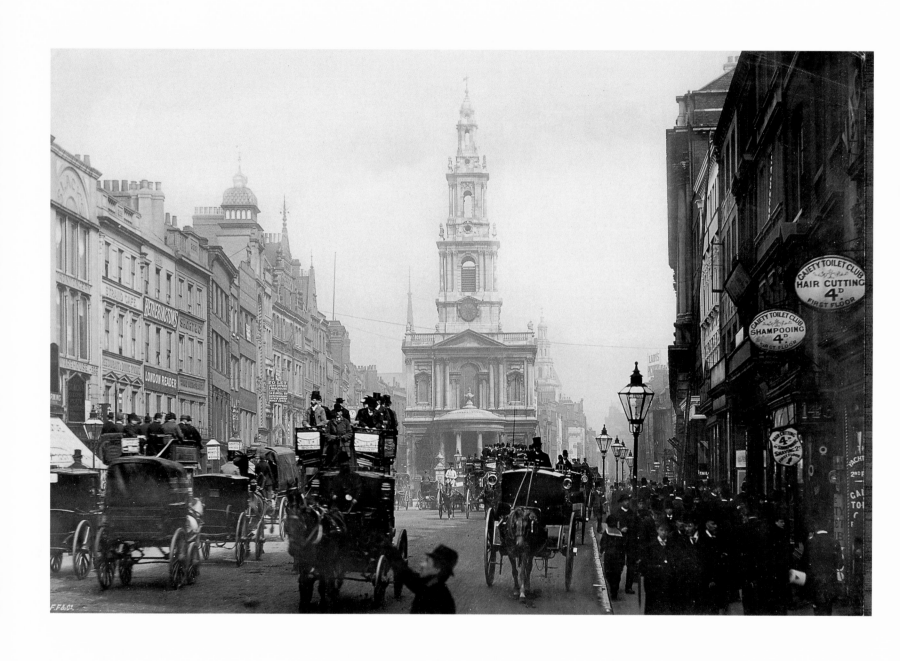

Francis Frith and Company *The Strand, London* 1880s albumen print

SOMETIME IN THE 1890S, AMID THE FRANTIC PACE OF LONDON'S busy Strand, a photographer set up his camera (see facing page). At that time, the street was "the great main thoroughfare of London from its most central point to the City. From early morning till past midnight it is more frequented than any other London street."[1] Home to theaters, the Law Courts, government offices, newspaper offices, and shops, the Strand displayed the bustle and energy of Victorian London. The individuals participating in the brisk foot traffic blend together in the darkness; specks of white collars in a sea of dark suits, uniformed and anonymous, signify modern urban life. Public omnibuses jostle past commercial vehicles, swirling around the church of St. Mary-le-Strand, a monumental anchor in this frozen image of purposeful movement. Like the crowd, the photographer remains anonymous. Marked only with "F. F. & Co.," this image was one of thousands produced by itinerant photographers for the publishing firm of the successful Victorian photographer Francis Frith. A few years earlier, a stroll past the print shops of the Strand prompted the Victorian art critic and thinker John Ruskin to ruminate on the nature of photography. Like many of his contemporaries, he grappled with the meaning of this new medium and its images, which had radically altered the visual culture of the Victorian era since photography's invention nearly fifty years before: "What was to come of all this literally 'black art' . . . Are our lives in this kingdom of darkness to be indeed twenty times as wise and long as they were in the light?"[2]

In his nearly thirty-year fascination with the photography of Victorian Britain, Janos Scholz amassed a unique collection of images that reveals the wonderfully varied relationship between the Victorians and the "black art" of photography. The announcement of the invention of photography in 1839 by William Henry Fox Talbot after years of experimentation led to further investigations into processes and products. Enthralled by the possibilities of the new medium, yet unsure of its exact place in their cultural vocabulary, Victorian photographers explored the nature and uses of

photography: What could the photograph represent? What should the photograph represent? Responses were enthusiastic and thoughtful, even skeptical. Above all, photographs were pervasive. The Victorian period presents us with the first photographic record of an era, a method of history making and recording now regarded as commonplace. The images document everything, from the far-flung travels of photographer-explorers to the closer-to-home, the tentative steps of a young child and the bond between young and old. These images emerge from Ruskin's "kingdom of darkness," the dimness of the darkroom and murky chemicals. Yet they provide the modern viewer with a kingdom of light created by the sun, an insight into Victorian ways of life and thought.

Janos Scholz gathered together a cross section of this Victorian exploration of the kingdoms of darkness and light. While he collected the "fine art" photography of the era, he also explored the myriad other uses for photography in the period: photographs as art mingle with photographs of art, travel albums of home and abroad, stereoviews, photographic visiting cards known as cartes de visite, and family scrapbooks. How can we characterize this diverse cultural production? The images in the Scholz Collection appear at once poignantly familiar and starkly distant from our own experience. Like the Victorians, we visit galleries and museums for photographic exhibitions. We purchase reproductions of our favorite works of art. We collect photographs of friends and family. We take the camera on vacation and send home photographic postcards. Few of us, however, announce a visit with a photographic cailing card, and most homes do not have a stereoviewer. The images in the Scholz Collection help us discover what is "Victorian" about Victorian photography, from the high ideals of Julia Margaret Cameron to the daily ambitions of the studio photographer.

The Virtue of Experimentation:
Fox Talbot, Hill and Adamson

William Henry Fox Talbot was in a good position to contribute to the invention of photography. As a wealthy and educated member of the landed elite, Talbot had the resources of time and money

to pursue a variety of scholarly pastimes, among them, translating Assyrian cuneiform and publishing papers on mathematics. Two other activities suited to his position in society—he traveled and he drew—led to his work in photography. As he traced over the lines refracted by his *camera lucida* while he sketched during a trip to Italy in 1833, he wished for something more: "I found that the faithless pencil had only left traces on the paper melancholy to behold."[3]

In 1834 Talbot became a fellow of the Royal Society (a club for educated gentlemen with an inclination towards science) and worked intermittently on his photographic method at his ancestral home of Lacock Abbey. The Scholz Collection allows us to trace the development of Talbot's experiments in image making. His earliest works are known as *photograms,* the result of placing an object on paper treated with light-sensitive chemicals. Talbot, however, desired more than the outline of an object; he wanted the sun to capture the image and fix it on the paper, as it did late in 1839, presenting the photographer with a view of the south side of his home, Lacock Abbey, towards Sharington's Tower (page 71). The brown block of the tower stands out against the cream colored sky, a major achievement absorbed into the weave of the thick woven paper. On

18 February 1840, he turned towards the clock tower at his ancestral home, improving the chemical mixtures and optical adjustments of his invention (page 70). In 1841 he introduced the public to these "light pictures," or *calotypes,* and patented the process the same year.

Unlike photogenic drawings, where objects leave a negative mark when placed on light-sensitive paper, Talbot's "light pictures" exposed chemically treated paper to the sun, producing an image in negative that could be transferred to another sheet of paper to produce a positive. Obsessive about recording the progress of his invention, Talbot dated the paper negative *Magdalen College, Oxford* to 28 July 1842 (see also page 72).

WILLIAM HENRY FOX TALBOT
detail, *Magdalen College, Oxford*
28 July 1842 calotype negative

In the confusion of light and dark, it is a technology we recognize today; negatives such as this one made photography reproducible.

To illustrate the reproducibility of this new medium, Talbot chronicled the story of his invention in *The Pencil of Nature*. Twenty-four calotypes illustrated the work and suggested, along with the text, how this new medium might be employed, from portraiture to the recording of one's possessions in case of theft. He viewed his achievements as the outcome of his combined interest in drawing and chemistry, interests shared by others of his class and education who formed a circle of friends, associates, and acolytes exchanging discoveries. They produced views of the local landscape, studies of animals, still-life images, and family portraits. Talbot obtained a patent for his process, and the cost of obtaining a license excluded the application of the calotype process to commercial ventures and limited it to the practice of these amateurs. Talbot continued to write about his work with photographic images and published his *Sun Pictures in Scotland* in 1845; the book was illustrated with landscape studies similar to *Loch Katrine* (page 73), a landmark of the picturesque tour of the Highlands of Scotland and a traditional subject for landscape artists of the period. This work placed the camera within the idea that the depiction of natural beauty could be morally uplifting and suitable material for a work of art.

Fox Talbot sought to introduce a Scottish audience to photography, and, through the interest of Sir David Brewster, Robert Adamson, the son of an associate, set up a professional calotype practice in Edinburgh in 1843 with his partner, the painter David Octavius Hill. From their rooftop Edinburgh studio at Rock House (Carlton Hill), Hill and Adamson produced 2,500 negatives in their five years together. Portraiture formed a major part of their practice, including 450 portraits for Hill's monumental painting memorializing the establishment of the Church of Scotland.

Portrait of Admiral Stoddard (page 130), a Hill and Adamson portrait, presents the viewer with a three-quarters view of the admiral's strong, aged visage and a three-quarter-length portrait. To maintain this pose, the admiral would have rested his head and neck in a headrest during the long exposure time while seated in a magisterial

armchair against a dark patterned background. The photographer touched out the apparatus during developing. The sitter holds a walking stick in his right hand, its shadowy presence in the image probably caused by movement during the exposure. Although Hill and Adamson's portraits borrow their visual language from the tradition of portrait painting, this photograph lacks the macho swagger of a large oil painting. For the first time in the history of image making, the picture presents the viewer with the actual subject, and the admiral seems small and human, his determined face highlighted against the dark background.

Hill and Adamson experimented with the expressive nature of photographic portraiture. Their portrait of Mrs. Marian Murray ignores the traditional focus of the sitter's face to show the standing figure from behind (page 131). Instead of noticing the curve of Mrs. Murray's chin, we examine the elaborate plaits in her hair. The calotype was a process carefully attuned to light and shade, and it admirably records the shimmering folds of Mrs. Murray's dress and the geometric border patterning of her wrap. It is easy to imagine a title for this photograph such as *Melancholy;* the sitter, we might think, was overcome by her emotions and turned away from the viewer.

Hill brought the sensitivity and training of a painter to his partnership with Adamson, as they explored various genres of image making, for example, the *memento mori,* a reminder to the living viewer of the frailty and vanity of life. In Edinburgh's Greyfriars cemetery, a reclining man adopts a thoughtful pose and gazes at another man, who stoops to read the inscription on the tomb (page 129). A seated woman, leaning back against the classical architecture of the tomb, also gazes at the inscription topped by an angel head and wings. The heavy watercolor paper absorbed the chemicals into the weave of the fibers, blurring the sharp edges and heightening the shadows of the cemetery. Contemporaries likened the images to Rembrandt's etchings. While drawing upon pictorial tradition, the moral thrust of this photograph—the contemplation of death and therefore our own mortality—is heightened by the medium itself. Photographs could be considered *memento mori* of another sort, for they remind us, as modern viewers, that the individuals in this scene

who contemplated death are by now dead, their presence reduced to traces of light on sensitized paper.

In 1844 Hill published an advertisement in the *Edinburgh Evening Courant* announcing the plan to prepare "for publication A Series of Volumes of Pictures executed solely by the agency of Light . . . the volumes will be produced in a style of great elegance on a paper the size and quality of 'Roberts's Views in the Holy Land.'"[4]

Here Hill is connecting the photographic project with one of the most ambitious and successful artistic publishing ventures of the first half of the nineteenth century: the publication of topographical painter David Roberts's lithographs of Egypt and the Holy Land in different series from 1842 to 1847 simultaneously reached a wide audience and established a benchmark for illustrated publishing ventures. The lithographs also inspired many photographic counterparts. With this announcement, Hill and Adamson declared the quality of their work and targeted an educated, appreciative viewer.

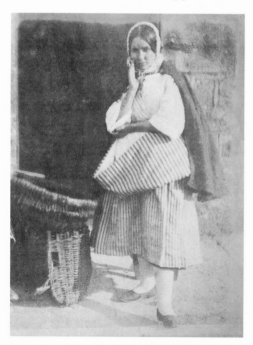

DAVID OCTAVIUS HILL
AND ROBERT ADAMSON
detail, *Three Fisherwomen of Newhaven*
c. 1845 salt print from a paper negative

The Fishermen and Women of the Firth of Forth was the first publication begun by Hill and Adamson.[5] For two years, between 1843 and 1845, the pair produced 130 images of the inhabitants of New Haven, a fishing village a few miles outside of Edinburgh. The village was idealized in the popular imagination as picturesque and primitive, where the inhabitants lived a simple life filled with old ways and informed by the values of hard work, in sharp contrast to the urbanization and industrialization then going on throughout Scotland. As a contemporary remarked, the calotypes of New Haven presented "Nature's own children painted by herself."[6] At the same time, the stripes and patterns of the fisherwomen's distinct costume supposedly pointed to their status as a different ethnic group. The women performed the land labor; they hauled in the

40

catch, cleaned the fish, carried their laden baskets to town, and sold the fish at market. Contemporary visitors often commented upon the handsomeness and strength of the women in ethnographic terms. Thus, the portfolio was both picturesque as well as documentary, a photographic record of a different "type" of people—perhaps the first of its kind to be illustrated with photographs. In our image of the fisherwomen (page 127), we find the distinct costume and confident, Amazonian-like stance that sets them apart from women like Mrs. Murray (see detail, page 40).

The work of Hill and Adamson addresses some of the issues that occupied other photographers in the early days of the medium. They explored many of the uses of photography that typified Victorian practice: studies for artists, portraiture, architectural views, documentary projects. They accepted commissions; they distributed albums, for example to the London dealer Colnaghi, and they planned publications like the *Fishermen and Women* series; they exhibited their work publicly and offered it for sale. In addition, they worked towards improving the practice of photography, perfecting the chemistry and experimenting with different lenses and formats. Hill and Adamson explored and, to an extent, established what photography could and could not represent in the Victorian era. Within the bounds of technology, photography could not yet capture movement or accurately convey value. They borrowed from other forms of representation as they forged a new, photographic form of representation.

Even though Talbot himself set up a photographic printing firm, his circle of followers are referred to as "amateurs," educated and genteel individuals. They exhibited their work at the Society of Arts, just as Hill and Adamson had at the society's Scottish counterpart, and the work often focused on architecture studies and picturesque local landscapes. Organizations such as the Calotype Society and the Photographic Club were formed in the late 1840s to provide organization to this "social context"; photographers would gather to discuss their work and their experiments, as well as to exchange their work, as the name Photographic Exchange Club implies. While photography continued as an amateur practice, as the 1840s came to a close, the debates about photography became increasingly public

as experiments led to new photographic methods, new practitioners, new uses, and new audiences for photography.

A Philosophical Instrument

Around 1853, an unknown photographer produced a calotype of the gardens at Castle Howard in North Yorkshire (page 140), the ancestral home of the earl of Carlisle. Taken from an authoritative viewpoint, nature appears controlled and ordered into geometrical arrangements. Popular garden designer William Andrews Nesfield had recently completed renovating the gardens.[7] He is credited with reviving interest in *parterres de broderie,* low box hedges laid out in baroque patterns and accented with colored gravels, as seen in this photograph. In that same year, the newly installed Atlas fountain became fully operational, releasing streams of water from Atlas's globe and Triton's conches. Designed by sculptor and architect John Thomas, this same fountain caused a stir at the Great Exhibition of 1851 in London. But who was the photographer? Perhaps it was George Howard, seventh earl of Carlisle, who purchased the fountain and ordered the garden renovation. Perhaps it was a local amateur, perhaps a friend of the earl's, who wanted to document the event, or a professional commissioned by the earl to commemorate the event or to sell to tourists. The first *Guidebook to Castle Howard* was published in 1857. Was the image commissioned by garden designer Nesfield to showcase his work? Was a publishing firm planning a portfolio, *The Gardens of North Yorkshire*? By 1853, these were all possibilities. Photography flourished as a practice for both amateurs and professionals and, like the Castle Howard's Atlas fountain, photography attracted attention at the Great Exhibition of 1851.

The Great Exhibition "of the Works of the Industry of all Nations" opened at the Crystal Palace in London in 1851. Organized in part by Prince Albert, the exhibition "invited all civilized nations to a festival, to bring into comparison the works of human skill," according to fellow organizer and founder of the South Kensington (now Victoria and Albert) Museum, Henry Cole.[8] The Crystal Palace presented a world on display for material consumption, a nation and a people on display, to view and be viewed, an expression of the Vic-

torian love of things and the desire to transcend those things to reach ideals. Photography was included in two different parts of the exhibition, with "philosophical instruments" and with "fine arts," an indication of the debate over photography's status as a product of scientific inquiry and as a fine art.

As photography became a public practice, artists, art critics, photographers, and cultural critics argued over the nature of the photographic image. Was the photograph a product of nature, a result of science? It was first presented to the public under the auspices of the Royal Society, a group devoted to scientific endeavors. The image seemed to act as a mirror that reflected back the object represented. The photograph did not seem to imbue the object with artistic feeling. According to mid-Victorian orthodoxy, the photograph contained knowledge through the depiction of reality and the "self-evidentness" of its process, the result of a positivist belief in the ability to render a truthful image of reality. A drawing necessitated the subjective hand of the artist for its production, an interpretive process that interfered with the factual truth of the image. Certain aspects of photographic production relied on this conception of photographic truth for their value as images. In an 1858 article in *The Photographic and Fine Art Journal*, J. T. Brown argues that the truth of photography makes it superior to drawing in the depiction of reality. However, this truth compromises photography's status as an artistic process, since the mechanical nature of the process secures this truth.[9] In this light, the photographer becomes the operator of a machine, the same as any other professional laborer. Photographers such as Hill and Adamson, however, insisted on the status of art for their photographs because of the arrangement of subject matter and the manipulation of texture, light, and shade. The painterly qualities of the calotype approximated the hand of the artist.

The Great Exhibition drew attention to photography, as well as to the fact that patent restrictions limited the development of the art-science. After the exhibition, Talbot agreed to loosen the patent restrictions. Soon after, Sir Charles Eastlake announced the establishment of the Photographic Society to hold annual exhibitions, and similar groups were formed in Manchester, Liverpool, and other cities. In addition, other venues were available for photographic

exhibitions, such as the newly established South Kensington Museum and the Architectural Photography Association in London. The popularity of the Great Exhibition engaged a nation in concern for the visual arts and consequently introduced a wider public to photography. The mid-Victorian era initiated a time of public exchanges about the photographic image.

For the medium and its practitioners, it was a time of technological advancement and experimentation as photographers developed new processes and explored the possibilities of the medium. Two important developments were announced in close succession: First, in 1851 Frederick Scott Archer published directions for his collodion on glass process in *The Chemist*. Archer sought to fix "the imperfections in paper photography arising from the uneven texture of the material."[10] His new collodion on glass process involved coating a glass plate with an emulsion, which then had to be exposed while still wet. We can observe the meticulous details of Christopher Columbus's suit of armor (see page 144), its gleaming metal in sharp contrast to the deep background in Juan Laurent's photograph (page 142). However, as with the paper negative, the size of the print was determined by the size of the glass negative. The camera was still a cumbersome piece of equipment, requiring a tripod and the presence of a darkroom nearby. The adventurous Francis Frith traveled through Egypt in 1856 with three cameras, hundreds of glass plates, corked glass bottles of chemicals, and a darkroom tent stored in a converted wicker baby carriage, leaving tracks across the sand. Still a relatively expensive practice, photography required a competent knowledge of chemistry to judge exposure times.

Second, the news of Louis-Désiré Blanquart-Evrard's use of albumen to coat the surface of the printing paper was published in London in 1852. Albumen prevents the chemicals from sinking into the weave of the paper and thus also results in a "sharper" image.

In the first part of the 1850s, both the calotype and the new practices remained current; however, as the decade progressed, the wet collodion negative printed on albumen-coated paper overtook the calotype. Increasingly photography was valued for its ability to capture reality and depict the truth. As the technology of the medium and its uses continued to develop, photography sparked

profound debate about the relationship between art and science as photographers and their viewers pondered the nature of the photographic image.

The organizers of the Great Exhibition seemed to have some insight into this value of photography when they classed the camera and its products with "philosophical instruments." The popularity of positivist thought in the Victorian era ensured that the "truth" of the camera was indeed philosophical; photography also aided in the timeless philosophical quest to "know thyself." The photographic portrait involved self-representation, artistic interpretation, and viewer expectation; the product of a moment, it allows the individual to transcend that moment.[11] Photography radically widened the field of portraiture, allowing a greater number of individuals to picture themselves.

The Misses Harvey posed for a portrait in a garden around 1860 (page 126). They appear conjoined, identical bonnets tied with identical bows, perhaps indicating their sisterly bond. The mimetic appearance of photography allied it to aspects of memory; hopefully each young Miss had a photograph to remind her of that bond.

Further, photography recalled what the mind could not, providing a presence in the absence of an individual. The absence of family members and loved ones was a common enough event in industrial and imperial Britain as men and women went off to fight in the Crimea or the Sudan, find work in Australia, or join the civil service in India. Julia Margaret Cameron took the image of her daughter-in-law Annie Cameron, the wife of her son Ewen Hay, and her grandson Ewen during one of their visits to England from their home in Ceylon (page 136). Cameron captures the affection between mother and child as a way to contain her own affection for both of them. She also used the photograph as a way to communicate her affection to others. Similarly, a mirror-like photograph captured and held the likeness of a person beyond death, and not surprisingly, photography became a way to memorialize the death of an individual. The presence provided by the photograph highlights absence, the necessity for the photographic surrogate in the first place.[12]

These aspects of the photograph are evident in an image such as the group of young boys, below which someone has written "When

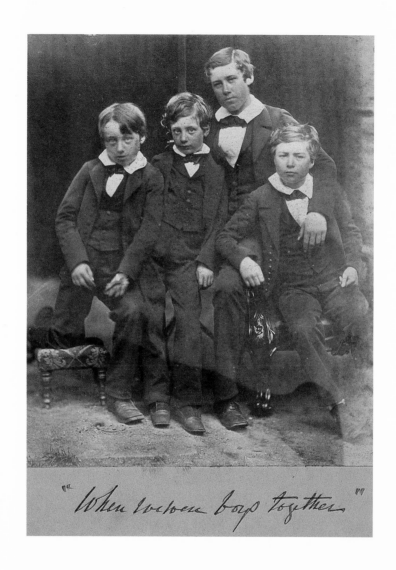

"When when boys together"

UNIDENTIFIED PHOTOGRAPHER *When We Were Boys Together* c. 1860 albumen print

we were boys together" (page 46). Dressed in their school clothes, these boys call to mind the close attachments that were often formed at British boarding schools. The oldest-looking boy places his arm around the younger boy on his left, while two still-younger-looking boys are grouped on his right. Their affectionate, though somewhat awkward, arrangement was probably necessitated by the demands of photography: they all must have something to rest against, a chair, a foot stool, each other, in order to remain still for the duration of the exposure. The headrest that secures the boy resting against the eldest boy's right knee is still visible. While this image on its own is a poignant reminder of childhood and the bonds of friendship formed at school, the inscription deepens its associations with memory and loss. The inscription acknowledges the passage of time and the fact that the moment captured by the camera existed once and can never be again. As Roland Barthes muses, the photograph does not "restore what has been abolished" but attests to the fact that "what I see has indeed existed."[13] The use of the plural *we* unites the boys in the image with each other. Furthermore, this *we* universalizes the experience of childhood friendship, even though the photograph originated in a world reserved for the boys in Victorian Britain.

In 1854, the French photographer and entrepreneur André-Adolphe-Eugène Disdéri patented his carte de visite, visiting card, photograph. This process allowed the photographer to make many small exposures (usually either eight or ten) on a large glass negative and thus produce multiple images during processing. When Queen Victoria and Prince Albert visited John E. Mayall's London studio in 1860, they were participating in what would become a cultural rite of passage: they had their carte de visite portrait done (page 61). Mayall published his hugely popular *Royal Album* of cartes of the royal family in August of that same year, thus confirming the popularity of this practice with the public.[14] Within their family circle, Victoria accumulated cartes as keepsake images of loved ones. Within the larger culture, her own carte became a celebrity portrait, part of the "cartomania" of the 1860s. Popular actors and performers, politicians, society celebrities all had carte portraits done and then gave permission to have them published. Mounted on hard cardboard roughly 2.5 x 4 inches, these

inexpensive photographs were sold at a variety of venues, from booksellers to street vendors.

Publisher Joseph Cundall, himself a photographer, issued a carte of the poet laureate Alfred, Lord Tennyson in 1861 (page 135). The carte was probably done after a print by Charles Lutwidge Dodgson, an amateur photographer and mathematics don at Oxford also known as Lewis Carroll, the author of *Alice in Wonderland.* Dodgson was a self-described "lion-hunter" who sought out Victorian luminaries to photograph. He finally succeeded in capturing Tennyson in 1857 on a visit to the Lake District: "a strange, shaggy-looking man entered: his hair, moustache and beard looked wild and neglected . . . his hair is black: I think his eyes are too; they are keen and restless—nose aquiline—forehead high and broad."[15] These aspects, portrayed by Dodgson's image, combine with the hat and cape to give us the romantic image of the poet.

Individuals could go to a photographic studio to have their own portrait taken or to have portraits taken of their children. These images also give the modern viewer an idea of photographic studio surroundings: the balustrade to rest the arm, the curtain and the classical column to frame the image. As one observer from the 1860s commented, "everybody sat for a picture in the new style [carte], and a system of portrait exchange and portrait collection was initiated, which has no precedent in pictorial art."[16] Portraiture was no longer the preserve of the wealthy, and the carte photograph inaugurated a new era of visual knowledge.

Portrait photographs such as that of the Misses Harvey and the cartes of Queen Victoria were often kept and displayed in albums. It is often thought that album making was the province of the women of the family, an extension of the ladylike pastimes of drawing and making scrapbooks. Through these activities, women enacted their role as the idealized emotional center of the family. These albums represent one of the many ways in which women participated in photography.[17] Often elaborately decorated with brightly colored leather bindings, embossed details, and decorative closures, many albums were designed specifically to display carte collections. One example in the Scholz Collection contains 120 cartes of European

royalty and Victorian personalities, such as the missionary explorer Dr. David Livingstone and Italian patriot Guiseppe Garibaldi, with each sitter carefully labeled by hand.

Photographs also entered the province of the scrapbook-type album whose pages were filled with a variety of popular cuttings and scraps, an eclectic practice. In one album from the Scholz Collection, an oval portrait of the eminent Victorian painter Sir Edwin Landseer is surrounded by smaller photographic reproductions of his paintings, including the animals for which he was famous—photography was a popular medium for the reproduction of works of art, and as such it introduced a broader public to painting. A few pages later, a rakish colonial group wearing accented hats rests on a hand-tinted Oriental rug. They are flanked by reproductions of paintings of the prince and princess of Wales. Above them, an image of the post office at Penang is grouped with two small round images of paintings of children. Below the men, a family group rests amid a view from Penang Hill and a Burmese temple. The album brings together all of the scattered associations of its maker: affection for the royal family, the colonial endeavors of absent loved ones, the importance of familial relations, interest in foreign locales, favorite works of art.

Stereoviews were another aspect of photography that invaded the Victorian parlor. Introduced to the public at the Great Exhibition of 1851 and purchased there by Queen Victoria, stereoviewers, at the close of the 1850s, could be found in a million homes in Britain. Devised by Sir Charles Wheatstone and Sir David Brewster, stereo images are premised on the notion that human eyes are approximately two and one-half inches apart, with each eye seeing a slightly different image. Images were taken with a twin lens camera and then viewed with a stereoviewer that made it possible to create the illusion of depth. The apparent depth of stereoviews heightened the illusion of photographic reality, thus extending the aura of photographic "truth" to travel scenes or, as on page 121, to the depiction of nudes. However, many stereoviews undercut the illusion of reality through the presentation of staged, often comic, scenes. For many Victorians, cartes, albums, and stereoviews defined the

photograph as a domestic object, a way of knowing and being known that could be brought into the home. The prevalence of these images attests to the powerful place of photography in the Victorian imagination, as Janos Scholz realized.

The Art Union

The Art Union of London embraced the new art of photography. Established in 1837 with the aim to "bring 'Art' to the rapidly expanding middle classes and to improve public taste on a general level," the Art Union of London and others like it offered subscribers an engraving of a popular work of art and the chance to win a work of art in a lottery. In 1858 and 1859, the Art Union offered photographic portfolios of twelve prints obtained from various photographers: reproductions of works of art, architectural studies, and views of foreign locales.[18] The 1859 portfolio includes photographs by Francis Frith, recently returned from Egypt and the Holy Land, and an image by publisher Joseph Cundall. The portfolio showcases the work of Roger Fenton, one of the most acclaimed photographers of the Victorian era.

Fenton trained as a painter in London and Paris before taking up photography in 1847. For the next twenty years, he planned and participated in a variety of photographic ventures: he photographed the royal family, journeyed to document the Crimean War, and recorded treasures in the British Museum. In his *Bust of Antoninus Pius* (page 134), Fenton has balanced the blank, staring eyes of the stone bust with the warmth of a human subject through the framing and mellow gold toning of the image. The Art Union portfolio of 1859 features Fenton's strength as an architectural photographer. His *Porch, Lichfield Cathedral* is a subtly beautiful study of England's medieval heritage (page 133). The photographer has incorporated the slight asymmetries of Gothic architecture into his own composition, as the open doorway, itself slightly off-center, leads into darkness. Fenton abandoned photography and turned to the legal profession in 1862; scholars have suggested that he was frustrated by the increasing commercialization of photography, in the same year that photography was to be displayed with the "mechanical arts" at the International Exhibition in London.

Societies similar to the Art Union offered prizes in Manchester and Birmingham to subscribers on a regular basis. An album of landscapes on the River Wye, harkening back to the romanticism of Wordsworth and the picturesque tradition of Gilpin, was awarded to a winner in Manchester. Not everyone appreciated the efforts of the Art Union to offer subscribers photographs when, as one dissenter argued, "every print-shop is inundated with specimens."[19] Through their offer of photographs to subscribers, the Art Union put photography on the level of engraving, arguably a method of reproduction rather than a work of art in its own right. Allen Staley has argued that while photography was unlike older print forms, "as the word 'photographic' implies, it was perceived as another graphic medium."[20] How, then, did photography as an art relate to the art of painting?

An anonymous contributor to *Photographic Notes* complained of the lowly status conferred on photography as an art form: "Photography has yet to be appreciated" by the "art critic, who smiles so condescendingly on the new art."[21] The author remains hopeful, however, that the critic "shall yet enter our photographic exhibitions as he does those devoted to paintings and criticise, with the same respectful attention, the productions of pencil and camera."[22] Photography as an art, then, should aspire to the condition of painting.

At the same time as he maintained a commercial practice, John E. Mayall ventured into the realm of "high art" photography, exhibiting works at the 1862 International Exhibition in London. In *A Great Light Shines through a Small Window* (see this page), a pretty blond girl with perfect ringlets reads from a massive tome, presumably the Bible (the "great light"), while an elderly man listens and perhaps contemplates the passage of time, as the hourglass on the table seems to indicate. This image draws its inspiration from popular genre paintings exhibited at the Royal Academy,

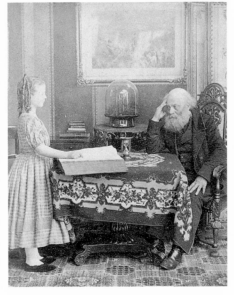

JOHN E. MAYALL
A Great Light Shines through a Small Window
c. 1862 albumen print

especially those of children.[23] Mayall envisioned his photographs in terms of high art meant "not merely to amuse, but to instruct, to purify, to ennoble."[24]

High art photography countered the verisimilitude of Victorian painting with similar subject matter rendered with photographic reality. The critic for the *British Journal of Photography* hints at the problem to this approach in his critique of Mayall's picture: "So far as regards the expression of any particular feeling or sentiment in either face, the book might be any other book, and the picture receive any other title."[25] The failure of the image was therefore not its staged quality but the failure of the photographer to elicit the necessary emotion from his sitters, his actors. In endeavoring to use photography to depict high art subject matter and therefore attain the status of fine art, photography had to escape its status as a facsimile of the real world, however allegorically rendered.

"The Utmost for the Highest": Julia Margaret Cameron

Some scholars have argued that photography as an art practice was premised upon the status of the photographer as amateur.[26] This distinction limits the status of "art photographer" to wealthy, even aristocratic, amateurs who were not required to earn a living from their work. According to Allen Staley, "the classic example" is Julia Margaret Cameron, whose "portraits taken purposely out of focus" are "in contrast to the expected sharp focus of the standard studio portrait."[27] We have seen Cameron's portrait of her daughter-in-law Mrs. Ewen Hay Cameron, an image with some of the softness that characterizes Cameron's other portrait studies (see page 136).

In *Our May* (page 137), Cameron's niece May Prinsep sits at a table in her frilled and striped dress; she holds her head in her hand, seemingly pausing in the act of writing. The candle burns low, and the clock nears two, probably in the morning. The Bible rests open in May's lap and the bird roams out of his cage. Cameron borrows themes and motifs from paintings and literature, and although the original narrative associations of the photograph are now lost, we can hypothesize about the image from the details, which Victorian

viewers would have had great practice in deciphering.[28] Perhaps the woman is spending a late and weary night contemplating a proposal of marriage, and, hesitating in writing her answer, she turns to the Bible for guidance.[29] Although traditionally viewed as an amateur, here Cameron's work bears many similarities in subject matter and treatment to the work of a professional high art photographer.

Julia Margaret Cameron envisioned her photography as art. As an educated and cultured woman, the fourth of seven sisters and prominent in Anglo-Indian society in Calcutta before her marriage, Cameron was interested in literature and the visual arts before her son gave her a camera to "amuse herself with" in 1863. It is telling that Lady Eastlake gendered photography as a "handmaid," a female, yet subservient, enterprise. Women photographers numbered among the ranks of commercial, professional, and amateur photographers. However, proscribed gender roles limited the possibility for women to participate publicly in photography, and the prominence of Cameron, the only female photographer considered in the Scholz exhibit, has proved to be the exception rather than the rule.[30] In her own works, Cameron said she "tried to ennoble photography and secure for it the character and uses of High Art by combining the real and ideal and sacrificing nothing of Truth by all possible devotion to Poetry and beauty."[31] An associate and admirer of Thomas Carlyle and Alfred, Lord Tennyson, Cameron was also a friend of the most allegorical of Victorian painters, G. F. Watts, whose motto, "the Utmost for the Highest," expressed his philosophy of art.[32] We could argue that Cameron envisioned her photography on the same terms as Watts envisioned his art, a combination of the real and the ideal in service of an uplifting Truth.[33] She fought for recognition as a professional artist rather than a commercial photographer. She exhibited and published her copyrighted images. She sold prints to the South Kensington (now the Victoria and Albert) Museum and made her work available for purchase through Colnaghi's gallery in London.

It seems that by the mid-1860s, photographers were no longer divided between amateur and professional in this debate about photography as a fine art; rather, a distinction existed between the photographer who was the operator of a machine in a commercial

setting and the photographer who worked as an artist depicting subject matter worthy of high art. The content, tone, shading, and texture of Hill and Adamson's images were discussed in terms of Old Master paintings. They readily borrowed forms from high art. Yet how does the art photographer working in collodion and albumen overcome the reality of the photographic image?

For Cameron, the manipulation of focus imbued the photograph with the status of "art." As she recalls in her autobiography, she did not plan on taking pictures out of focus; rather, "when focussing and coming to something which, to my eye was very beautiful, I stopped there instead of screwing on the lens to the more definite focus."[34] The photographs are paintings on glass with chemicals. Cameron produced portrait studies of "famous men and fair women" as well as religious, literary, and allegorical pieces featuring friends, family, household members, and sometimes strangers pressed into the service of her camera.[35]

In *A Double Star* (page 137), Cameron pictures two young children loosely wrapped in white fabric and locked in an embrace. Their physical closeness recalls the bonds of affection and friendship seen in images such as *When We Were Boys Together* and invokes the allegorical meaning of the title. A *double star* or *binary star* is actually a pair of stars in orbit around a common center of gravity. They were first discovered by Sir William Herschel and cataloged by Sir John Herschel, an intimate of the Cameron family and a sitter for Cameron.[36] We notice these similarities and wonder at the strangeness, like the conjoining of the young Misses Harvey (page 126), arranged in the garden dressed in their finest outfits, complete with identical bonnets tied with identical bows.

In Victorian parlance, a double star was the eternal unity of two celestial bodies, an astrological symbol for perfect human relations, the union of two souls in heaven. Carol Armstrong has pointed out that the name *Double Star* "allegorizes photography as a point of light that reproduces itself."[37] The soft focus renders the image in diffuse, diaphanous tones absorbed into the texture of the paper. Critics and other photographers reacted in diverse ways to Cameron's new photographic aesthetic. A reviewer for the *Art Journal* praised Cameron's portraits: "The beauty of the heads in these

photographs is the beauty of the highest art."[38] The *Illustrated London News* praised them as "the most bold and successful applications of the principles of fine-art to photography."[39] The professional photographic press and its writers were less kind. Henry Peach Robinson was a high art photographer famous for his use of composite negatives. As a theorist of pictorial photography, he called photography the "art of definition" and did not appreciate Cameron's work.[40] While Cameron's subject matter was in accordance with both high art tradition and her social standing as a gentlewoman, the soft-focus aesthetic seemed to subvert the definition of photography as a visual image.

Grand Tours

William Henry Fox Talbot's frustrated sketching in Italy led him to seek a new method of capturing foreign views. In 1839, the year that Frenchman Louis-Jacques-Mandé Daguerre announced the invention of his photographic process known as the *daguerreotype* and William Henry Fox Talbot announced the calotype, François Arago, a member of the French Academy of Sciences, suggested that photographers be sent to Egypt to record hieroglyphics. According to Arago, "the reproductions will surpass all others in accuracy and . . . will outshine the work of the most skillful painter."[41] Since its inception, photography has been allied with travel. Photography developed alongside the steamship and the railroad; foreign policy and other "enabling institutions," such as currency exchange regulations, made distant regions more accessible to the traveling photographer and the tourist and fuelled the desire to travel as well as the desire for views of foreign lands.[42]

The richness of the Scholz Collection in foreign views and reproductions of famous works of art, both loose and compiled in albums, attests to the popularity of travel photography in the Victorian era. The technological advancements of the period enabled a greater number of people, namely, members of the middle class, to travel abroad and participate in that aristocratic right of passage, the Grand Tour. Documented as early as the Elizabethan era, a Grand Tour of the monuments of Italy and perhaps Greece via France

became a liminal educational experience for English gentlemen and English artists in the eighteenth century.[43] In the early nineteenth century, Spain was often added to the itinerary, idealized in the popular imagination as the romantic site of picturesque premodern culture and mysterious Catholic ritual. Aristocratic Grand Tourists of the past commissioned paintings of Italian scenes from artists such as Pompeo Batoni and Canaletto. Like their predecessors, the new Grand Tourists wanted images of Italy and other locales to take home with them as souvenirs to place in albums or hang on walls. As an inexpensive substitute for painting, photography flourished in this endeavor as British photographers such as Robert Macpherson established themselves abroad to produce images for visiting nationals. "Native" photographers, many of whom, like Tommaso Cuccioni, began their careers as publishers or engravers, produced images for foreign visitors.

The aura of photographic truth enhanced the value of the photograph as a travel memento. The realism of the photograph reproduced the ancient monuments of Rome, for example, with a detail that attests to their presence, as well as the presence of the visitor (page 149). In this sense, the photographs acted as documentary proof of a tour. From our images, we could travel from the treasures of Spanish museums (page 144) and picturesque Spanish culture (pages 142 and 143) to the bridges of Venice (page 57) on to the towers of Bologna (page 147). Next to Rome, to see antiquities (pages 149–151), Renaissance art (page 104), and even papal splendor as in the view by Tommaso Cuccioni of the Seahorses Fountain in the Villa Borghese (page vi), the estate of Pope Paul V (1605–21), on the edge of the city. We continue southward to the ruins of the Roman city of Pompeii. Here we again find photography associated with death, the catastrophic eruption of Mount Vesuvius in 79 C.E. German-born photographer Giorgio Sommer was given special permission by the head of excavation to photograph plaster casts of humans and a dog who perished in the ash of Vesuvius (pages 152 and 153). Perhaps we would end our tour in ancient Greece (page 154), along the way purchasing images from British photographers, such as Charles Clifford in Spain (page 144), to German photographers,

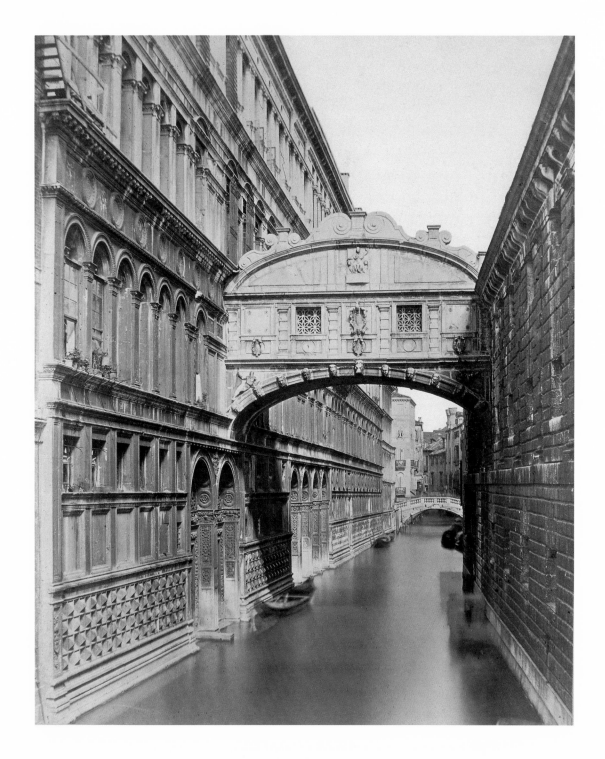

CARLO PONTI *The Bridge of Sighs, Venice* 1862 albumen print

such as Michele Mang (page 149), who catered to an international audience gathered in Rome.

With images such as these, Grand Tourists compiled a record of their travels, bound by the conventions of photography. Photography purports to portray reality, and the idea of documentary photography is based on this assertion. However, as these images reveal, photographs can convey only a version of reality constructed by the photographer, the subject, and the technological capabilities and limitations of the equipment. While the camera could ably capture immobile monuments, the bustle of city life was lost. Humans are included to indicate the scale of ancient ruins and scenes of "local life" are carefully staged for the camera's gaze. These images fail to record the incidentals that would contribute to an accurate record of a visit, such as street traffic and the weather. These photographs do not provide the tourist with the reality of their travels. Rather, they formulate the reality of the travels.

The tourist was often not alone is selecting the destinations. Often, the tradition of the Grand Tour dictated that certain cities, such as Rome and Florence, form part of the itinerary. Literary texts such as Lord Byron's *Childe Harold's Pilgrimage* often functioned as a sort of sentimental guide to tourists. Undoubtedly, Ponti's image of the Bridge of Sighs in Venice (page 57), traversed by prisoners from the Doge's palace on the left to the prison building on the right (thus causing them to sigh at their fate)—a scene memorialized by Byron—proved popular with foreign visitors. Nathaniel Hawthorne's 1860 *The Marble Faun: Or, the Romance of Monte Beni* (British title, *Transformation*) acted as a popular guidebook to the monuments and art treasures of ancient Rome. More than two hundred albumen prints illustrate this text in the Scholz Collection, depicting picturesque scenes of Italy and reproductions of well-known works of art and architecture that relate to Hawthorne's tale of the adventures of four friends in Rome. According to Henry James, the novel was "part of the intellectual equipment of the Anglo-Saxon visitor to Rome."[44] The official travel guidebooks, such as those by Karl Baedeker in Germany and John Murray in England, were first published and popularized in this period. As Charles Lever facetiously asked in his 1844 musing

on tourism, "Does [the tourist] look upon a building, a statue, a picture, an old cabinet, or a manuscript, with whose eyes does he see? With John Murray's to be sure!"[45] Murray's handbooks were popular with British tourists, who relied on their fellow countryman to provide them with information about everything from how to obtain medical care to fashionable places to stay while abroad. Murray also recommended where to buy photographs: "Photography has been of late very successfully applied in delineating the monuments of ancient and modern Rome."[46]

For photographs of Rome, Murray recommended those of Robert Macpherson.[47] Macpherson was a commanding figure in the cultural and social circles in Rome as a painter, photographer, and art dealer; he was also active in photographic societies in Edinburgh, London, and Rome. In 1840 he left Scotland and his medical background to become a painter and settled in Rome, the traditional locus of such aspirations. In 1851 he learned photography from a visiting friend; spouse of the niece of Victorian writer and art historian Anna Jameson, Macpherson was well placed to sell his photographs to British visitors. Macpherson produced views such as the magnificent *Falls of Terni* (page 146); the large format evokes the grandeur of the falls of the River Aniene, recording the crags of the stone while giving the water a velvety finish. Scholars have praised Macpherson for the simplicity and elegance of his work, which was available for purchase at his establishment in the Piazza di Spagna, where he kept a large catalogue of prints and portfolios, such as his *Sculptures of the Vatican.*[48]

Photography and the Victorian Worldview

Beyond the traditional Grand Tour, photographers utilized developments in travel and photography to journey to even more distant locales in search of views. Felice Beato, for example, worked with James Robertson and photographed the Crimean War before traveling to India in 1857 to document the so-called Indian Mutiny. He photographed the Opium Wars in China and then moved onto Japan in 1864, where he set up a studio practice in Yokohama, the center

of foreign interests in Japan.[49] Opened to the West since 1854, Japan was a subject of popular interest for the British tourist as well as for the "armchair traveler" who could not journey to Japan. Beato produced views for Western visitors and the home audience, such as *Buddhist Temple and Cemetery, Nagasaki* (page 163). The deserted city streets lend the scene an air of solemnity appropriate for a religious image. Victorian viewers would have wondered at the strange landscape and architectural style.

Photography was praised for its ability to capture a scene and bring it home to educate the British viewer. *The Art Journal* admired Francis Frith's views of Egypt for their realism and their portability: "We desire that as many as possible may share the enjoyment we have ourselves derived from this very fertile source of interest, and cordially thank the enterprising traveller . . . for having given us an 'evening' brimful of delight."[50] Felice Beato's brother Antonio Beato also produced views of Egypt, such as his *Cairo, the Tombs of the Mamluks* (page 161), the traditional Islamic rulers of Egypt. Photographers, including Frith and Beato, produced views of the ancient monuments of Egypt, and in this period Egypt and the Holy Land became another sort of Grand Tour. Thomas Cook organized his first tour of Egypt in 1861. While not officially part of the British Empire, Egypt was valued as an overland route to India. One could argue that the far-reaching grasp of the British Empire, "a quarter of the land mass of the earth and a quarter of its population" by 1897, allowed for these safe travels.[51] According to James Buzard, "effected, normalized, and legitimized by bureaucratic administrations—empire and tourism developed to the accompaniment of stirring ideologies of progress."[52] Tourism relied upon imperialism for its safe existence, and tourism fostered imperialism through interest in these locales.

The camera became an intimate part of the relationship between tourism and imperialism. A photograph extracted part of the "truth" of a person, place, or thing for the viewer through its perceived realism, and this aura of truth made the photograph an invaluable aspect of travel. The nineteenth-century visitor who purchased Italian photographer Carlo Ponti's view of the Bridge of Sighs (page 57) also brought home the image of a Venetian water carrier in traditional dress (page 145). This image recalls similar painted scenes of

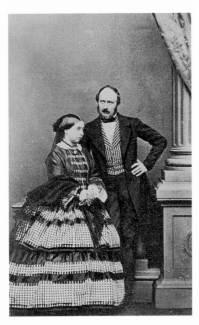

JOHN E. MAYALL *Queen Victoria and Prince Albert*
c. 1860 albumen print from wet collodion negative

rustic Italian culture, such as British artist Thomas Unwin's canvas from only twenty years earlier, *An Italian Mother Teaching Her Child the Tarantella* (Victoria and Albert Museum, London), a picture popular enough to be made into wallpaper. Although Unwin's image places the picturesque Italian group in the native landscape, the artist did not actually go to Italy for inspiration. In contrast, Ponti's photograph insists upon the reality of the scene depicted. At the same time, however, the photograph is in denial of reality. Photographs of Italy from this period, especially those purchased by tourists, often ignore the turbulent formation of the Italian nation that was going on at the time, especially in Austrian-occupied Venice. The bland studio setting and weary look of the water carrier have none of the vivacious romanticism of the dancing Neapolitan mother. As John Murray informs us in his 1866 handbook, "The Venetians have laid aside the peculiarities of dress which marked their nationality in the days of independence."[53] Ponti's image denies history, similar to Juan Laurent's image of a couple from Maragatería (page 143), an area of northern Spain thought to be isolated from centuries of invasion and thus to represent genuine Spanish

culture. These photographs present views of Italy and Spain that are both foreign and familiar: foreign, because they are exotic and not modern, for they are tied to their cultural history and national identity as "traditional"; familiar, because they do not challenge romanticized notions about the locales. Photographers like Ponti, an Italian himself, catered to a foreign audience who wanted views of the Italy that existed in their imagination, where the Italian is Other.

This notion of the ahistorical foreign Other took on different associations when envisioned in terms of non-Western cultures. However, the figures also illustrate the costume of the local culture as well as the listless idleness supposedly characteristic of native people. The conception of the photograph as "truth" reinforced a positivist belief in its ability to collect information, an experience that validated the viewers and the world around them. As photographer William Lake Price explained, "Photography has already added and will increasingly tend to contribute to the knowledge and happiness of mankind: by its means the aspects of our globe, from the tropics to the poles—its inhabitants . . . its cities, the outlines of its mountains, are made familiar to us."[54] The British photography team of Walter Bentley Woodbury and James Page maintained a studio in Batavia, Java, to produce images of local landscape and native "types," such as the image of a family group on page 162. We observe the family in an outdoor studio setting decorated with "traditional" objects, sometimes of questionable provenance, that would have been familiar to the British visitor to international exhibitions. The photograph, as Price described, purports to make this family in Java, and therefore the people of Java, "familiar" to us—just as the elaborately inlaid chest of drawers that serves as a backdrop would have been recognizable to visitors of exhibits. Their Otherness is domesticated (they are a family) and controlled by the camera. Such images reinforce the connection in this period between photography and anthropology, as well as the pseudo-science of ethnology, which popularized the notion of a hierarchy of racial and ethnic groups, with Anglo-Saxon Christians at the pinnacle. In physical anthropology, photography played a crucial role in documenting and classifying people according to the so-called evolution of their physical features.

British photographers went to all corners of their empire in the Victorian era, and photography became an official part of military training in 1865. British photographer Samuel Bourne, famous for his landscape views of India, believed that the camera "taught the natives . . . that their conquerors were the inventors of other instruments besides the formidable guns of artillery, which . . . attained their object with less noise and smoke."[55] Captain Eugene Clutterbuck Impey was one of many British soldier-photographers active in India in the 1860s, a time of increasing involvement after the Indian Mutiny of 1857 caused the government to take over control of the subcontinent from the East India Company. Impey worked in Rajasthan, where he produced documents of the British settlement near Mount Abu, as well as records of native architecture and culture. After several other appointments, Impey was made "Political Agent for the Marwar State" and was stationed at Rajasthan, where he became intimate with the court and produced portraits of the Maharaja Takhat Singh (page 138), who ruled from 1843 to 1873, and his son Maharaja Jeswunt Singh (page 139). Of Takhat Singh's government, Impey noted that is was "undoubtedly the worst administered state in Rajpootana, perhaps in India; in fact, there is no regular government of any kind."[56] Impey's photograph characterizes the dissipated maharaja, fond of drink as well as his large harem (according to Impey), in his hooded gaze and the rich details of his costume and accoutrements. In a sense, this image conveys the complexity of attitudes surrounding relations between the British and the Indian ruling class. Although revered as a ruler, the maharaja is a decadent monarch subservient to the British. Dressed in a lavish costume and seated on a throne, the elder Singh is in stark contrast to his son, dressed in simple white garments and seated on white cushions next to his gun. These images are found in Impey family albums, the collection of the British Library, and at the court at Jodhpur, where they influenced the royal court painters.[57] In their circulation, images such as Impey's formulated the Victorian worldview, documenting not only his encounter with the maharaja but also the cultural interaction of Great Britain and India, an interaction that continues through their display.

For the Victorian viewer, photographs, through the widespread

availability of photographic images, became an essential part of how individuals formulated ideas about themselves and others. Like many of his contemporaries, Ruskin held contradictory attitudes towards photography and the modern society that embraced it. While he praised the energy and detail of some photographs, he doubted their humanity, their ability to record the "living perception of a good and great human soul."[58] The richness of the Scholz Collection throws Ruskin's skepticism in doubt, for the good and the great emerge from these photographs as well as the quotidian. They are full of emotion and intelligence as well as ignorance and misunderstanding; they contribute to the worldview of Victorian culture. Janos Scholz assembled a portrait of the Victorian era that fascinates today in its conflicting assertion of a perfect present, the desire for a better future, and a nostalgia for times past.

Plates

William Henry Fox Talbot

WILLIAM HENRY FOX TALBOT *Portrait of Nicolaas Henneman* probably 15 April 1841 calotype negative

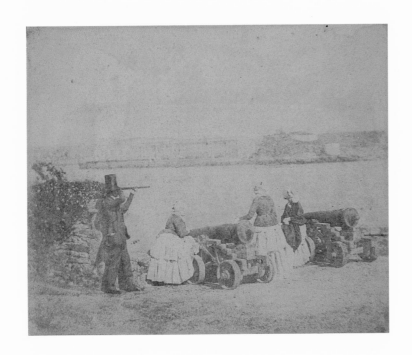

WILLIAM HENRY FOX TALBOT *Battery at Mt. Edgcumbe, Plymouth* September 1845 varnished salt print from a calotype negative

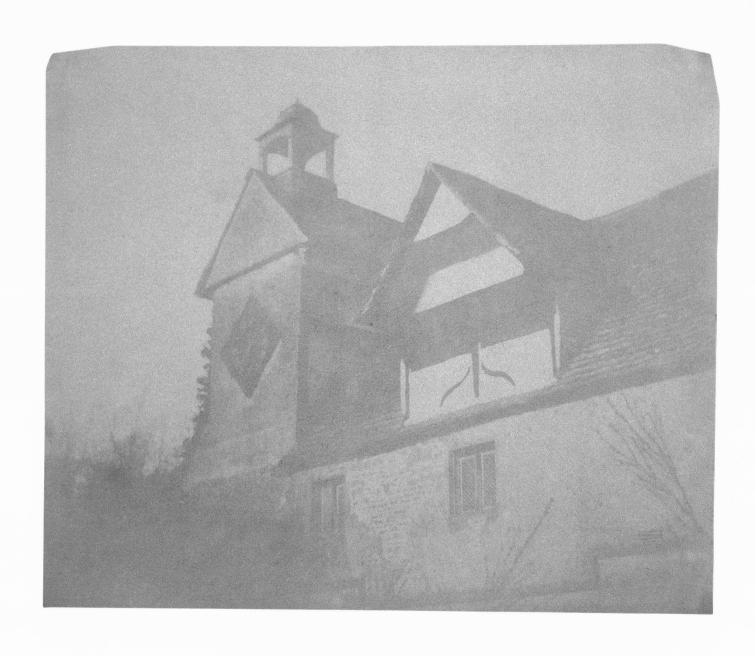

WILLIAM HENRY FOX TALBOT *Clock Tower, Lacock Abbey* 18 February 1840 salt print from a photogenic drawing negative

WILLIAM HENRY FOX TALBOT *Lacock Abbey, South Side toward Sharington's Tower* November 1839
salt print from a photogenic drawing negative

William Henry Fox Talbot *Magdalen College, Oxford* 28 July 1842 calotype negative

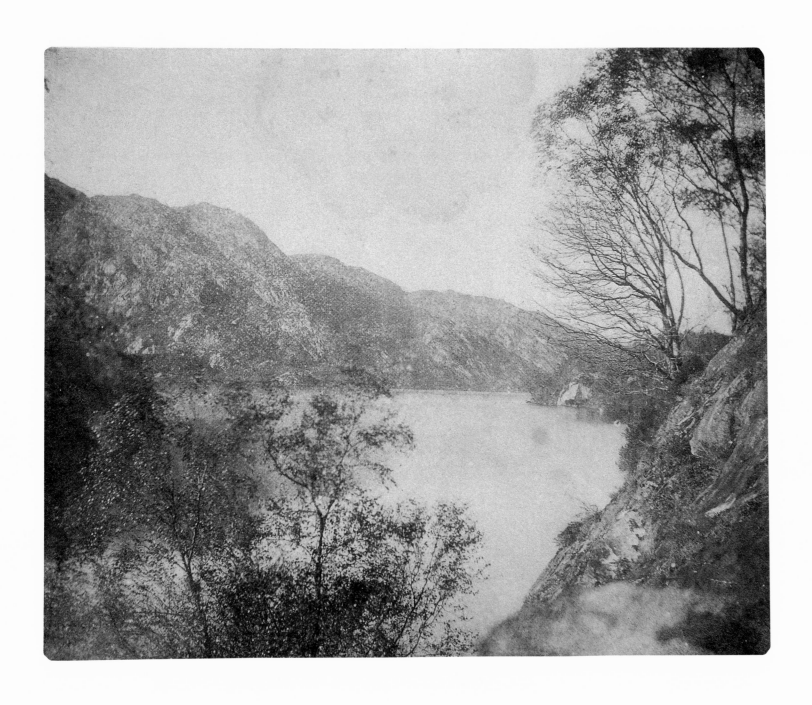

WILLIAM HENRY FOX TALBOT *Loch Katrine, Scotland* 19–21 October 1844 salt print from a calotype negative

WILLIAM HENRY FOX TALBOT *The Pantheon, Paris* c. 1858 photoglyphic engraving

French

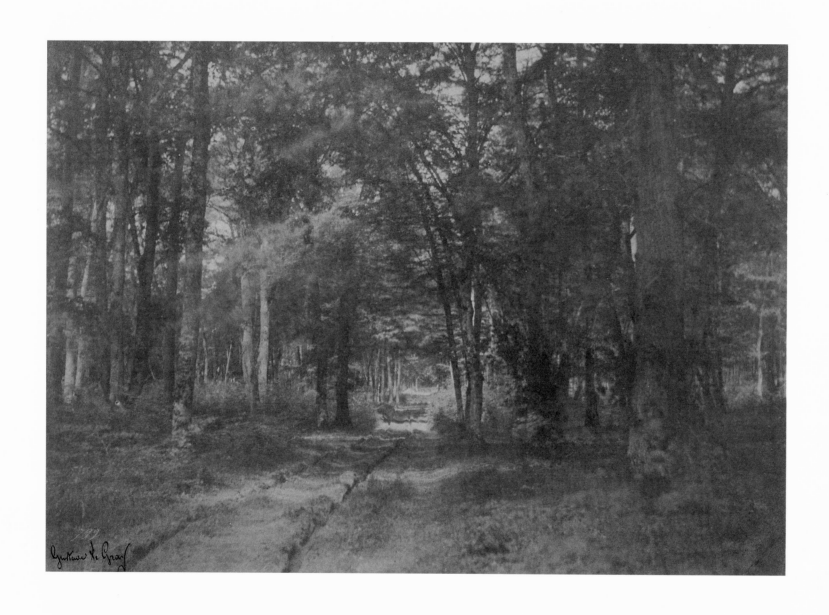

GUSTAVE LE GRAY *Forest of Fontainebleau* c. 1853 salt print from a waxed paper negative

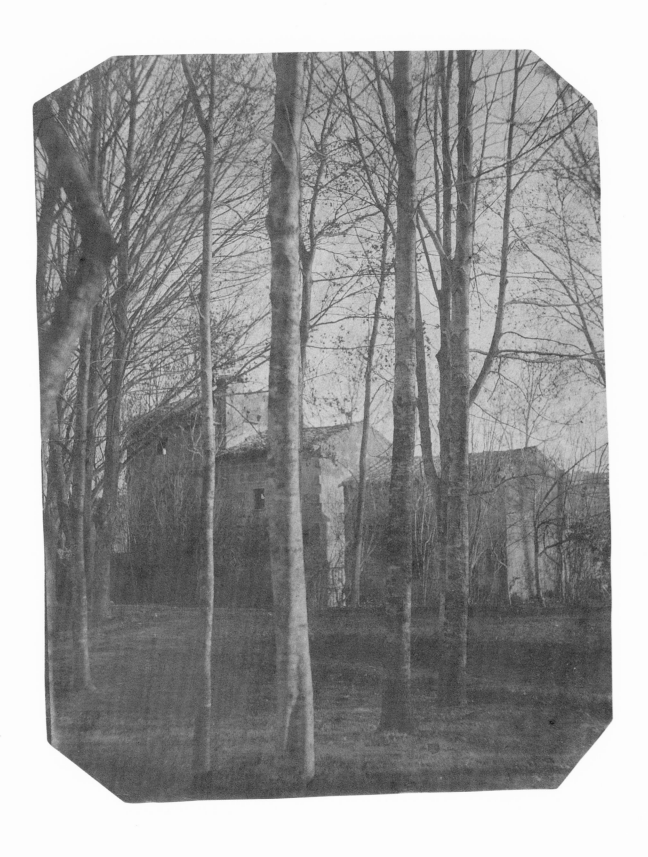

UNIDENTIFIED PHOTOGRAPHER *Trees and House, Rural France* c. 1852 calotype, on mount

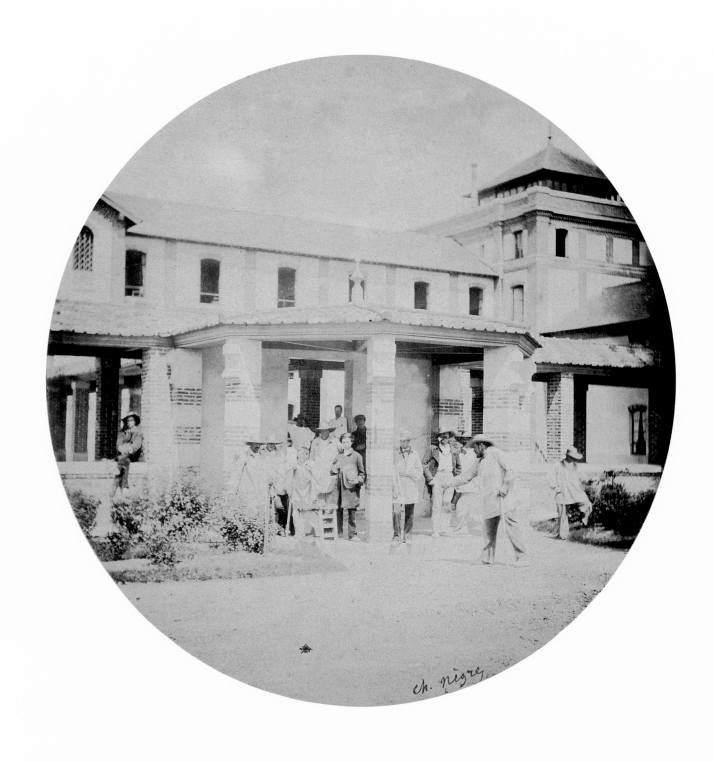

CHARLES NÈGRE *Playing Boules at the Asylum at Vincennes* c. 1859 albumen print

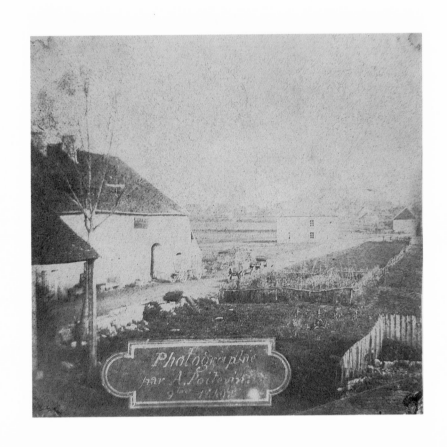

ALPHONSE LOUIS POITEVIN *Salt Works at Gouhemans* 1849 salt print

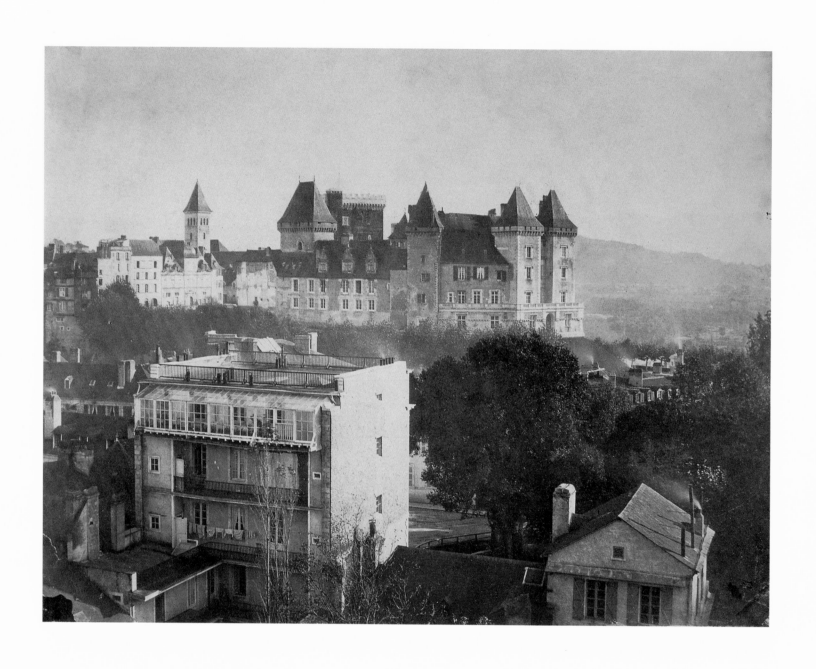

JEAN-JACQUES HEILMANN *Chateau and Town of Pau* c. 1854 salt print from a wet collodion negative

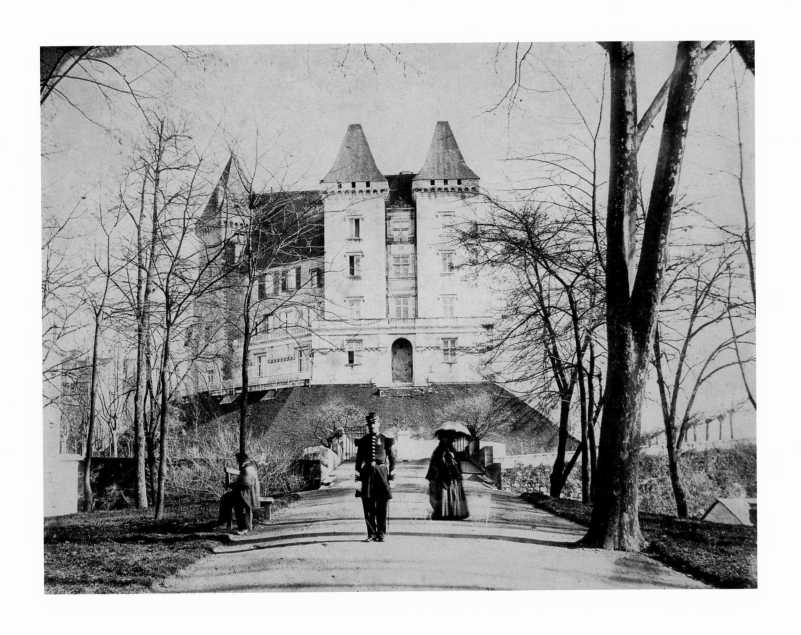

EDOUARD-DENIS BALDUS *Avignon, from across the Rhône River* late 1850s or early 1860s albumen print

EDOUARD-DENIS BALDUS *Avignon, Ramparts under the Flood* 1856 albumen print

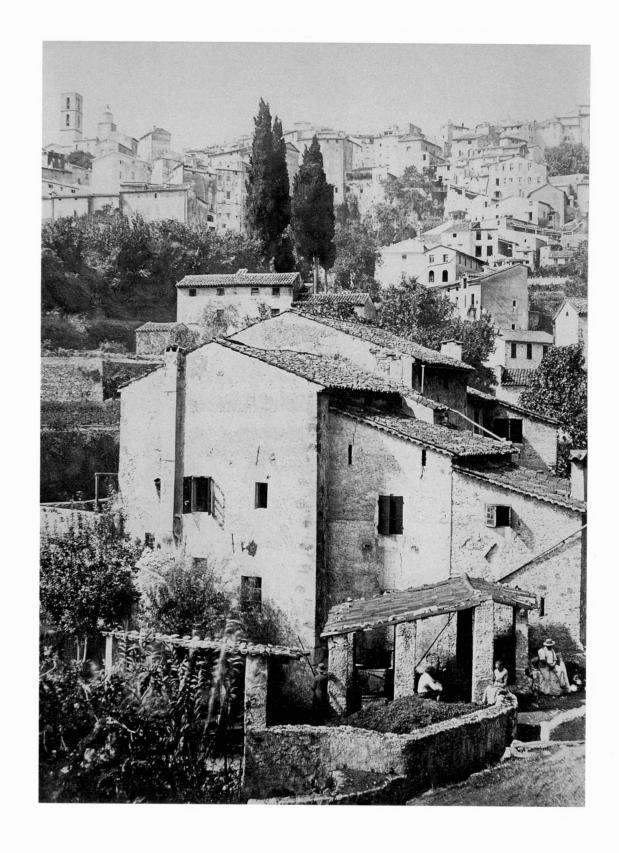

CHARLES NÈGRE *Olive Press and Houses at Grasse* 1852 albumen print from a waxed paper negative

UNIDENTIFIED PHOTOGRAPHER *Interior Courtyard, Chateau de Tournoël* c. 1870 albumen print

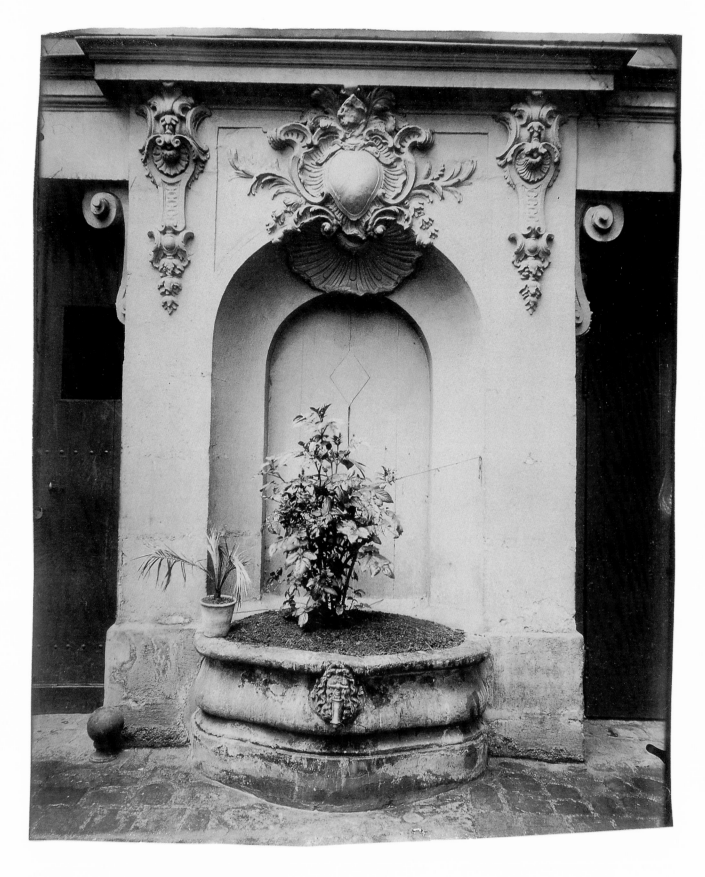

EUGÈNE ATGET *Paris, Fountain in a Courtyard (Hôtel de Parliamentaires, 3 Rue du Lyons)* c. 1905 albumen print

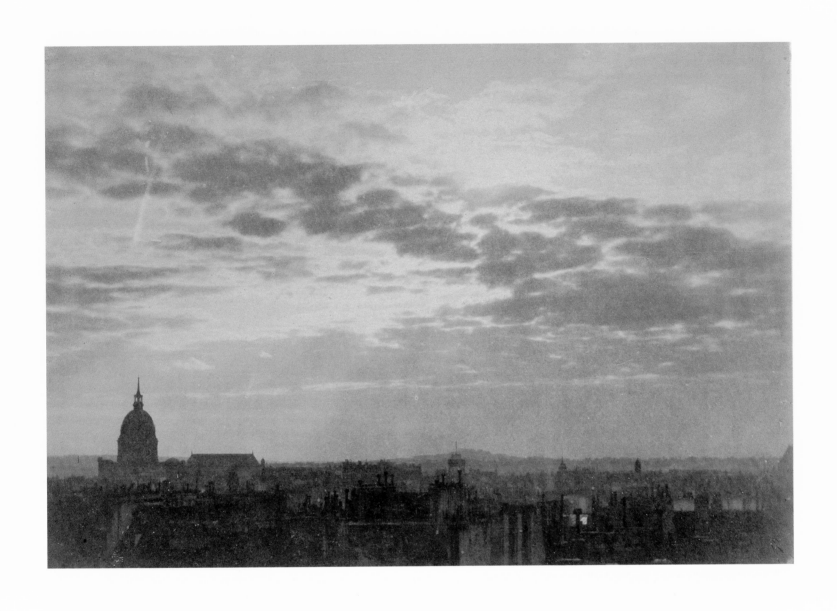

CHARLES MARVILLE *Sky Study, Paris, with the Dome of the Invalides in Silhouette* c. 1860 albumen print

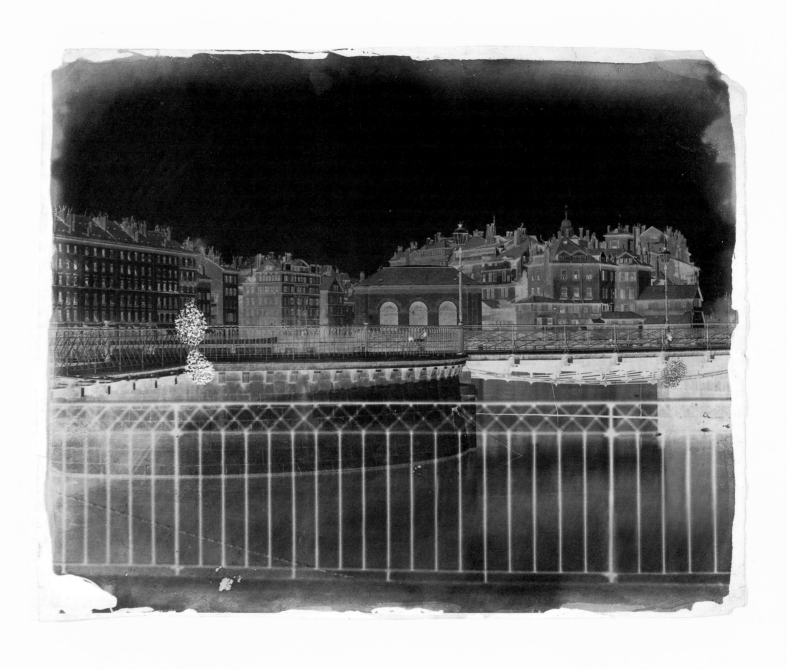

UNIDENTIFIED PHOTOGRAPHER *"La machine": The Waterworks, Geneva* c. 1854 paper negative

FRANÇOIS-AUGUSTE RENARD *Paris, Gare de Strasbourg* c. 1852 albumen print from albumen on glass negative

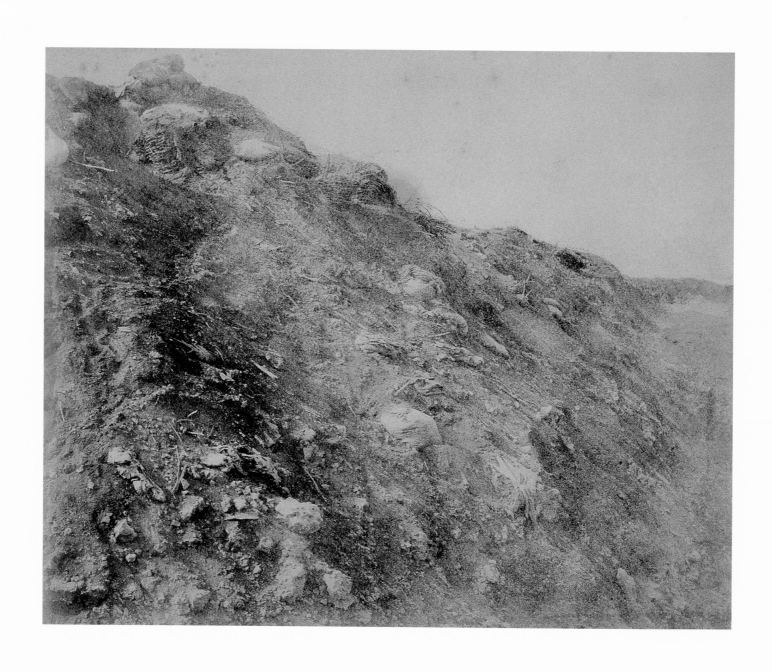

COLONEL JEAN-CHARLES LANGLOIS *Ramparts of Malakhov, near Sebastopol, Crimean War* 1855 salt print from a paper negative

NADAR *Paris Catacombs* 1862 albumen print

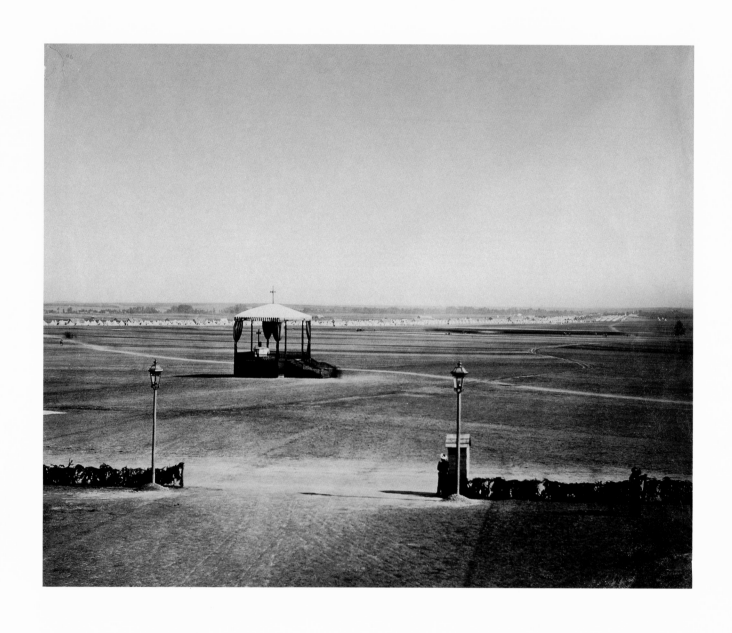

GUSTAVE LE GRAY *Camp de Châlons, Chapel* 1857 albumen print from wet collodion on glass negative

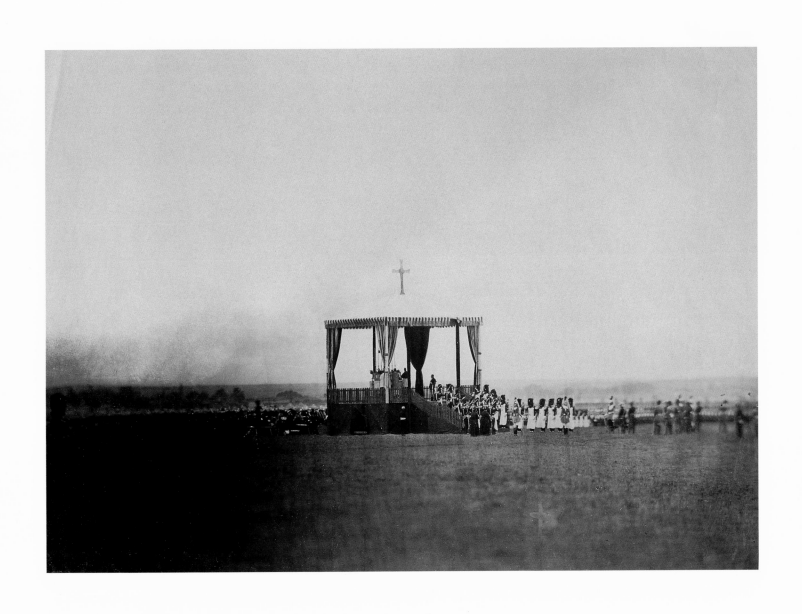

GUSTAVE LE GRAY *Mass in the Presence of the Emperor, Camp de Châlons* 1857 albumen print from wet collodion on glass negative

E. Nicolas *Senlis, the Ruins of the Old Chateau and the Cathedral* c. 1855 salt print from a waxed paper negative

94

EMMANUEL, DUC DE NOAILLES *Chateau at Maintenon* 1850s salt print

95

ALPHONSE JEANRENAUD *Garden Scene* c. 1860 albumen print

96

ACHILLE QUINET *Pont Mally* c. 1870 albumen print

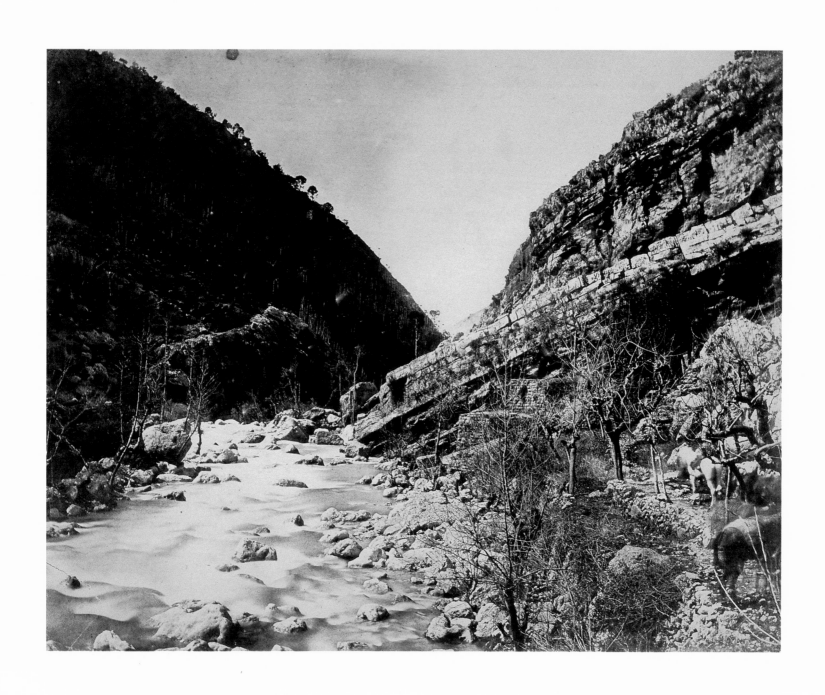

Lieutenant Louis Vignes *Vallée de Nahr-el-Kelb* 1864 albumen print

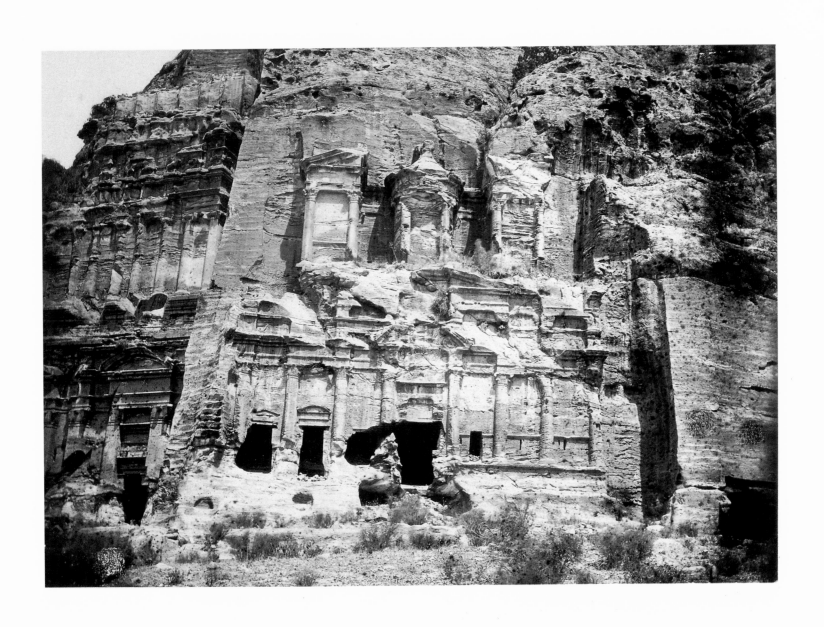

LIEUTENANT LOUIS VIGNES *Petra* 1864 albumen print

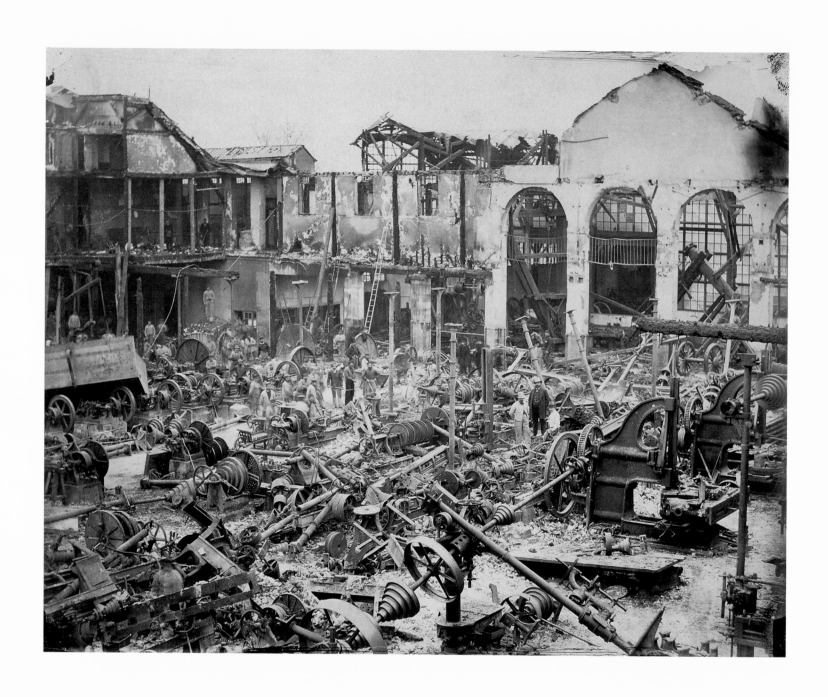

UNIDENTIFIED PHOTOGRAPHER *Ruins of a Factory, Paris* c. 1871 albumen print

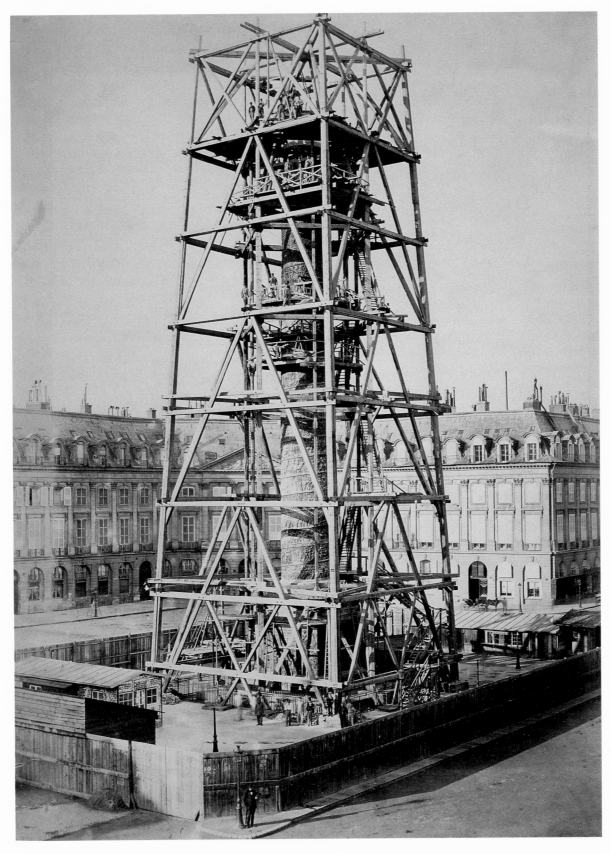

CHARLES MARVILLE *Paris, Reconstruction of the Column in the Place Vendôme* 1875 albumen print

UNIDENTIFIED PHOTOGRAPHER *Fruit on Branches* c. 1870–80 albumen print

CAMILLE SILVY *Hunting Still Life* 1858 albumen print

CHARLES MARVILLE *Marble Bas-Reliefs by Luca Della Robbia* 1853–54 salt print

Louis-Rémy Robert *Porcelain from the Factory at Sèvres* 1855 salt print

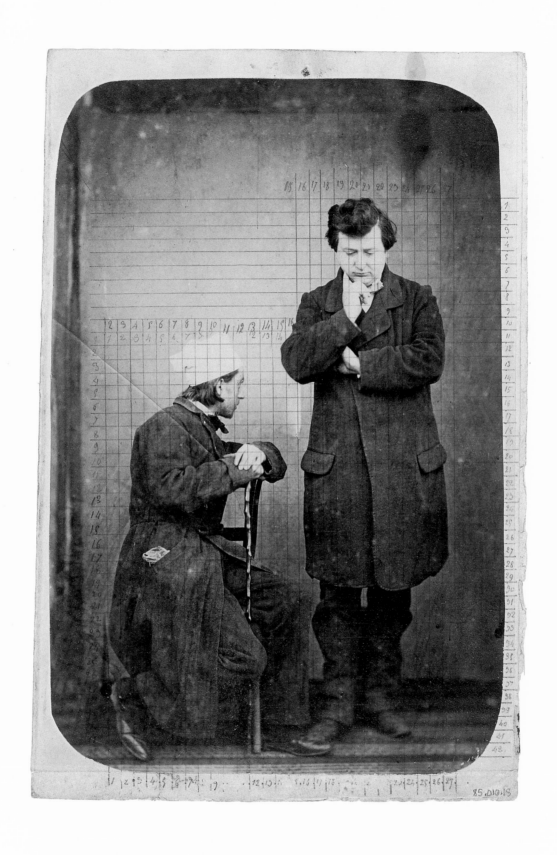

JEAN NICOLAS TRUCHELUT *Two Models in a Studio* c. 1856–60 albumen print

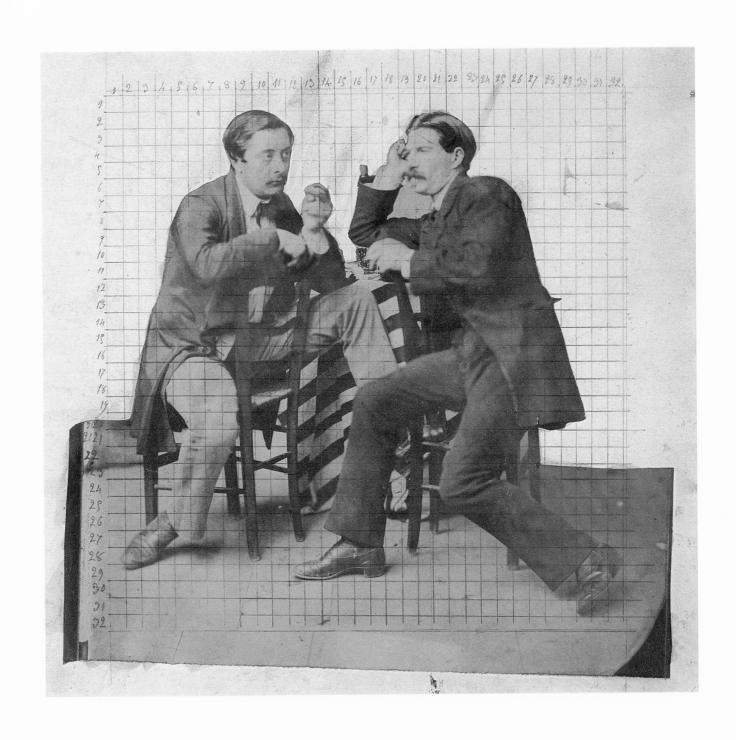

JEAN NICOLAS TRUCHELUT *Two Men in Chairs in a Studio* c. 1865 albumen print

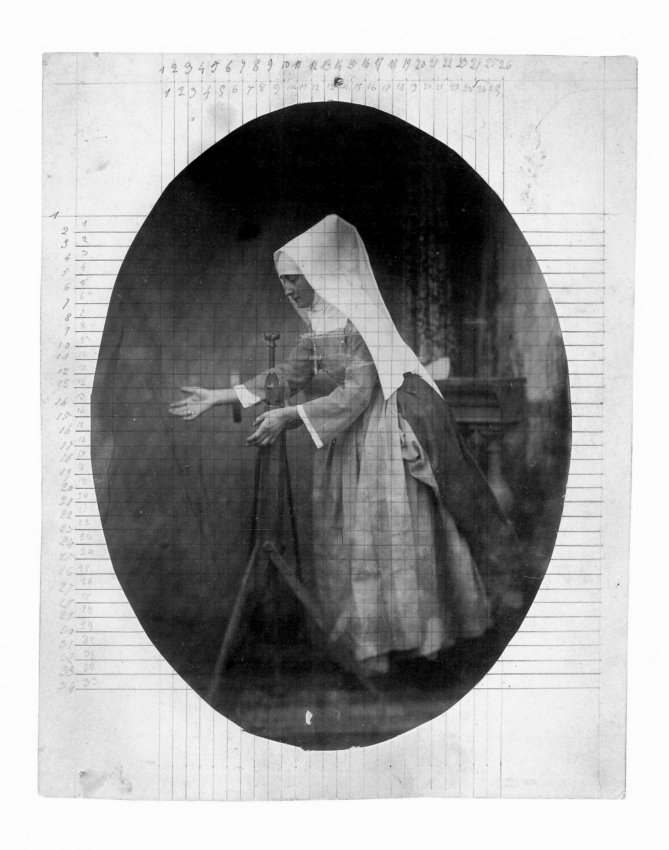

JEAN NICOLAS TRUCHELUT *Model Dressed as a Nun* c. 1865 albumen print

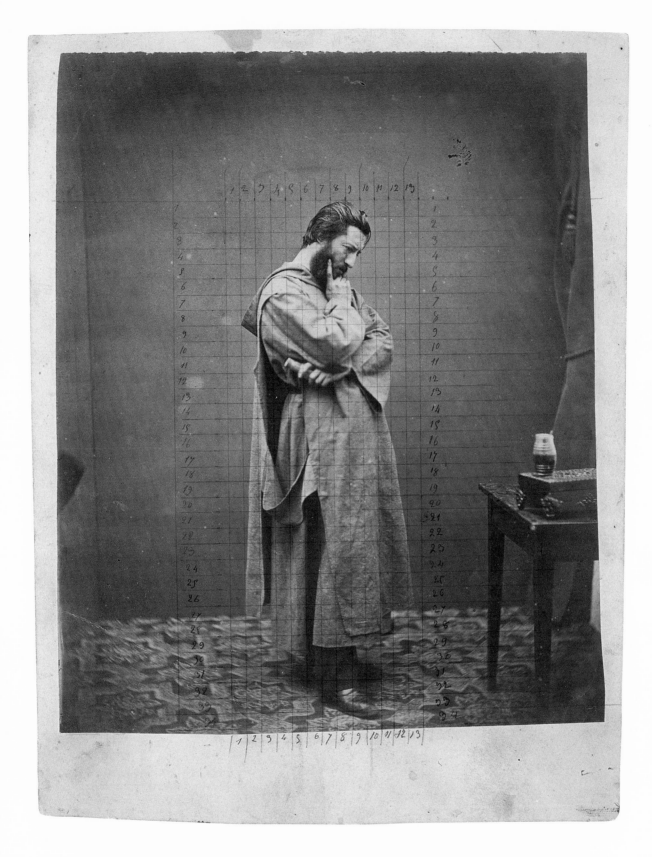

Jean Nicolas Truchelut *Man Dressed as Monk, Standing* c. 1865 albumen print

ATTRIBUTED TO VICTOR LAISNE *Portrait of Eugène Delacroix* c. 1853 salt print

LOUIS MAURICE BOUTET DE MONVEL *Portrait of Paul Gauguin* c. 1890 albumen print

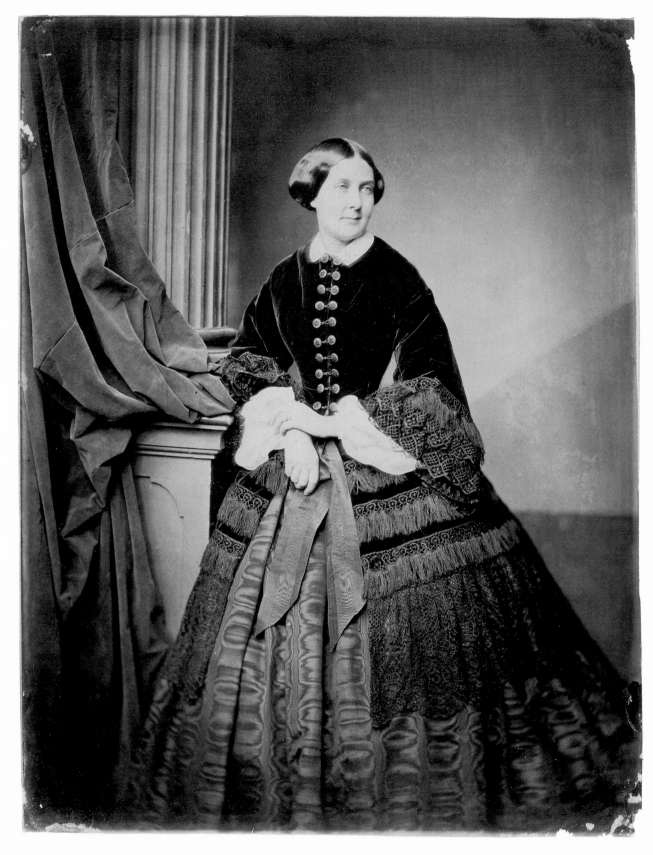

ANTOINE SAMUEL ADAM-SALOMON *Portrait of a Lady* c. 1860 albumen print

DURAND OF LILLE *Seated Woman with Lace Collar* c. 1855 salt print with hand coloring

LUIGI CRETTE *Portrait of the Journalist Alphonse Karr* c. 1860 albumen print

ALPHONSE LOUIS POITEVIN *Portrait of a Seated Lady* 1861 carbon print

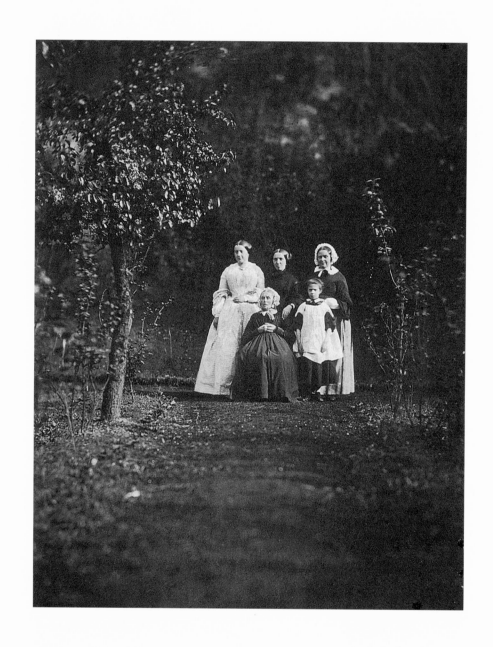

ALPHONSE LE BLONDEL *Family Group in Garden* c. 1855 salt print

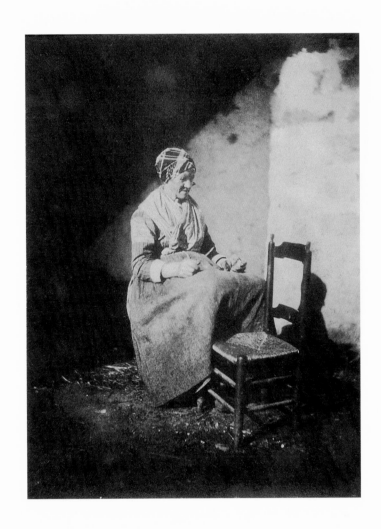

UNIDENTIFIED PHOTOGRAPHER *Woman Seated, Peeling Vegetables* 1853 salt print

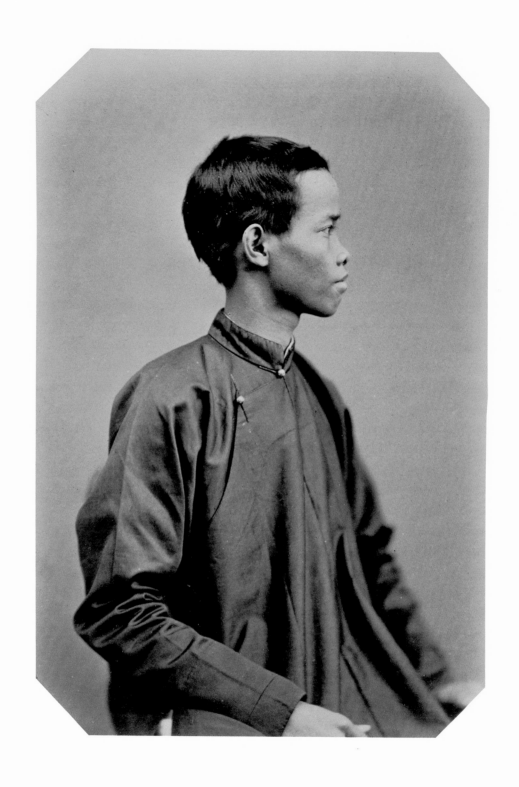

PHILIPPE JACQUES POTTEAU *Vietnamese Youth, Profile View* 1863 albumen print

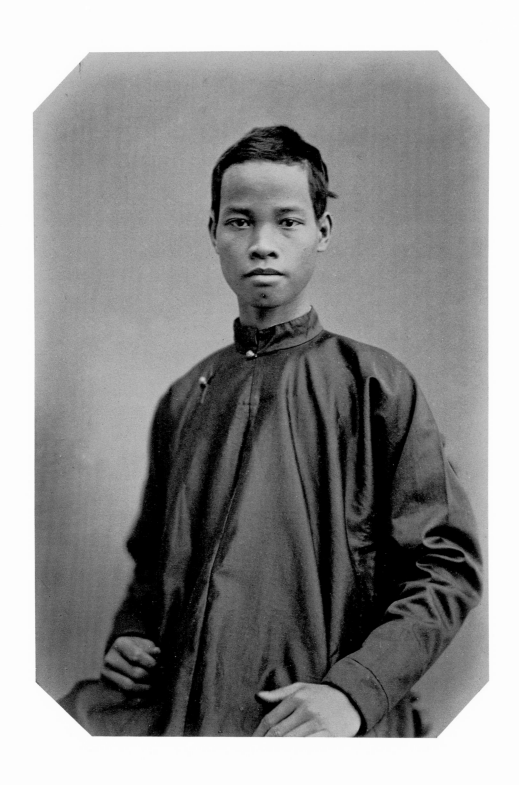

PHILIPPE JACQUES POTTEAU *Vietnamese Youth, Front View* 1863 albumen print

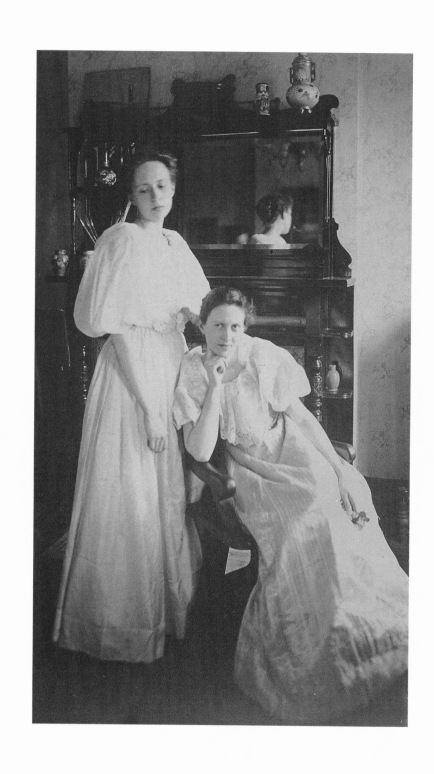

UNIDENTIFIED PHOTOGRAPHER *Two Women* c. 1900 cyanotype

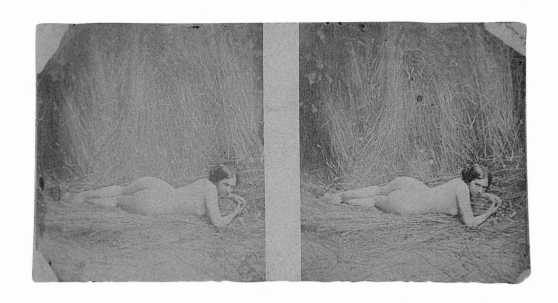

UNIDENTIFIED PHOTOGRAPHER *Reclining Female Nude, in Stereo* early 1850s salt print

ALFRED BRIQUET *Olive Trees in Southern France* 1860s albumen print

EUGÈNE ATGET
Apple Tree 1898 or before
albumen print

EUGÈNE ATGET
Willow Tree 1898 or before
albumen print

CONSTANT ALEXANDRE FAMIN *Boy and White Horse* c. 1860 albumen print

British

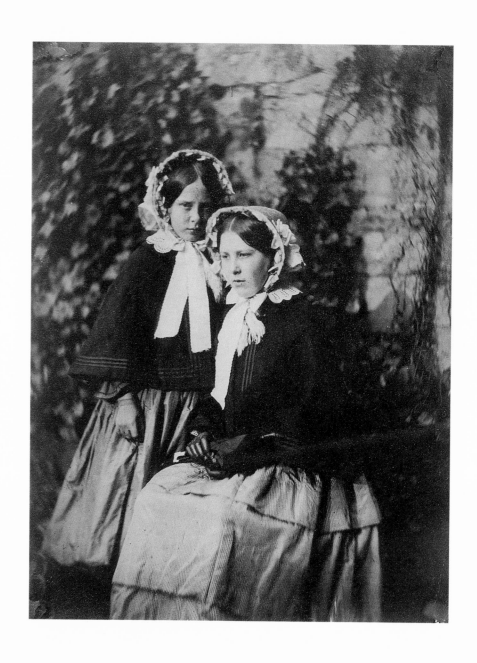

UNIDENTIFIED PHOTOGRAPHER *Portrait of the Misses Harvey* 1860s albumen print

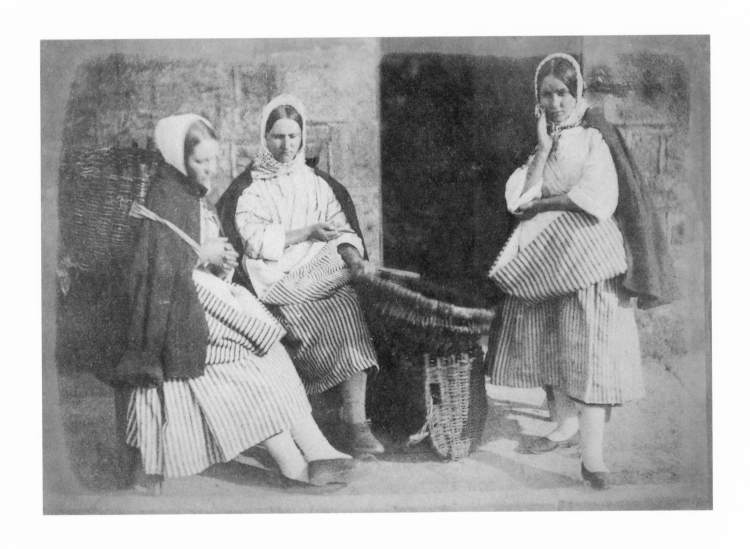

David Octavius Hill and Robert Adamson *Three Fisherwomen of Newhaven* c. 1845 salt print from a paper negative

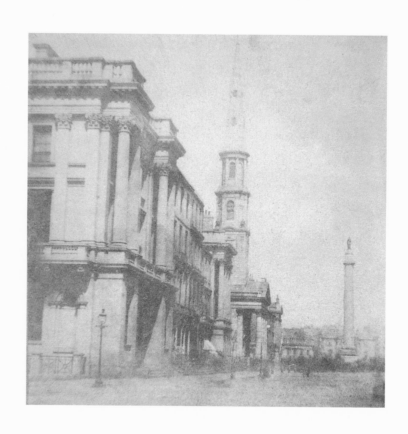

David Octavius Hill and Robert Adamson *Edinburgh, George Street and St. Andrew's Church* 1843
salt print from a paper negative

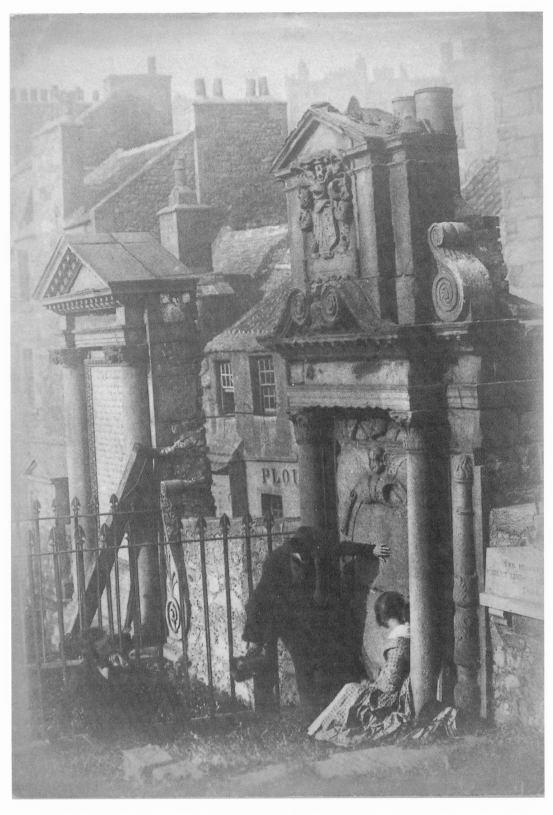

DAVID OCTAVIUS HILL AND ROBERT ADAMSON *The Covenanters' Tomb, Greyfriars Churchyard, Edinburgh* c. 1845
salt print from a paper negative

DAVID OCTAVIUS HILL AND ROBERT ADAMSON *Portrait of Admiral Stoddard* 1845 salt print from a paper negative

<small>David Octavius Hill and Robert Adamson</small> *Mrs. Marian Murray* c. 1847 salt print from a paper negative

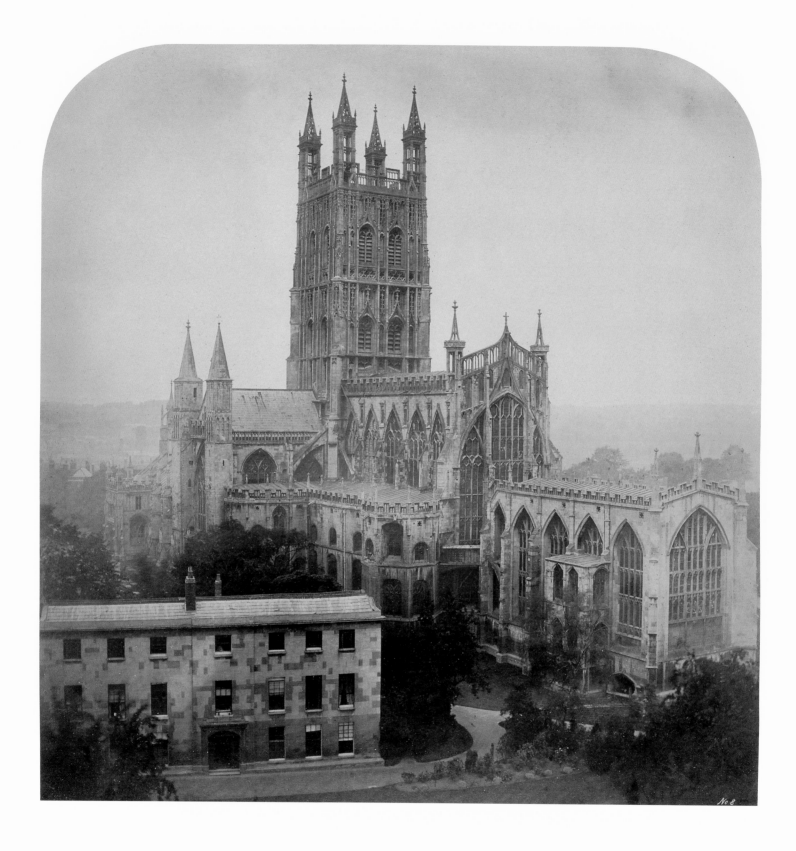

ROGER FENTON *Exterior of Gloucester Cathedral* c. 1855 albumen print

ROGER FENTON *Porch, Lichfield Cathedral* 1859 albumen print

ROGER FENTON *Bust of Antoninus Pius* 1859 albumen print

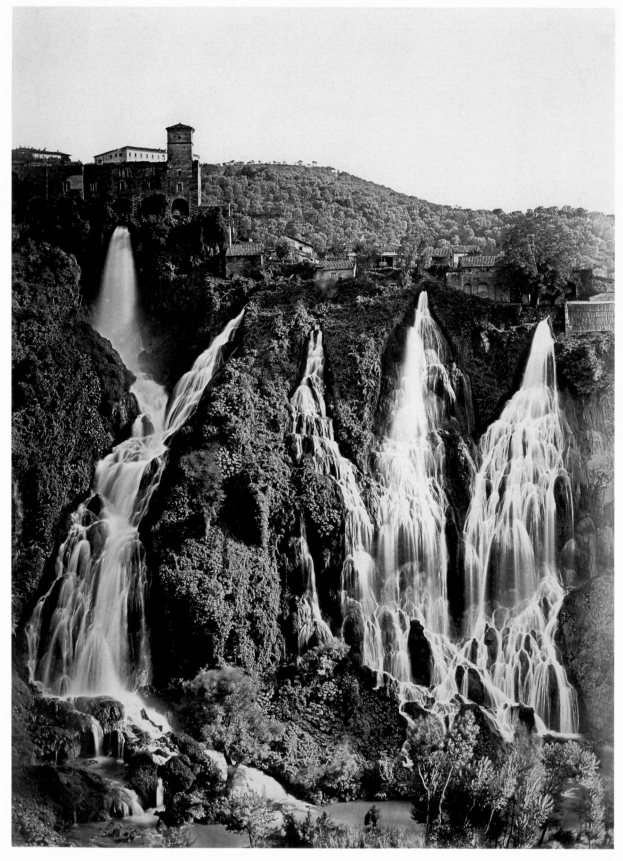

Robert Macpherson *The Falls at Terni* 1858–60 albumen print

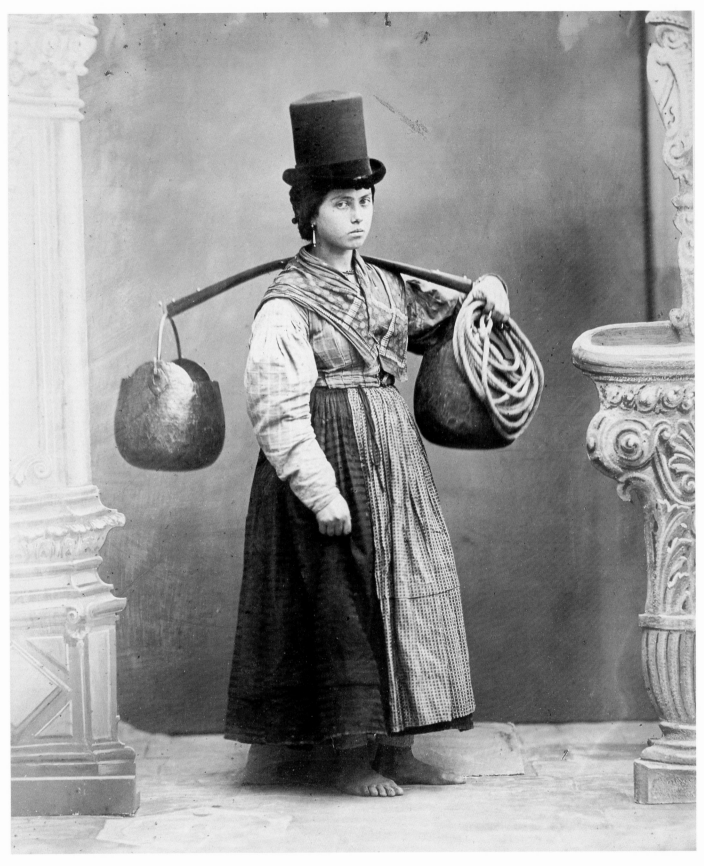

CARLO PONTI *Venetian Water Carrier* c. 1858–60 albumen print

CHARLES CLIFFORD *Christopher Columbus's Armor* c. 1858 albumen print

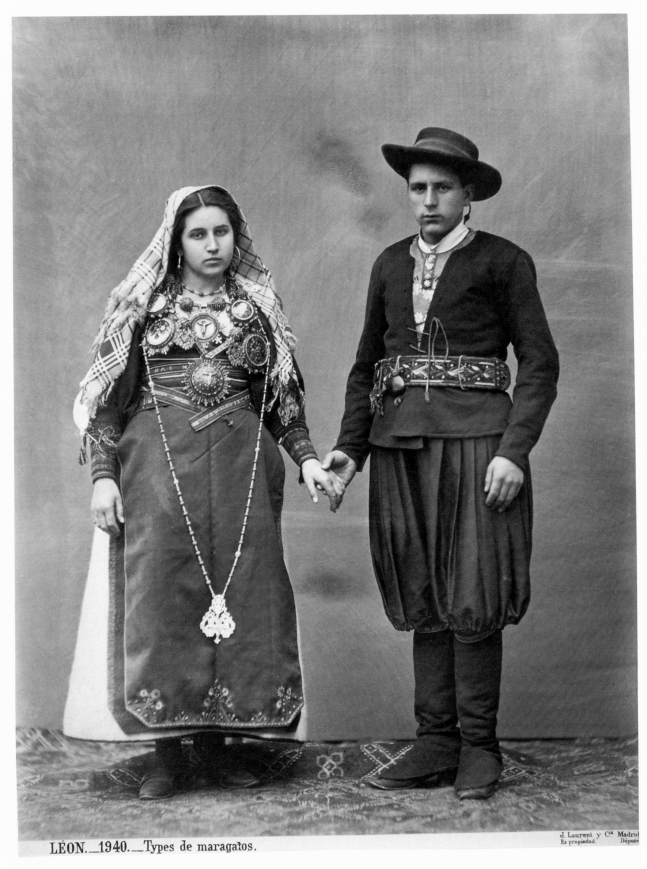

LÉON.__1940.__Types de maragatos.

J. Laurent y Cᵃ Madrid
Es propiedad. Déposé

JUAN LAURENT *Types de Maragatos, Spain* c. 1880 albumen print

143

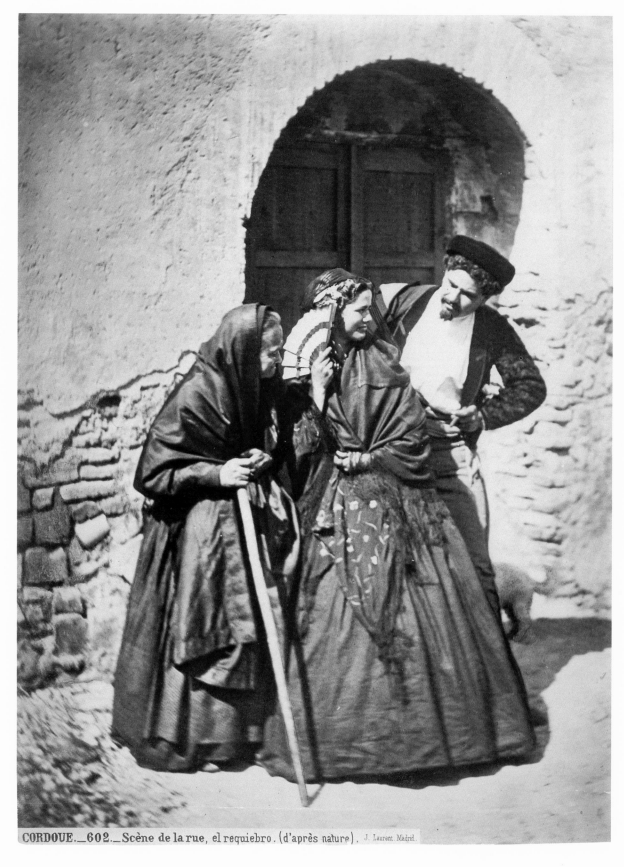

CORDOUE.—602.—Scène de la rue, el requiebro. (d'après nature). J. Laurent. Madrid.

JUAN LAURENT *The Chaperone* c. 1870-75 albumen print

Travel

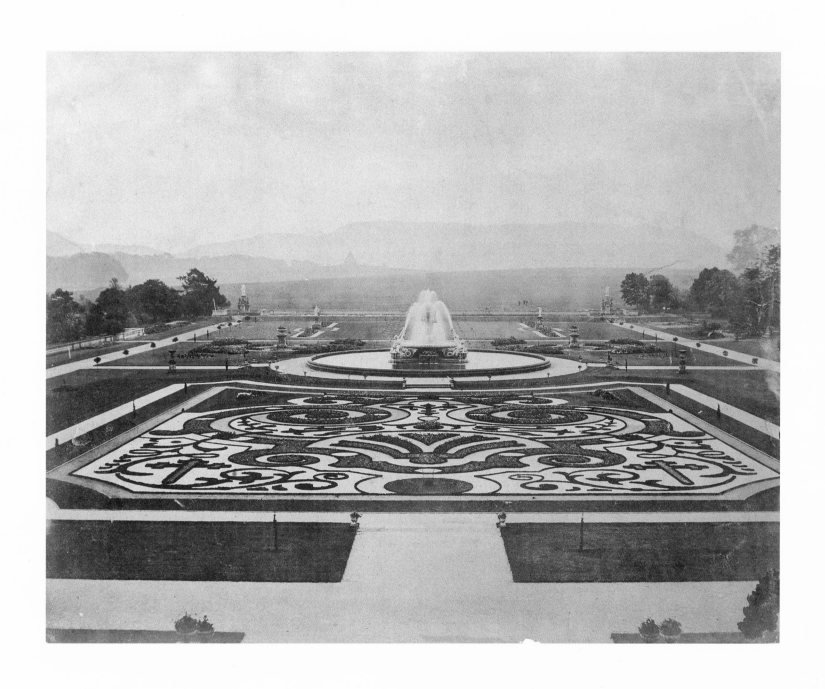

UNIDENTIFIED PHOTOGRAPHER *Atlas Fountain and Gardens, Castle Howard* c. 1853 salt print

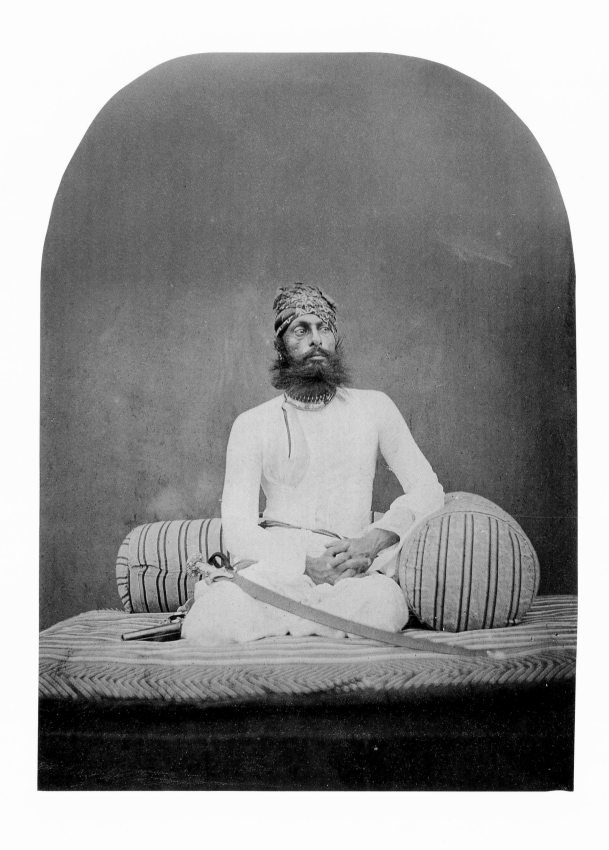

CAPTAIN EUGENE CLUTTERBUCK IMPEY *Portrait of Maharaja Jeswunt Singh* c. 1860 albumen print

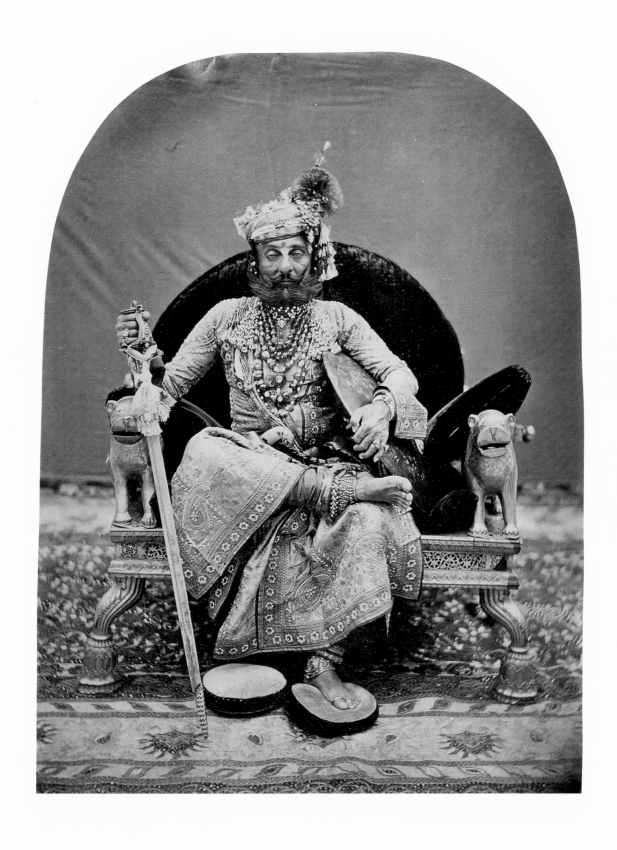

CAPTAIN EUGENE CLUTTERBUCK IMPEY *Portrait of Maharaja Takhat Singh* c. 1860 albumen print

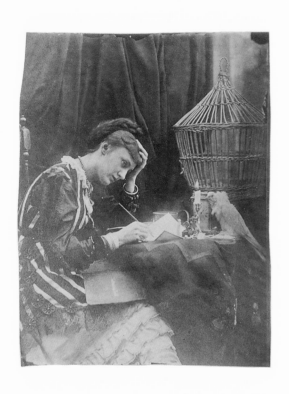

JULIA MARGARET CAMERON
Our May 1870 albumen print

JULIA MARGARET CAMERON
A Double Star 1864 albumen print

137

Julia Margaret Cameron *Mrs. Ewen Hay Cameron (Annie Chinery) and Son* c. 1875 albumen print

LEWIS CARROLL (CHARLES DODGSON) *Portrait of Alfred, Lord Tennyson* c. 1857 albumen print

FOTOGRAFIA DELL'EMILIA *Bologna, Asinelli and Garisendi Towers* c. 1870s albumen print

GIACOMO CANEVA *Pine Trees near Rome* c. 1852 salt print from a waxed paper negative

MICHELE MANG *Baths of Caracalla, Rome* c. 1865 albumen print on board

UNIDENTIFIED PHOTOGRAPHER *Rome, the Arch of Constantine* c. 1865 albumen print

UNIDENTIFIED PHOTOGRAPHER *Rome, Arch of the Silversmiths* c. 1860 albumen print from wet collodion negative

Giorgio Sommer *Plaster Cast of Dead Man from Pompeii* c. 1870 albumen print

GIORGIO SOMMER *Cast of Dog from Pompeii* c. 1870 albumen print

DMITRI CONSTANTIN *The Erechtheum, Athens* c. 1860 albumen print

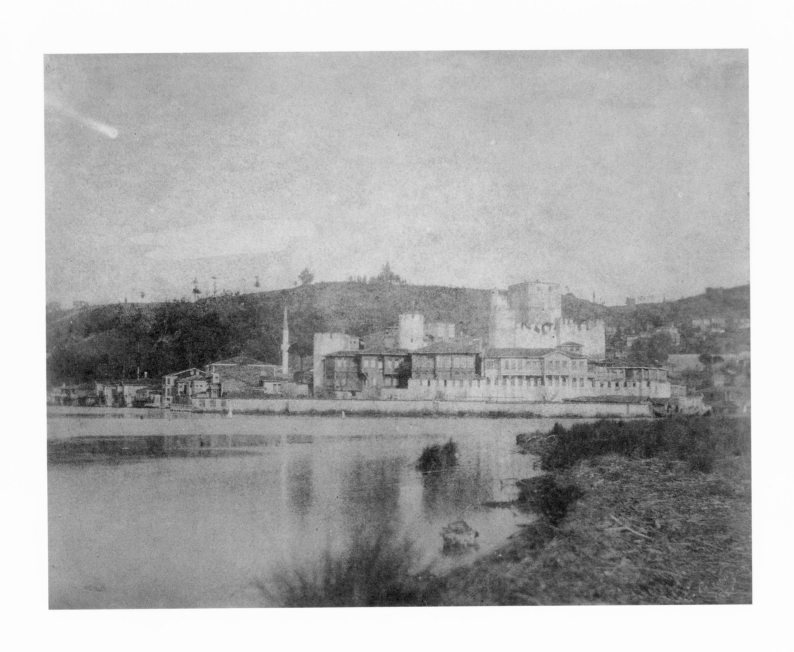

ERNEST DE CARANZA *Istanbul, View of the Bosphorus* c. 1853 salt print

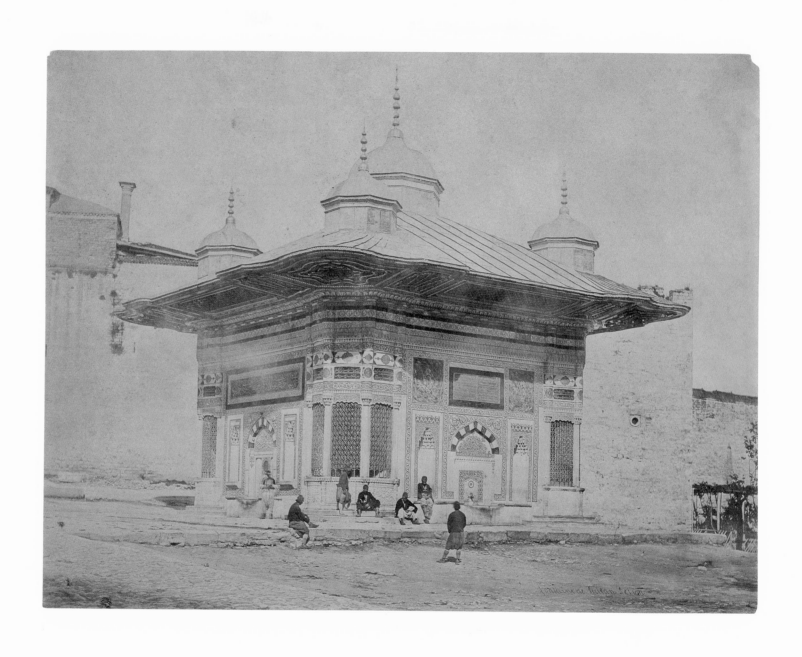

James Robertson *Istanbul, Fountain of Sultan Selim* before 1857 salt print

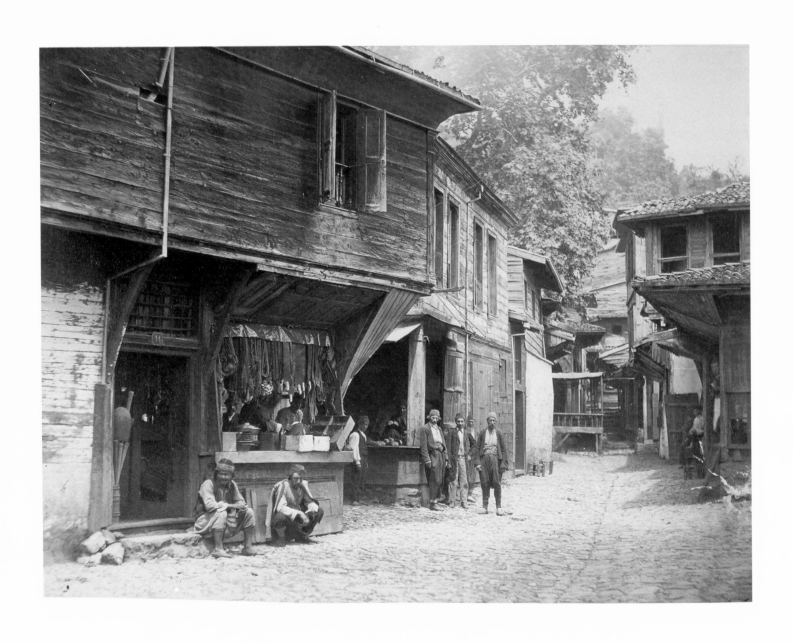

GUSTAVE DE BEAUCORPS *Beicos (Anatolia), Turkey* c. 1860 albumen print

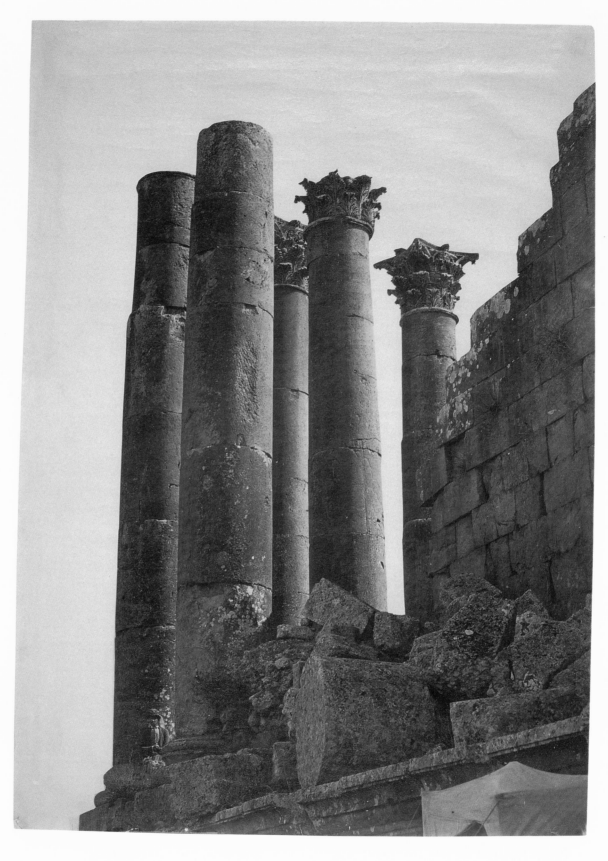

UNIDENTIFIED PHOTOGRAPHER *Jordan, Temple of the Sun at Jerash, from the North* c. 1865–75 albumen print

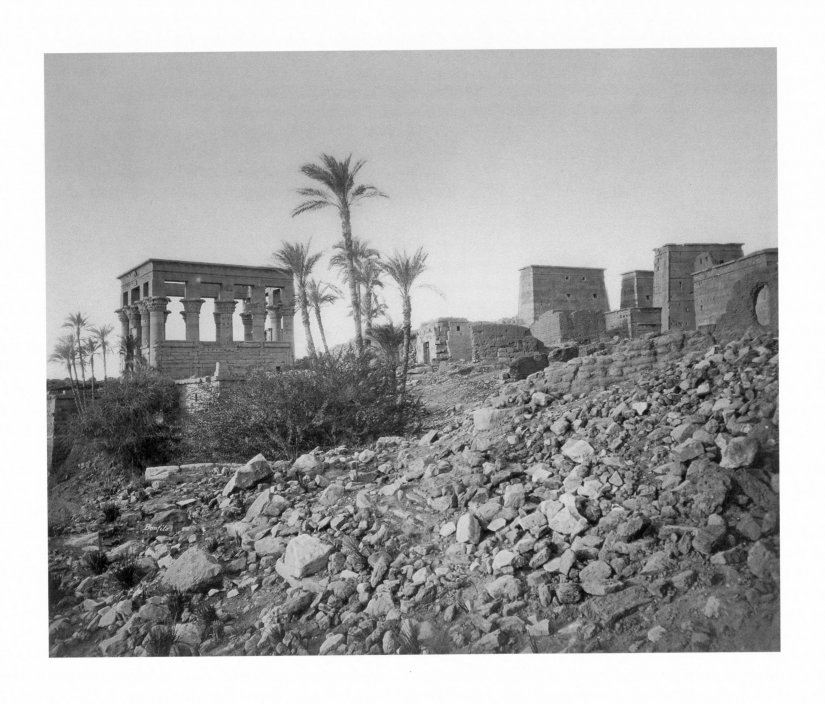

Félix Bonfils *Egypt, Temple of Isis* 1870s albumen print

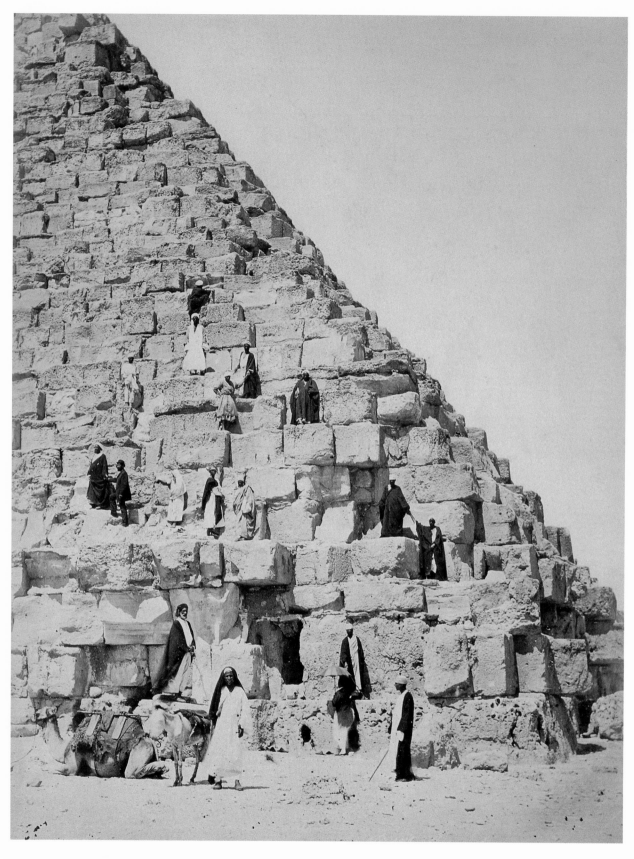

UNIDENTIFIED PHOTOGRAPHER *Pyramid in Egypt* c. 1860–75 albumen print

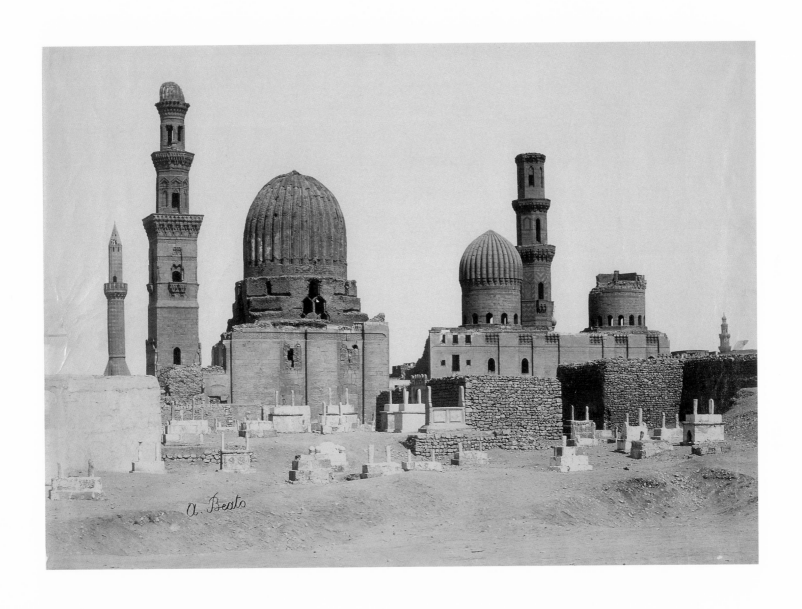

ANTONIO BEATO *Cairo, the Tombs of the Mamluks* 1870s or 1880s albumen print

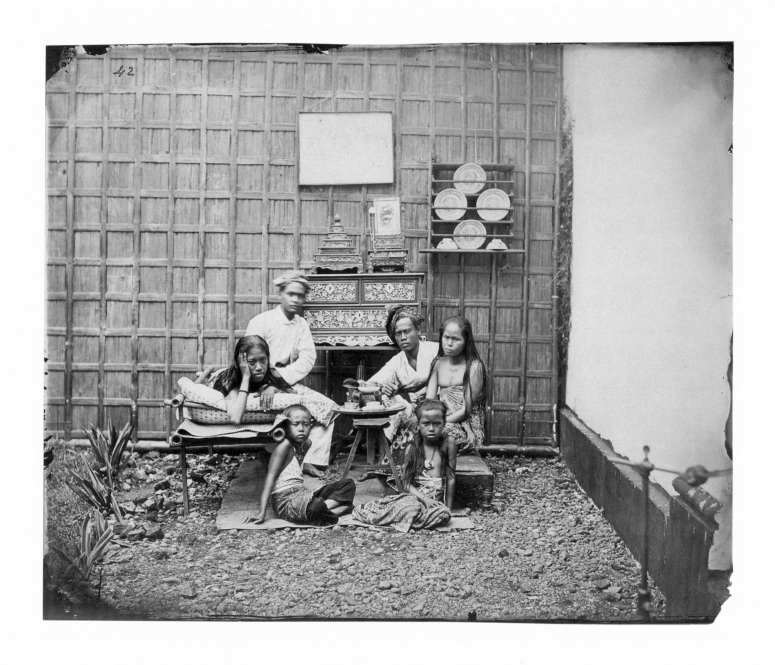

WOODBURY & PAGE *Family Group, Java* c. 1860 albumen print

162

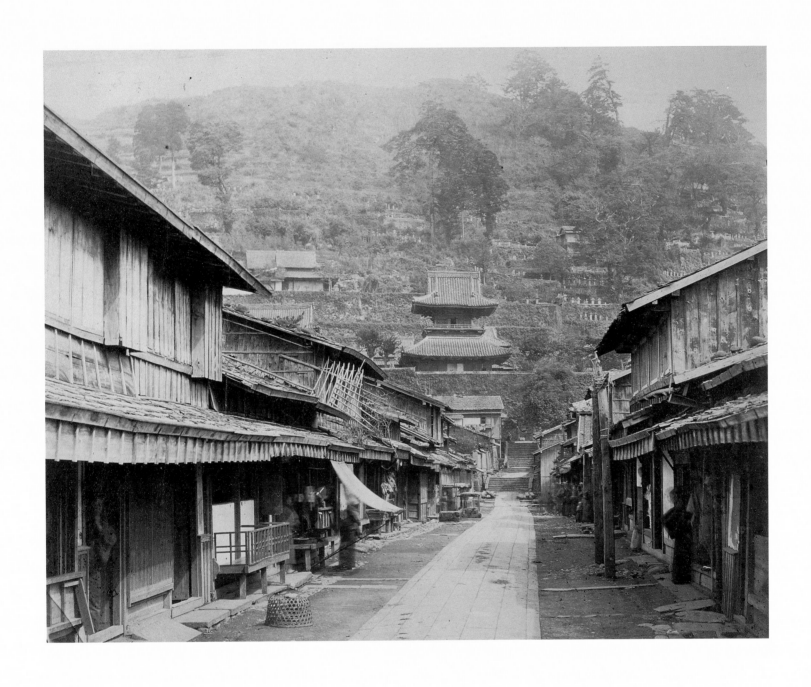

Felice Beato *Buddhist Temple and Cemetery, Nagasaki* 1864–65 albumen print

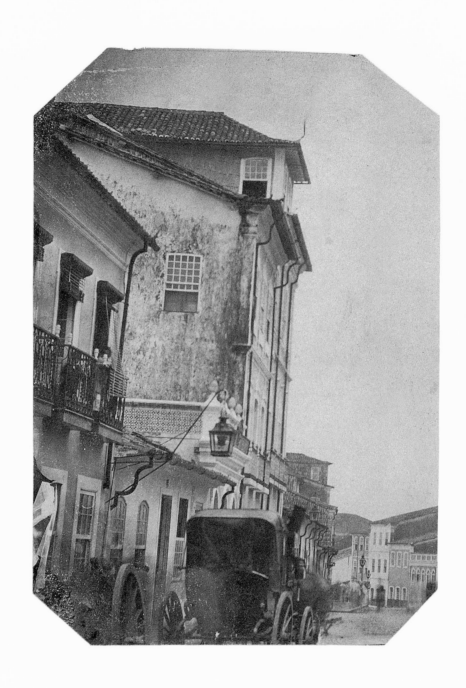

BEN R. MULOCK *Street in Salvador, Bahia, Brazil* c. 1859 salt print

Notes on the Photographs

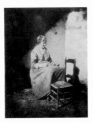

page ii
unidentified photographer
Woman Seated, Peeling Vegetables, 1853
4.81 x 3.63 in. (12.217 x 9.22 cm)
salt print
1984.012.042

See the photograph at original size on page 117.

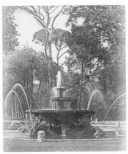

page vi
Tommaso Cuccioni (Italian, d. 1864)
Rome, Fountain in the Garden of the Villa Borghese,
 c. 1860
18.38 x 13.13 in. (46.685 x 33.35 cm)
albumen print
1984.012.016

The Villa Borghese, also known as the Pincian Gardens, was a popular place for wealthy and titled Italians and visitors to see and be seen. The *Fountain of the Seahorses,* a work in marble by Christopher Unterberger, was added in the eighteenth century.

See discussion on page 56.

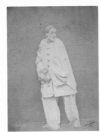

page viii
Nadar (1820–1910) and Adrien Tournachon
 (1825–1903)
Pierrot the Thief, 1854–55
11.25 x 8.13 in. (28.575 x 20.65 cm)
salt print
AA1975.091

Nadar was the professional name of Gaspard Félix Tournachon, who with his brother Adrien produced a series of studies of the famous mime Charles Deburau. The series was very popular and won a gold medal at the Exposition Universelle of 1855. Shortly after completing the project Nadar quarreled with Adrien, and they dissolved their partnership.

This photograph is not in the Scholz collection.

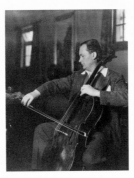

page 2
Arnold Genthe (1869–1942)
Portrait of Janos Scholz, 1937 (printed later)
9.5 x 7.5 inches (24.13 x 19.05 cm)
silver gelatin print, toned
1975.010

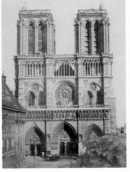

page 8
Edouard-Denis Baldus (1813–89)
Paris, West Façade of Notre Dame, c. 1857
17.13 x 12.93 in. (43.51 x 32.842 cm)
albumen print
1984.012.004

Janos Scholz thought it was appropriate that he purchase this image and donate it to the University of Notre Dame. The building on the left of the photograph was later torn down as part of Baron Hausmann's plan to restructure Paris.

See discussion on page 21.

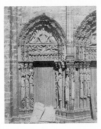

page 14
Em. Pec (active 1840s–1850s)
Doorway of Chartres Cathedral, c. 1852
7.88 x 10.13 in. (20.015 x 25.73 cm)
salt print
1985.010.003

Historians of photography have argued about the identity of the gifted photographer who used the signature *Em. Pec* on a small number of beautiful salt prints that have turned up in France. One candidate is the photographer E. Pecquerel, who sent work to an exhibit in London in 1852.

See discussion on page 21.

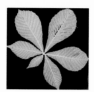

page 15
unidentified photographer
Photogram of a Leaf, 1860
5.44 x 5.63 in. (13.818 x 14.300 cm)
albumen print
1984.012.020

See discussion of photograms on pages 15–16.

page 18
Pierre-Ambrose Richebourg (1810–after 1893)
The Campidoglio, Rome, c. 1842
3.12 x 4.12 in. (7.925 x 10.465 cm)
daguerreotype
1985.009.004

Outdoor daguerreotypes of Rome taken at such an early date are extremely rare. Richebourg was a successful commercial photographer in Paris. He was the first person to propose using photographs in passports for identification.

See discussion of daguerreotypes on pages 17–18, 20, and 55.

page 20
Alphonse Louis Poitevin (1819–82)
detail, *Salt Works at Gouhemans,* 1849

For the complete photograph, see page 79.

page 24
François-Auguste Renard (active 1850s)
Paris, Quai de l'Horloge, c. 1852
6.5 x 8.75 in. (16.51 x 22.225 cm)

albumen print from albumen on glass negative
1987.015.017

Renard's training as an architect may explain his fascination with urban landscape. This view along the Seine was part of a collaboration with Henri Plaut that was published in 1853 as *Paris photographié,* the first book of photographs of Paris. The long exposure has smoothed out the ripples in the river so that it looks like ice or glass.

See discussion on page 25.

page 29
Samuel Broadbent (1810–80)
Mrs. Rebecca Earp, Seated, c. 1855
7.25 x 5.25 in. (18.42 x 13.34 cm)
salt print
1984.012.010

Samuel Broadbent ran a commercial studio for many years in Philadelphia. Early in his career he occasionally printed his negatives as salt prints. American salt prints are very rare, because the U.S. buying public preferred albumen prints.

See discussion on page 29.

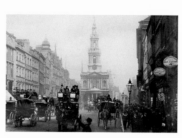

page 34
Francis Frith and Company
 (studio, active 1859–1971)
The Strand, London, 1880s
7.48 x 11.02 in. (19.0 x 28.0 cm)
albumen print
1984.048.009.H

While indoor plumbing was becoming more common in the 1890s, public bathing houses still

abounded in the city. Bright, prominent signs advertise the "Gaiety Toilet Club" on the Strand.

See discussion on pages 27 and 35.

page 37
William Henry Fox Talbot (1800–1877)
detail, *Magdelen College, Oxford,* 28 July 1842

For the complete photograph, see page 72.

page 40
David Octavius Hill (1802–70)
 and Robert Adamson (1821–48)
detail, *Three Fisherwomen of Newhaven,* c. 1845

For the complete photograph, see page 127.

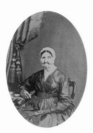

page 46
unidentified photographer
When We Were Boys Together, c. 1860
6.250 x 5.250 in. (15.875 x 13.335 cm)
albumen print
1994.030.053

This image draws its title from popular Victorian poetic yearning for the innocence of childhood. The American poet Eugene Field expressed this very sentiment in his late Victorian poem, "Old Times, Old Friends, Old Love": "There are no boys like the good old boys,— / When *we* were boys together!"

See discussion on pages 45 and 47.

page 150
John E. Mayall (1810–1901)
A Great Light Shines through a Small Window,
 c. 1862
2.950 x 2.360 in. (7.5 x 6.0 cm)
albumen print
1984.048.009.K

Mayall's image provides the viewer with some symbolic clues to decode its meaning. For example, the hourglass on the table could stand for the swift passing of time, making the missionary efforts of the girl even more urgent. These symbols were not always understood, and some critics judged this image a failure.

See discussion on pages 51–52.

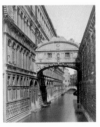

page 58
Carlo Ponti (1823–93)
The Bridge of Sighs, Venice, 1862
12.75 x 10.46 in. (32.385 x 26.568 cm)
albumen print
1994.030.177.D

See discussion on pages 56, 58, and 60.

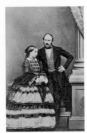

page 61
John E. Mayall (1810–1901)
Queen Victoria and Prince Albert, c. 1860
3.4 x 2.1 in. (8.636 x 5.334 cm.)
albumen print from wet collodion negative
1984.048.015.F

This photograph is in the format of a carte de visite, visiting card.

See discussion on pages 28, 47–48.

page 68
William Henry Fox Talbot (1800–1877)
Portrait of Nicolaas Henneman,
 probably 15 April 1841
2.25 x 1.75 in. (5.715 x 4.445 cm)
calotype negative
1985.074.020.A

Nicolaas Henneman was born in Holland and educated in Paris. He became the valet at Lacock Abbey and soon was working alongside Talbot in the photographic process. This negative was probably taken as part of a series of experiments to reduce the time of exposure so that a person could sit still long enough for a successful portrait. The image is remarkably similar to one in the Smithsonian Institution that is dated 15 April 1841.

See discussion on pages 16–17 and 19.

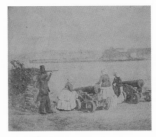

page 69
William Henry Fox Talbot (1800–1877)
Battery at Mt. Edgcumbe, Plymouth,
 September 1845
3.19 x 3.81 in. (8.103 x 9.677 cm)
varnished salt print from a calotype negative
1984.012.062

One of the women in this charming little photograph is Constance, Talbot's wife. The man with the telescope is probably Reverend Calvert Richard Jones, who was an accomplished photographer in his own right. Talbot began having some of his prints coated with varnish around 1845 in an attempt to stop the fading that had afflicted much of his work.

See discussion on page 19.

page 70
William Henry Fox Talbot (1800–1877)
Clock Tower, Lacock Abbey, 18 February 1840
7.25 x 9.0 in. (18.415 x 22.86 cm)
salt print from a photogenic drawing negative
1985.074.023

In 1840, the abundant spring sunshine allowed Talbot to return to the photographic experiments that he had shelved in 1839. This is the first of a series of outdoor views that Talbot captured in 1840, a year that also saw his first successful portraits. Only one other print of this image is known, preserved since 1840 in the collection of the French Académie des Beaux-Arts in Paris. Because of the print's continued sensitivity to light, *Clock Tower* will not appear in the Snite Museum's exhibit.

See discussion on page 37.

page 71
William Henry Fox Talbot (1800–1877)
Lacock Abbey, South Side toward Sharington's Tower,
 November 1839
6.38 x 5.31 in. (16.205 x 13.487 cm)
salt print from a photogenic drawing negative
1984.012.059

Photography was only a few months old when Talbot photographed the front of his ancestral home. He had not yet discovered how to develop an image after a short exposure, so the negative for this photograph was produced by allowing the paper to stay in the camera until the action of the light itself burned in the image. Because of the print's continued sensitivity to light, *Lacock Abbey* will not appear in the Snite Museum's exhibit.

See discussion on page 37.

page 72
William Henry Fox Talbot (1800–1877)
Magdalen College, Oxford, 28 July 1842
6.5 x 7.75 in. (16.51 x 19.685 cm)
calotype negative
1985.074.019.A

Although a Cambridge man himself, Talbot loved photographing the various buildings at Oxford. This is one of Talbot's negatives, which was exposed briefly in the camera and then "developed" in a darkroom to make the latent image appear. It was waxed to make it more transparent for printing.

See discussion on pages 16–17 and 37–38.

page 73
William Henry Fox Talbot (1800–1877)
Loch Katrine, Scotland, 19–21 October 1844
7.25 x 9.0 in. (18.415 x 22.86 cm)
salt print from a calotype negative
1985.074.010

Loch Katrine was a popular site for Victorian tourists, especially after it was used as a setting for Sir Walter Scott's *Lady of the Lake.* Talbot took a number of views in different sizes from this side of the lake.

See discussion on pages 18 and 38.

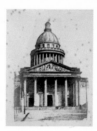

page 74
William Henry Fox Talbot (1800–1877)
The Pantheon, Paris, c. 1858
10.25 x 7.0 in. (26.035 x 17.78 cm)
photoglyphic engraving
1985.074.009

Talbot sensed from the very beginning that photography would be much more useful if photographs could be reproduced in large numbers on a printing press, not just individually in a darkroom. In the 1850s and 1860s he experimented with etching a photographic image onto a metal plate so that it could be inked and printed, and this picture shows how successful his experiments had become. The negative used here by Talbot was probably produced by the French photographer Charles Soulier (1840–75).

See discussion on page 19.

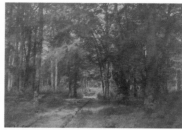

page 76
Gustave Le Gray (1820–82)
Forest of Fontainebleau, c. 1853
10.13 x 14.56 in. (25.73 x 36.982 cm)
salt print from a waxed paper negative
1984.012.030

In this photograph, certainly one of the finest images in the Scholz collection, the golden brown tones and soft, diffuse focus of the salt print process perfectly complement the languorous feeling of a hot, sunny, summer day in the woods. A slight breeze rustling the leaves produced the very soft blurring in the upper branches of the trees. The rutted path leads off into the woods, inviting the viewer to enter.

See discussion on pages 10, 20, and 22–23.

page 77
unidentified photographer
Trees and House, Rural France, c. 1852
8.63 x 6.75 in. (21.9 x 17.145 cm)
calotype, on mount
1985.010.014

In this striking image, the soft golden tones complement the trunks of the trees and the stones of the building in the distance.

See discussion on page 23.

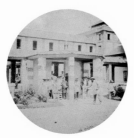

page 78
Charles Nègre (1820–80)
Playing Boules at the Asylum at Vincennes, c. 1859
6.75 x 6.75 in. (17.145 x 17.145 cm)
albumen print
1984.012.045

The French government, extremely proud of the state-of-the-art hospital constructed by Napoleon III at Vincennes, commissioned Nègre to document the facilities. His photographs were unusual for the period in that he showed the staff and patients in situations that appear very natural and unstaged. In this photograph people are playing a game of boules, similar to English lawn bowling or Italian bocce.

See discussion on page 21.

page 79
Alphonse Louis Poitevin (1819–82)
Salt Works at Gouhemans, 1849
4.0 x 4.25 in. (10.160 x 10.795 cm)
salt print
1994.030.011

This small image is one of the first photographs made by Poitevin, who at the time was working as a chemist and civil engineer in a saltworks in the French Jura.

See discussion on page 20.

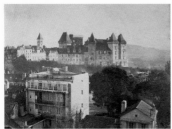

page 80
Jean-Jacques Heilmann (1822–59)
Chateau and Town of Pau, c. 1854
7.63 x 10.0 in. (19.368 x 25.4 cm)
salt print from a wet collodion negative
1994.030.030

Because of its scenic location in the French Pyrenees, the town of Pau attracted tourists and thus also attracted photographers. Heilmann, a civil engineer, moved to the area from Alsace in the hope that the milder climate would help his tuberculosis. This image is printed on salted paper but is unusually detailed because the negative was glass. The building in the middle distance has a glassed-in porch on the top-floor apartment; perhaps the porch served as a photographic studio.

See discussion on pages 23 and 26–27.

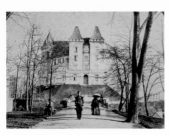

page 81
Jean-Jacques Heilmann (1822–59)
Pau, the Entrance of the Chateau, c. 1854
7.13 x 9.56 in. (18.11 x 24.282 cm)
salt print from a wet collodion negative
1984.012.024

The characters along the entrance to the chateau form a wonderful group. The little soldier stands proudly, while the gentleman on the bench has dramatically turned his back to the camera. The lady with the umbrella is accompanied by a pair of white dogs, or possibly by a single very active one, represented by blurs on either side of her, with their or its tiny legs just visible.

See discussion on pages 26–27.

page 82
Edouard-Denis Baldus (1813–89)
Avignon, from across the Rhône River,
 late 1850s or early 1860s
7.88 x 10.0 in. (20.015 x 25.4 cm)
albumen print
1984.012.046

Baldus carefully composed this image as a series of horizontal bands leading up to the old papal palace on the hill, which hardly seems real.

See discussion on page 21.

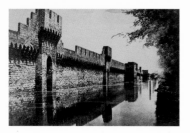

page 83
Edouard-Denis Baldus (1813–89)
Avignon, Ramparts under the Flood, 1856
5.88 x 8.38 in. (14.935 x 21.285 cm)
albumen print
1984.012.005

In May of 1856 a series of rainstorms resulted in flooding along the valley of the Rhône. Baldus was commissioned by the government to document the area, and his eye was caught by the scene of water all the way up to the base of the old ramparts at Avignon. This particular photograph, which has been reprinted smaller than the original negative, was probably made by Baldus later for commercial sale.

See discussion on page 21.

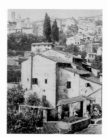

page 84
Charles Nègre (1820–80)
Olive Press and Houses at Grasse, 1852
7.81 x 5.88 in. (19.837 x 14.935 cm)
albumen print from a waxed paper negative
1984.012.043

Nègre was originally from Provence, and in 1852 he returned to his birthplace of Grasse and produced over two hundred negatives documenting life in the region. In this photograph Nègre has carefully composed the image geometrically; the houses on the hillside look like little cubes. The people in the foreground are gathered around an olive press.

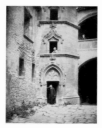

page 85
unidentified photographer
Interior Courtyard, Chateau de Tournoël, c. 1870
8.86 x 6.61 in. (22.5 x 16.8 cm)
albumen print
1985.011.016.H

The Chateau de Tournoël in the Auvergne region of France has been a popular tourist destination since it fell into ruins in the seventeenth century. In a tableau that would have delighted Sigmund Freud, a priest in the lower doorway appears to have women on his mind—two, to be precise.

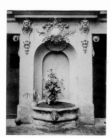

page 86
Eugène Atget (1857–1927)
Paris, Fountain in a Courtyard
(Hôtel de Parliamentaires, 3 Rue du Lyons),
 c. 1905
8.44 x 7.0 in. (21.438 x 17.78 cm)
albumen print
1984.012.003

This urban architectural detail is very typical of Atget's work. He was fascinated by the way structures evolve over the years. Here we see an elegant fountain which has first had a faucet stuck into the mouth of the small spouting face and then been converted into a planter.

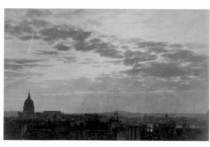

page 87
Charles Marville (1816–79)
Sky Study, Paris, with the Dome of the Invalides in
 Silhouette, c. 1860
5.69 x 8.94 in. (14.453 x 22.708 cm)
albumen print
1987.015.025

Marville shot this photograph from the window of his studio, part of a series of studies of different cloud effects over the city.

See discussion on page 22.

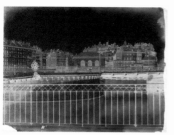

page 88
unidentified photographer
"La machine": The Waterworks, Geneva, c. 1854
9.5 x 12.0 in. (24.13 x 30.48 cm)
paper negative
1994.030.066

For many years, collectors paid little attention to the paper negatives that were produced by the earliest photographers. This would have saddened their makers, who often proudly exhibited the negative next to the print. Besides being a handsome image in its own right, this early Swiss negative has a strong sense of being a handcrafted object, not only because of the irregular shape of the chemical coating but also because the careless photographer's fingerprints appear in several places.

See discussion of paper negatives on pages 16–17.

page 89
François-Auguste Renard (active 1850s)
Paris, Gare de Strasbourg, c. 1852
6.5 x 8.5 in. (16.51 x 21.59 cm)
albumen print from albumen on glass negative
1987.015.016

The train station that is now called the Gare de l'Est had been completed just two years before Renard photographed it. He was experimenting with glass negatives, which would print with much more detail than a paper negative. Renard coated his plates with albumen from egg whites, a technique perfected in 1848 by Abel Nièpce de Saint-Victor. One of the major problems with albumen

negatives was their low sensitivity to light, which necessitated exposures ranging from five to fifteen minutes. In Renard's image of a bustling train station, the streets are strangely depopulated; the only person who was still long enough to register on the plate was the loafer sitting against the fence.

See discussion on page 25.

page 90
Colonel Jean-Charles Langlois (1789–1870)
Ramparts of Malakhov, near Sebastopol,
 Crimean War, 1855
10.25 x 12.5 in. (26.035 x 31.75 cm)
salt print from a paper negative
1994.030.106.A

Langlois retired from the French army with the rank of colonel after the Battle of Waterloo. He studied painting, and from 1830 until his death he specialized in panoramas of great battles. In 1855 he visited the battlefields in the Crimea, where he commissioned and directed the photographers Léon-Eugène Méhédin and Frédéric Martens in producing a set of prints that gave a 360-degree view of the field and the ramparts. These fortifications had recently been captured by French troops of the Imperial Guard. The brown tones and soft focus of this image give the viewer a strong impression that the dirt of the battlefield has been smeared across the paper.

See discussion on page 23.

page 91
Nadar (1820–1910)
Paris Catacombs, 1862
9.19 x 7.19 in. (23.343 x 18.263 cm)
albumen print
1984.012.041

The first person to photograph underground, Nadar started in the Paris catacombs and then later visited the city's famous sewer system. He assembled batteries on the street level and snaked cables down manholes to power arc lights. The patriots buried on this spot had been shot by royal troops near the Pont Neuf during spontaneous political demonstrations the nights of 28 and 29 August 1788.

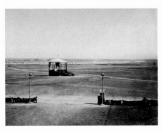

page 92
Gustave Le Gray (1820–82)
Camp de Châlons, Chapel, 1857
12.0 x 14.25 in. (30.48 x 36.195 cm)
albumen print from wet collodion
 on glass negative
1984.012.031

In 1857 Napoleon III directed a series of military training maneuvers near Châlons-sur-Marne, east of Paris. The pavilion in the photograph was constructed to serve as a temporary altar for the outdoor masses attended by the emperor. This print originally appeared at the far right of a six-part panoramic view of the field.

See discussion on pages 10 and 21.

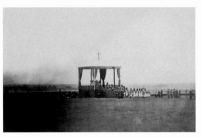

page 93
Gustave Le Gray (1820–82)
Mass in the Presence of the Emperor,
 Camp de Châlons, 1857
10.0 x 13.7 in. (25.4 x 34.798 cm)
albumen print from wet collodion
 on glass negative
1984.012.032

On Sundays the emperor customarily attended a mass celebrated by his chaplain, with the entire army present in full dress uniform. The choir was composed of grenadiers, and many of the people from the neighboring towns also attended the service. Photographs from this period that capture a historical event while it was happening are rare.

See discussion on pages 10 and 21.

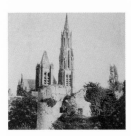

page 94
E. Nicolas (active 1850s)
Senlis, the Ruins of the Old Chateau
 and the Cathedral, c. 1855
8.38 x 8.75 in. (21.285 x 22.225 cm)
salt print from a waxed paper negative
1987.015.023

Almost nothing is known about Nicolas, including his or her first name. The photographer apparently lived in Senlis, a picturesque town north of Paris. All of Nicolas's photographic works were found in a portfolio in Paris in the 1930s. The work has a strong sense of craftsmanship.

See discussion on page 23.

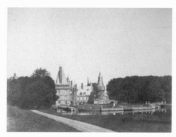

page 95
Emmanuel, Duc de Noailles (b. 1830)
Chateau at Maintenon, 1850s
10.88 x 14.31 in. (27.635 x 36.347 cm)
salt print
1984.012.047

Photographs by the marquis Emmanuel are extremely rare; the only other works are located in the collections of the Société Française de Photographie. The ancestral home of the illustrious Noailles family, the chateau of Maintenon is now a historical monument, with a golf course on the front lawn.

See discussion on page 25.

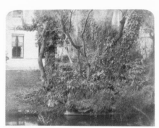

page 96
Alphonse Jeanrenaud (1818–95)
Garden Scene, c. 1860
10.25 x 12.81 in. (26.035 x 32.537 cm)
albumen print
1984.012.027

The most likely explanation for this photograph—a portrait of shrubbery—was that Jeanrenaud made it to sell to artists for use in the studio as a visual reference when painting a landscape.

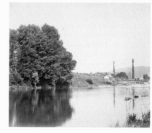

page 97
Achille Quinet (1831–1900)
Pont Mally, c. 1870
7.69 x 9.06 in. (19.533 x 23.012 cm)
albumen print
1987.015.013

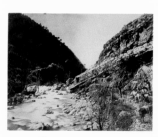

page 98
Lieutenant Louis Vignes (1831–96)
Vallée de Nahr-el-Kelb, 1864
7.88 x 10.94 in. (20.015 x 27.788 cm)
albumen print
1987.015.019

Vignes's use of the empty sky as a strong negative shape between the cliffs strongly resembles photographs that Timothy O'Sullivan would make in America a few years later.

See discussion on page 26.

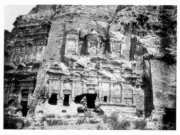

page 99
Lieutenant Louis Vignes (1831–96)
Petra, 1864
6.88 x 9.69 in. (17.475 x 24.613 cm)
albumen print
1987.015.018

Vignes, an officer in the French navy, was recruited by the Duke de Luynes to accompany an expedition to the Middle East. After a crash course in photography, Vignes proved himself quite capable as the group made its way through Lebanon, the Holy Land, the Dead Sea, and Jordan.

See discussion on page 26.

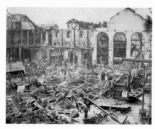

page 100
unidentified photographer
Ruins of a Factory, Paris, c. 1871
10.25 x 8.0 in. (26.035 x 20.32 cm)
albumen print
1985.010.008

Photography is one of the few professions that usually profits from disaster. This factory was turned into a mess of twisted metal during the Franco-Prussian War; the employees and one well-dressed man, who looks like the owner, pose for the photographer. The chaos of the ruins evokes other scenes of urban destruction.

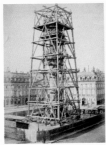

page 101
Charles Marville (1816–79)
*Paris, Reconstruction of the Column
in the Place Vendôme*, 1875
13.93 × 9.75 in. (35.382 × 24.765 cm)
albumen print
1984.012.038

See discussion on pages 21–22.

page 102
unidentified photographer
Fruit on Branches, c. 1870–80
10.75 × 8.25 in. (27.305 × 20.955 cm)
albumen print
1994.030.124

page 103
Camille Silvy (1834–1910)
Hunting Still Life, 1858
9.19 × 6.38 in. (23.343 × 16.205 cm)
albumen print
1984.012.055

Silvy had already studied law and been a French diplomat before he began experimenting with photography. He had only been photographing a year when he produced this still life, which he dated and initialed in the image by writing on the wood with crayon or chalk. In 1859 he decided to move to London, where he became one of the most popular society portraitists. The only other known print that is similar to this, in the Victoria and Albert Museum, does not show the little projection of the gun barrel above the edge of the image.

page 104
Charles Marville (1816–79)
Marble Bas-Reliefs by Luca Della Robbia, 1853–54
5.5 × 14.0 in. (13.97 × 35.56 cm)
salt print
1994.030.151

Photographs of famous works of art were very popular in the early days of the medium. The sale of such prints was often a major source of income for the first commercial studios, especially in France.

See discussion on pages 21 and 56.

page 105
Louis-Rémy Robert (1811–82)
Porcelain from the Factory at Sèvres, 1855
10.13 × 12.63 in. (25.73 × 32.08 cm)
salt print
1984.012.053

page 106
Jean Nicolas Truchelut (active 1850s–1870s)
Two Models in a Studio, c. 1856–60
7.44 × 5.38 in. (18.898 × 13.665 cm)
albumen print
1985.010.018

The name of the painter who commissioned the four Truchelut figure studies—François-Victor Jeannenet—comes down to us from a signature on the photographs. So far, no painting has been found that includes the subjects of the Truchelut photographs, and little is known about Jeannenet.

See discussion on page 30.

page 107
Jean Nicolas Truchelut (active 1850s–1870s)
Two Men in Chairs in a Studio, c. 1865
6.5 x 7.25 in. (16.51 x 18.415 cm)
albumen print
1994.030.135

See entry above, Truchelut's *Two Models in a Studio*.

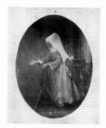

page 108
Jean Nicolas Truchelut (active 1850s–1870s)
Model Dressed as a Nun, c. 1865
8.0 x 6.0 in. (20.32 x 15.24 cm)
albumen print
1994.030.129

See entry above, Truchelut's *Two Models in a Studio*.

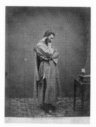

page 109
Jean Nicolas Truchelut (active 1850s–1870s)
Man Dressed as Monk, Standing, c. 1865
8.25 x 6.75 in. (20.96 x 17.15 cm)
albumen print
1994.030.133

See entry above, Truchelut's *Two Models in a Studio*.

page 110
attributed to Victor Laisne (b. 1807)
Portrait of Eugène Delacroix, c. 1853
5.31 x 4.0 in. (13.487 x 10.16 cm)
salt print
1984.012.017

The painter Delacroix sat for many different photographers. The tentative attribution of this image to Laisne is based on similarities in style and format to Laisne's photographs illustrating Théophile Silvestre's *Histoire des artistes vivants* (Paris, 1853).

See discussion on page 30.

page 111
Louis Maurice Boutet de Monvel (1851–1913)
Portrait of Paul Gauguin, c. 1890
6.38 x 5.0 in. (16.2 x 12.7 cm)
albumen print
1985.010.001

The painter Paul Gauguin was invited to the studio of the academic painter Boutet de Monvel in order to have his picture taken. Gauguin's pose and expression project a haughty arrogance, which was probably deliberate. While this photograph has frequently been reproduced over the years, original prints are quite scarce.

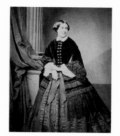

page 112
Antoine Samuel Adam-Salomon (1818–81)
Portrait of a Lady, c. 1860
10.56 x 8.25 in. (26.822 x 20.955 cm)
albumen print
1984.012.001

Adam-Salomon ran a lavish and successful studio in Paris and was immensely popular, both in France and England. Among his admirers were Henry Peach Robinson and P. H. Emerson, who thought Adam-Salomon was one of the three greatest photographers, on a level with Julia Margaret Cameron. This portrait of a well-off client is as much about the rich textures of the dress and props as it is about the sitter.

page 113
Durand of Lille
Seated Woman with Lace Collar, c. 1855
5.88 x 4.38 in. (14.935 x 11.125 cm)
salt print with hand coloring
1984.048.040

Durand is not listed in the standard photographic references, but he must have had a studio in the town of Lille in the 1850s. The subtle hand coloring makes this portrait exceptionally delicate and elegant, reminding us that there were accomplished photographers working all over the country.

page 114
Luigi Crette (1823–72)
Portrait of the Journalist Alphonse Karr, c. 1860
10.38 x 13.13 in. (26.365 x 33.35 cm)
albumen print
1984.012.015

Alphonse Karr was a gardener, writer, the editor of
Figaro, and friend of Victor Hugo, George Sand,
and Balzac. His intense intelligence is evident in
this strong portrait by Luigi Crette, a photogra-
pher who is more often associated with views of
the French Riviera.

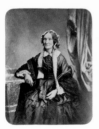

page 115
Alphonse Louis Poitevin (1819–82)
Portrait of a Seated Lady, 1861
7.81 x 6.06 in. (19.837 x 15.392 cm)
carbon print
1984.012.048

Poitevin was a perpetual experimenter, and one of
his goals was to find a photographic process that
was not susceptible to fading. One of his inven-
tions was the carbon print, of which this portrait
is an example. First a negative was printed onto a
tissue coated with gelatin and potassium bichro-
mate, which had a stable pigment in it, such as
carbon. The gelatin with the pigment was then
transferred onto another sheet of paper, produc-
ing a shiny, rich, durable print.

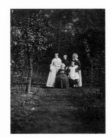

page 116
Alphonse Le Blondel (1812–75)
Family Group in Garden, c. 1855
5.81 x 4.56 in. (14.757 x 11.582 cm)
salt print
1984.012.029

This print is one of the few photographs in the
Scholz collection with an exhibition history, hav-
ing been shown in Edinburgh in 1979 in an ex-
hibit of nineteenth-century French photography.

See discussion on page 23.

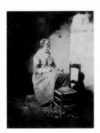

page 117
unidentified photographer
Woman Seated, Peeling Vegetables, 1853
4.81 x 3.63 in. (12.217 x 9.22 cm)
salt print
1984.012.042

It is unfortunate that the photographer of this
lovely image is unknown. The composition is han-
dled well, especially in the use of shadows, and
the tones are very rich.

See discussion on page 23.

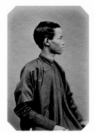

page 118
Philippe Jacques Potteau (1807–76)
Vietnamese Youth, Profile View, 1863
6.93 x 4.72 in. (17.6 x 12.0 cm)
albumen print
1987.015.015

See discussion on page 29.

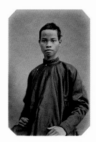

page 119
Philippe Jacques Potteau (1807–76)
Vietnamese Youth, Front View, 1863
6.93 x 4.72 in. (17.6 x 12.0 cm)
albumen print
1987.015.014

See page 118 and discussion on page 29.

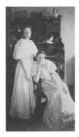

page 120
unidentified photographer
Two Women, c. 1900
7.09 x 4.13 in. (18.0 x 10.5 cm)
cyanotype
1994.030.181.A

This lovely little picture comes from an album that was assembled by the Philadelphia painter Milton Bancroft (1867–1947) during a trip to Europe at the end of the nineteenth century. Bancroft used the contents of his albums as inspiration for paintings and magazine illustrations. The blue tones of this print come from the cyanotype process, discovered in 1842 by the British scientist Sir John Herschel. We are more familiar with its use in copying architectural drawings to make blueprints, but it can also be used to print a continuous tone negative, with beautiful results.

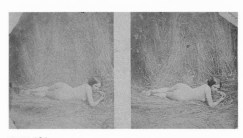

page 121
unidentified photographer
Reclining Female Nude, in Stereo, early 1850s
2.75 x 5.25 in. (6.985 x 13.335 cm)
salt print
1994.030.048

Salt print stereographs of nude figures are rare. The sharper realism of daguerreotypes and albumen prints was generally preferred in erotic images.

See discussion on pages 30 and 49.

page 122
Alfred Briquet (active 1850s–1900)
Olive Trees in Southern France, 1860s
8.56 x 6.5 in. (21.742 x 16.51 cm)
albumen print
1984.012.009

The marvelous shape of the ancient olive trees can easily distract the viewer from the figure of the young man lounging on the ground. Briquet began as a printer in Montmartre but switched to photography in the 1850s. He may have traveled to Mexico in the 1870s.

page 123
Eugène Atget (1857–1927)
Willow Tree, 1898 or before
7.09 x 5.12 in. (18.0 x 13.0 cm)
albumen print
1994.030.181.C

Both this and Atget's *Apple Tree* are from the Milton Bancroft albums and presumably were acquired by him directly from Atget in Paris. The smaller size of the image of the coppiced willow tree shows that it dates from Atget's earliest body of work, as he soon switched to a larger camera.

See discussion on page 30.

page 123
Eugène Atget (1857–1927)
Apple Tree, 1898 or before
8.66 x 7.09 in. (22.0 x 18.0 cm)
albumen print
1994.030.181.B

Atget loved trees and photographed them throughout his career. This is one of his earlier versions. It was probably taken during a photographic excursion through northern France.

page 124
Constant Alexandre Famin (1827–88)
Boy and White Horse, c. 1860
4.0 x 5.5 in. (10.16 x 13.97 cm)
albumen print
1994.030.001

This strange image makes more sense if we remember that boys with horses were as common in the nineteenth century as boys with their cars are today. Is the rear view a sign of carelessness on the part of the photographer, or are we meant to admire the musculature of the haunches? The soft glow around the animal is a result of light scattering, called *halation.*

page 126
unidentified photographer
Portrait of the Misses Harvey, 1860s
6.0 x 4.5 in. (15.240 x 11.430 cm)
albumen print
1994.030.049

See discussion on pages 45 and 54.

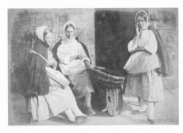

page 127
David Octavius Hill (1802–70)
 and Robert Adamson (1821–48)
Three Fisherwomen of Newhaven, c. 1845
5.250 x 7.750 in. (13.335 x 19.685 cm)
salt print from a paper negative
1994.030.041

While a number of the photographs in this series were taken on location at Newhaven, the doorway in the background places the scene at Rock House in Edinburgh. The women journeyed frequently to the city in order to hawk their fish on the streets.

See discussion on pages 40–41.

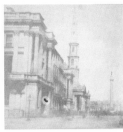

page 128
David Octavius Hill (1802–70)
 and Robert Adamson (1821–48)
Edinburgh, George Street and St. Andrew's Church,
 1843
3.88 x 3.88 in. (9.855 x 9.855 cm)
salt print from a paper negative
1984.012.025

Outdoor shots by Hill and Adamson are rare, and this particular print is the only one of this image that has been located. Scottish lay theologian and geologist Hugh Miller (1802–56) described the photograph in detail in *The Witness* of July 1843, in an article entitled "The Calotype." Miller praised the picture for its clear demonstration of the laws of perspective. To Scottish historians it is more important as one of the oldest surviving photographs of St. Andrew's Church, the site of the public reading of a protest in May 1843 that led to the founding of the Free Church of Scotland.

page 129
David Octavius Hill (1802–70)
 and Robert Adamson (1821–48)
*The Covenanters' Tomb, Greyfriars Churchyard,
 Edinburgh*, c. 1845
8.250 x 5.750 in. (20.955 x 14.605 cm)
salt print from a paper negative
1994.030.040

The figure reclining on the left is David Octavius Hill, co-creator of the photograph. In 1961 Walt Disney made a movie about a small dog, Greyfriars Bobby, who lived by the grave of his master for fourteen years after he was buried in this churchyard in 1858.

See discussion on page 39.

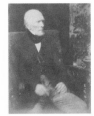

page 130
David Octavius Hill (1802–70)
 and Robert Adamson (1821–48)
Portrait of Admiral Stoddard, 1845
8.13 x 5.88 in. (20.650 x 14.935 cm)
salt print from a paper negative
1984.012.026

See discussion on pages 38–39.

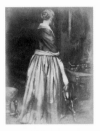

page 131
David Octavius Hill (1802–70)
 and Robert Adamson (1821–48)
Mrs. Marian Murray, c. 1847
8.0 x 6.0 in. (20.320 x 15.240 cm)
salt print from a paper negative
1994.030.042

Mrs. Murray wed the noted publisher, John Murray, in 1847.

See discussion on pages 39 and 41.

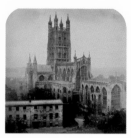

page 132
Roger Fenton (1819–69)
Exterior of Gloucester Cathedral, c. 1855
11.13 x 10.88 in. (28.27 x 27.635 cm)
albumen print
1984.024.007

Fenton is remembered as one of the foremost architectural photographers of his generation. His vantage point in this photograph allows the viewer to survey the cathedral, which was in the midst of extensive and controversial renovation by the Victorian architect Sir George Gilbert Scott, who aimed to return the cathedral to its medieval appearance. He also renovated the interior of Lichfield Cathedral.

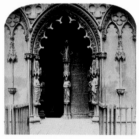

page 133
Roger Fenton (1819–69)
Porch, Lichfield Cathedral, 1859
10.63 x 10.88 in. (27.0 x 27.635 cm)
albumen print
1984.024.008

See discussion on page 50.

page 134
Roger Fenton (1819–69)
Bust of Antoninus Pius, 1859
13.5 x 9.75 in. (34.29 x 24.765 cm)
albumen print
1984.024.003

Hired by the British Museum to document its extensive collection of antiquities, Roger Fenton initiated a standard museum practice: a photographic record of objects in the collection. Museum officials and Fenton soon quarreled, however, over the ownership of the negative and reproduction rights. This image, produced for the Art Union portfolio, must have angered museum officials who felt that they owned the rights to reproduce images of their object.

See discussion on page 50.

page 135
Lewis Carroll (Charles Dodgson) (1832–98)
Portrait of Alfred, Lord Tennyson, c. 1857
3.750 x 2.380 in. (9.525 x 6.045 cm)
albumen print
1984.048.018

This image captures the poet, named poet laureate in 1850, on the brink of popular fame. Two years later, he would publish the first four *Idylls of the King*, a cycle based on Arthurian legend, to popular praise and critical abuse.

See discussion on page 48.

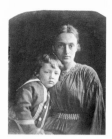

page 136
Julia Margaret Cameron (1815–79)
Mrs. Ewen Hay Cameron (Annie Chinery) and Son, c. 1875
5.250 x 4.130 in. (13.335 x 10.478 cm)
albumen print
1994.030.043

Cameron is known for her elaborately costumed, often allegorical images as well as her portrait heads of "famous men and fair women." This image represents a departure in her work, a straightforward portrait of mother and son in contemporary dress; it probably served as a memento for Cameron to remember her daughter-in-law and grandson, who resided in Ceylon.

See discussion on pages 45 and 52.

page 137
Julia Margaret Cameron (1815–79)
Our May, 1870
3.380 x 2.630 in. (8.573 x 6.668 cm)
albumen print
1994.030.045

Like Mayall, Cameron borrowed themes and motifs from contemporary painting. This image probably had a more descriptive title that gave some hint of the narrative. The technology of photography, however, necessitated some distinction between painting and photography. While a painter could study a bird from life, Cameron's motionless prop on May's table must have been stuffed.

See discussion on pages 52–53.

page 137
Julia Margaret Cameron (1815–79)
A Double Star, 1864
3.250 x 2.130 in. (8.255 x 5.398 cm)
albumen print
1994.030.044

See discussion on pages 54–55.

Page 138
Captain Eugene Clutterbuck Impey
 (active 1858–65)
Portrait of Maharaja Takhat Singh, c. 1860
7.750 x 5.880 in. (19.685 x 14.935 cm)
albumen print
1994.030.100

Captain Impey was an amateur photographer and officer in the Bengal Cavalry, stationed in Rajasthan. He photographed the ruling family there on occasions both official and unofficial. As the backdrop indicates, he had to set his camera up outdoors to obtain the correct exposure.

See discussion on page 63.

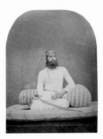

page 139
Captain Eugene Clutterbuck Impey
 (active 1858–65)
Portrait of Maharaja Jeswunt Singh, c. 1860
7.750 x 5.880 in. (19.685 x 14.935 cm)
albumen print
1994.030.101

The portrait perhaps illustrates the contrast between youth and age. While Maharajah Takhat Singh holds tight to his sword and shield, Maharajah Jeswunt Singh has his pistol within easy reach. While the elder Singh is encrusted with jewels and overcome by pattern, the younger Singh rests easily on simple striped cushions.

See page 138 and discussion on page 63.

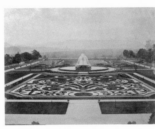

page 140
unidentified photographer
Atlas Fountain and Gardens, Castle Howard, c. 1853
10.63 x 13.7 in. (27.0 x 34.798 cm)
salt print
1984.012.052

This photograph probably commemorates the opening of the so-called New Pleasure Grounds at Castle Howard in the 1850s. By the 1890s, though, these formal gardens fell out of fashion and they were demolished by the Countess of Carlisle in favor of a more simple lawn. Castle Howard was used as the setting for the televised version of *Brideshead Revisited.*

See discussion on page 42.

page 142
Juan Laurent (French, 1816–92)
The Chaperone, c. 1870–75
13.0 x 9.75 in. (33.02 x 24.765 cm)
albumen print
1994.030.143

The smiles on the faces of Laurent's subjects show that they knew they were only acting out a little drama for the tourist trade.

See discussion on page 56.

page 143
Juan Laurent (French, 1816–92)
Types de Maragatos, Spain, c. 1880
12.75 x 9.75 in. (32.385 x 24.765 cm)
albumen print
1994.030.145

Like Ponti working in Italy (see page 145), Laurent recorded the costumes and manners characteristic to particular regions, in this instance, the Maragatos. Thought during the Victorian era to be descended from Moorish conquerors of Spain (which would explain their distinctive dress), the Maragatos were an object of romantic fascination.

See discussion on pages 56 and 61.

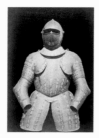

page 144
Charles Clifford (British, 1819–63)
Christopher Columbus's Armor, c. 1858
13.0 x 9.0 in. (33.02 x 22.86 cm)
albumen print
1994.030.138

Born in Wales, Clifford worked for most of his life in and around Madrid. It is thought that he was eventually appointed as court photographer for Spain's Queen Isabella II.

See discussion on pages 44 and 56.

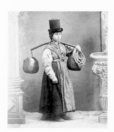

page 145
Carlo Ponti (Italian, 1823–93)
Venetian Water Carrier, c. 1858–60
12.150 x 10.25 in. (30.861 x 26.035 cm)
albumen print
1994.030.177.A

See discussion on pages 60–61.

page 146
Robert Macpherson (Scottish, 1811–72)
The Falls at Terni, 1858–60
16.63 x 12.25 in. (42.24 x 31.115 cm)
albumen print
1979.122.001

Macpherson's vantage point allows the viewer to appreciate the grandeur of the falls. The rushing water posed a problem for the long exposure time, however, which lends the falls an architectural quality.

See discussion on page 59.

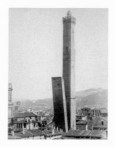

page 147
Fotografia Dell'Emilia
 (Italian studio, active 1860s–1870s)
Bologna, Asinelli and Garisendi Towers, c. 1870s
8.0 x 10.0 in. (20.3 x 25.4 cm)
albumen print
1978.081.167

The unknown photographers who formed the studio "Photographers of Emilia," appealed to the tourist markets with images of famous sites in Emilia-Romagna, such as the Asinelli and Garisendi Towers in Bologna. Like their famous neighbor to the south in Pisa, both towers lean.

See discussion on page 56.

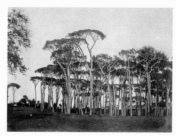

page 148
Giacomo Caneva (Italian, 1819–90?)
Pine Trees near Rome, c. 1852
8.0 x 10.93 in. (20.32 x 27.762 cm)
salt print from a waxed paper negative
1984.012.011

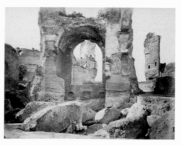

page 149
Michele Mang (German, active 1860s–1870s)
Baths of Caracalla, Rome, c. 1865
7.85 x 10.1 in. (19.939 x 25.654 cm)
albumen print on board
1984.048.008.B

The baths were located on the outskirts of the ancient city to facilitate access to fresh water. Their ruined grandeur was a central attraction for the Victorian visitor, and this photograph provided visitors with a reminder of their trip. Mang has included a poetically posed figure to give some indication of the scale of the ruins.

See discussion on pages 56 and 58.

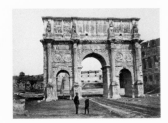

page 150
unidentified photographer
Rome, the Arch of Constantine, c. 1865
7.7 x 10.0 in. (19.558 x 25.4 cm)
albumen print
1984.048.008.A

See discussion on page 56.

page 152
Giorgio Sommer (Italian, 1834–1914)
Plaster Cast of Dead Man from Pompeii, c. 1870
7.91 x 10.04 in. (20.1 x 25.5 cm)
albumen print
1985.011.015.B3

The appointment of Giuseppe Fiorelli as director of excavations for Pompeii in 1861 marked a more systematic and scientific approach to the archaeological excavations of the ancient city. He invented the practice of taking plaster casts and thus gave form to the victims of Mount Vesuvius.

See discussion on page 56.

page 154
Dmitri Constantin (Greek, active 1850s–1860s)
The Erechtheum, Athens, c. 1860
11.13 x 15.13 in. (28.27 x 38.430 cm)
albumen print
1994.030.178.H

See discussion on page 56.

page 151
unidentified photographer
Rome, Arch of the Silversmiths, c. 1860
15.44 x 11.25 in. (39.219 x 28.575 cm.)
albumen print from wet collodion negative
1984.012.002

See discussion on page 56.

page 153
Giorgio Sommer (Italian, 1834–1914)
Cast of Dog from Pompeii, c. 1870
8.0 x 10.0 in. (20.32 x 25.4 cm)
albumen print
1985.011.015.Z2

See page 152 and discussion on page 56.

page 155
Ernest de Caranza (French, 1839–63)
Istanbul, View of the Bosphorus, c. 1853
6.63 x 8.63 in. (16.84 x 21.92 cm)
salt print
1984.012.012

Despite developments in technology that would have resulted in a sharper image, de Caranza continued to use the salt print for his views of Turkey. The process accentuates the idea of Istanbul as a distant and romantic land for the Western viewer.

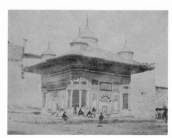

page 156
James Robertson (Scottish, 1813–88)
Istanbul, Fountain of Sultan Selim, before 1857
9.06 x 11.89 in. (23.0 x 30.2 cm)
salt print
1987.015.026

During the 1840s Robertson was superintendent and chief engraver of the mint in Constantinople. He returned later as a photographer.

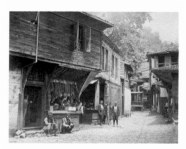

page 157
Gustave de Beaucorps (French, 1825–1906)
Beicos (Anatolia), Turkey, c. 1860
8.75 x 11.75 in. (22.5 x 30.2 cm)
albumen print
1994.030.164.C

Between 1857 and 1861 Beaucorps traveled from France through Spain, Algeria, Turkey, Egypt, and Italy.

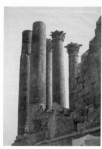

page 158
unidentified photographer
Jordan, Temple of the Sun at Jerash, from the North, c. 1865–75
14.75 x 10.75 in. (37.465 x 27.305 cm)
albumen print
1994.030.105.A

Jerash, the ancient Roman city of Gerasa, is in the modern-day nation of Jordan. The city was "rediscovered" by enterprising travelers during the Victorian era as an example of both well-preserved ancient architecture and the long reach of the Roman empire. The tent in the foreground is probably the photographer's, where the glass negatives were prepared and developed.

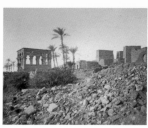

page 159
Félix Bonfils (French, 1831–85)
Egypt, Temple of Isis, 1870s
10.0 x 12.0 in. (25.4 x 30.48 cm)
albumen print
1981.031.516

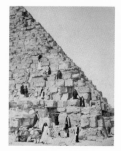

page 160
unidentified photographer
Pyramid in Egypt, c. 1860–75
14.0 x 9.5 in. (35.56 x 24.13 cm)
albumen print
1982.011.024.0

The advent of tourism spurred on by industrial and technological developments also witnessed the birth of a services industry that catered to the needs and wants of mostly European and American travelers in Egypt. In this instance, "pushers" and "pullers" stand at the ready to help Western visitors ascend the pyramid.

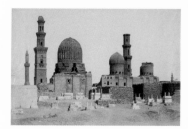

page 161
Antonio Beato (Italian, 1830–1906)
Cairo, the Tombs of the Mamluks, 1870s or 1880s
10.13 x 14.19 in. (25.73 x 36.043 cm)
albumen print
1984.012.006

Only recently have scholars separated the work of Antonio Beato, who photographed mostly in Egypt, from that of his brother Felice Beato, who photographed and traveled widely. Unlike most photographers in Egypt, Antonio Beato turned his camera to the Muslim, rather than the ancient, culture of that nation. The focus, however, remains on architecture.

See discussion on page 60.

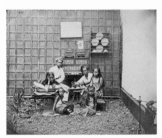

page 162
Woodbury & Page (Woodbury, British,
 active 1857–85; studio, active 1850s)
Family Group, Java, c. 1860
7.92 x 9.92 in. (20.117 x 25.197 cm)
albumen print
1994.030.161.B

The advent of the wet-plate process allowed pho-
tographers to produce sharper images of foreign
locales, but the process also required them to
carry more equipment: a glass plate for each expo-
sure, a darkroom tent, various glass bottles with
chemicals, and glass baths to rinse and fix the ex-
posure. In addition to bringing these materials,
photographers such as Woodbury and Page took
pains to recreate the studio atmosphere while on
location, here in Java.

See discussion on page 62.

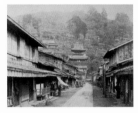

page 163
Felice Beato (Italian, 1830–1906)
Buddhist Temple and Cemetery, Nagasaki, 1864–65
9.0 x 11.2 in. (22.86 x 28.448 cm)
albumen print
1994.030.161.A

Felice Beato was one of the first photographers in
Japan, establishing a practice in Yokohama soon
after the ports of Japan were opened to West-
erners in 1859. Shadowy and blurred figures in
the street indicate that Beato's view was not de-
serted; rather, people were moving too fast to
be photographed. In the distance, the steps lead
to the *tera-machi,* "temple town," above.

See discussion on page 60.

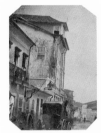

page 164
Ben R. Mulock (British, active 1858–61)
Street in Salvador, Bahia, Brazil, c. 1859
6.0 x 4.25 in. (15.24 x 10.795 cm)
salt print
1994.030.009

Mulock was a British pharmacist who practiced
photography in Brazil for a few years and then
disappeared. While the daguerreotype was intro-
duced into Brazil soon after its discovery, paper
prints were not popular at first, so this is one of
the earliest surviving examples.

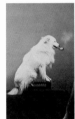

page 196
J. C. Tourtin (French, active 1860s–1890s)
Dog Smoking a Pipe, c. 1860s
3.6 x 2.2 inches (9.144 x 5.888 cm)
albumen print from wet collodion negative
1984.048.012.A

The photographic image was quickly adopted by
the comic print tradition. The "reality" of the
photograph, however, often added an unsettling
undertone to this humor. Only a very well-trained
dog could have held this position long enough for
an exposure. The smoke was added in later.

Notes to the Essays

Bibliography

Notes to the Essays

Notes to
"The essence of luxury": Janos Scholz as Collector
pages 1–11

1. Dean A. Porter, *Janos Scholz: Musician and Collector* (Notre Dame, Ind.: Snite Museum of Art, 1980), 26–27.

2. John Canaday, "Morgan Library Obtains 1,500 Piece Art Treasure," *New York Times,* Wednesday, 12 December 1973, 1, 60.

3. See the website for the Janos Scholz Cello Music Collection at the University of North Carolina at Greensboro: http://www.library.uncg.edu/depts/speccoll/cello/scholz.

4. Porter, *Janos Scholz,* 12.

5. John Russell, quoted in Janos Scholz's obituary, *New York Times,* 6 June 1993, 19.

6. Janos Scholz, *Italian Master Drawings, 1350–1800, from the Janos Scholz Collection* (New York: Dover Publications, 1976), vii.

7. See the list of award recipients at the website for the Eva Janzer Memorial 'Cello Center: http://www.music.indiana.edu/som/ejmccf/honorees/posthonoreers.html.

8. Jeffrey Solow, "In Print; Does It Exist? Where Can I Find It? Sources and References for Cello and Chamber-Music Repertoire," *Strings* 92 (February–March 2001), available online at http://www.stringsmagazine.com/issues/strings92/inprint.

9. Canaday, "Morgan Library."

10. Porter, *Janos Scholz,* 16.

11. Ibid.

12. Ibid.

13. Clarence Gray Dinsmore (1847–1905) was an ancestor of Janos Scholz's wife, the former Helen Marshall Schelling. Dinsmore's father had become wealthy after investing in freight companies, banks, and the Pennsylvania Railroad. In addition to residences in Paris and New York City, he owned a home on the Hudson River, where he practiced photography and raised orchids. He was the first person to import Mercedes automobiles into America.

14. Porter, *Janos Scholz,* 17–18.

15. From an invoice in Janos Scholz's files. Photographers listed include Le Blondel, Renard, Vignes, Marville, Richebourg, Nicolas, and Truchelut.

Notes to
"The agency of light": Early Photography in England and France
pages 13–32

For further information about the photographs discussed in this essay, see Notes on the Photographs, pages 165–185, following the plates.

1. The resulting images are more commonly called *photograms* today, and the process is still taught in beginning photography classes to help instill the basic fundamentals of the medium. In the 1920s and 1930s Laszlo Moholy-Nagy produced striking photograms, as did Man Ray, who referred to them as *rayograms.* The contemporary photographer Adam Fuss has produced some very striking photograms in the darkroom, many of them in color (see *Adam Fuss* [Santa Fe: Arena Editions, 1997]).

2. Talbot told this story some years later in the introduction to *The Pencil of Nature* (London: Longman Brown, Green, and Longmans, 1844–46). For a more detailed explanation of Talbot's career and discoveries, see H. J. P. Arnold, *William Henry Fox Talbot: Pioneer of Photography and Man of Science* (London: Hutchinson Benham, 1977); and Gail Buckland, *Fox Talbot and the Invention of Photography* (Boston: David R. Godine, 1980). By far the finest book yet produced on Talbot's photography is the sumptuous publication by Larry J. Schaaf, *The Photographic Art of William Henry Fox Talbot* (Princeton: Princeton University Press, 2000). Schaaf's book reproduces one hundred Talbot images in their original size and color, thus giving the public its first opportunity to evaluate Talbot as an artist and not just as an inventor. Schaaf's book reproduces a print from the Janos Scholz collection, *Clock Tower, Lacock Abbey* (page 70).

3. For a more detailed description of the daguerreotype and its inventor, see Helmut and Alison Gernsheim, *L. J. M. Daguerre: The History of the Diorama and the Daguerreotype,* 2d ed. (New York: Dover Publications, 1968). Most scholars agree that the earliest extant photograph is the faint image of a farmyard on the back of a small silver plate that was once in the Gernsheims' collection. Taken by Joseph Nicéphore Niépce around 1827, it can be seen at the Humanities Research Center at the University of Texas, Austin. There were numerous other claimants to the title of discoverer of photography, among them Hippolyte Bayard, whose achievements are only recently being recognized and appreciated.

4. Eugenia Parry Janis examines the aesthetics of early paper photographs in *The Art of French Calotype* (Princeton: Princeton University Press, 1983).

5. Gustave Le Gray became known for his seascapes with dramatic clouds, but this effect was frequently accomplished by artfully combining two negatives, one of the clouds and one of the foreground. Another photographer of the period who produced prints with added cloudscapes, but with less finesse, was the American Civil War photographer George N. Barnard.

6. Quoted in the exhibition catalogue, *The Second Empire, 1852–1870: Art in France under Napoleon III* (Philadelphia: Philadelphia Museum of Art, 1978), 401.

7. Le Gray's argument is explained in detail in Eugenia Parry Janis's essays in *Art of French Calotype* and *The Photography of Gustave Le Gray* (Chicago: Art Institute of Chicago and University of Chicago Press, 1987). Le Gray was capable of producing detailed albumen prints from glass negatives when it seemed appropriate for the commission (see the two Le Gray photographs of the Camp de Châlons, pages 92 and 93).

8. This is the argument of William Crawford in *The Keepers of Light* (Dobbs Ferry, N.Y.: Morgan and Morgan, 1979). Crawford in turn was greatly influenced by William Ivins's analysis of photography's relationship to earlier forms of printmaking in *Prints and Visual Communication* (Cambridge: Harvard University Press, 1953).

9. Originally in the London *Quarterly Review* 101 (April 1857), Lady Eastlake's article is reproduced in *Photography: Essays and Images*, ed. Beaumont Newhall (New York: Museum of Modern Art, 1980), 81.

10. John Szarkowski, *The Photographer's Eye* (New York: Museum of Modern Art, 1966). In Ridley Scott's brilliant film, *Bladerunner*, renegade androids attempt to create a sense of being real human beings by assembling ersatz collections of family photographs, thus creating what none of them has but every human person does: a past.

11. Bruce Bernard, *Photodiscovery: Masterworks of Photography, 1840–1940* (New York: Harry N. Abrams, 1980), 240.

12. See Van Deren Coke, *The Painter and the Photograph* (Albuquerque: University of New Mexico Press, 1972), 7–9.

13. The Bancroft albums, then in the possession of photography dealer Daniel Wolf, are mentioned in John Szarkowski and Maria Morris Hambourg, *The Work of Atget*, 4 vols. (New York: Museum of Modern Art, 1981), vol. 4: *Old France*, 152 and 161, notes.

14. Szarkowski, *Photographer's Eye*, 10.

15. Susan Sontag, *On Photography* (New York: Delta Books, 1977), 15–16. A similar phenomenon has occurred since the destruction of the twin towers of the World Trade Center. Earlier photographs of the skyline that show the towers still standing became best-sellers on postcard racks. Another powerful and touching use of photographs was the appearance of hundreds of portraits of people missing in the building collapse, with requests for information about the fate of the person. Taped and stapled to utility poles and walls all around lower Manhattan, the faces of the missing and presumed dead stared back from these makeshift shrines like figures in a medieval altarpiece.

For further information about the photographs discussed in this essay, see Notes on the Photographs, pages 165-185, following the plates.

1. As quoted in Charles Eyre Pascoe, *London of To-Day: An Illustrated Handbook for the Season 1890* (London: Simpkin, Marshall, Hamilton, Kent, and Co., Ltd., 1890), 235.

2. John Ruskin, "'The Black Arts': A Reverie in the Strand," in *The Library Edition of the Works of John Ruskin*, 39 vol. (New York: George Allen, 1903-12), 14:357-64.

3. As quoted in Malcolm Daniel, "'A Little Bit of Magic Realised': William Henry Fox Talbot and His Circle," in *Inventing the New Art: Early Photography from the Rubel Collection in the Metropolitan Museum of Art* (*Metropolitan Museum of Art Bulletin*, spring 1999) (New York: Metropolitan Museum of Art, 1999), 5.

4. Sara Stevenson, *David Octavius Hill and Robert Adamson: Catalogue of Their Calotypes Taken between 1843 and 1847 in the Collection of the Scottish National Portrait Gallery* (Edinburgh: National Galleries of Scotland, c. 1981), 11.

5. See Sara Stevenson, *Hill and Adamson's Fishermen and Women of the Firth of Forth* (Edinburgh: National Galleries of Scotland, 1990), 12.

6. Stevenson, *Fishermen and Women*, 14.

7. I am grateful for the independent research of Jill Deupi.

8. C. Gibbs-Smith, *The Great Exhibition of 1851* (London: V&A, 1950; reprinted 1981), 7.

9. J. T. Brown, "On the Application of Photography to Art and Art Purposes," *Photographic and Fine Art Journal* 11/5 (May 1858): 129-34.

10. Frederick Scott Archer, "On the Use of Collodion in Photography," reprinted in Beaumont Newhall, ed., *On Photography: A Source Book of Photo History in Facsimile* (Watkins Glen, N.Y.: Century House, 1956), 79.

11. Richard Brilliant discusses these terms in relationship to portraiture in general in *Portraiture* (Cambridge: Harvard University Press, 1991), 56.

12. This interpretation of the photographic image is indebted to my reading of Roland Barthes, *Camera Lucida: Reflections on Photography*, trans. Richard Howard (New York: Hill and Wang, 1981).

13. Barthes, *Camera Lucida*, 82. Christian Metz also addresses this notion in his discussion of the fetish value of the photograph (see "Photography and Fetish," *October* 34 [fall 1985]: 81-90).

14. Audrey Linkman, *The Victorians: Photographic Portraits* (London: Tauris Parke Books, 1993), 61.

15. As quoted in Morton N. Cohen, *Reflections in a Looking Glass: A Centennial Celebration of Lewis Carroll, Photographer* (New York: Aperture, 1998).

16. *Living Age* 92 (1867): 208, as quoted in Nancy Armstrong, *Fiction in the Age of Photography: The Legacy of British Realism* (Cambridge: Harvard University Press, 1999), 114.

17. For a further discussion of the issue of gender and photography,

see Lindsay Smith, *The Politics of Focus: Women, Children, and Nineteenth-Century Photography* (Manchester: Manchester University Press), 1998.

18. Information about the Art Union comes from Elizabeth Aslin, "The Rise and Progress of the Art Union of London," *Apollo* 85 (1969): 12–16; and Lyndel Irene Saunders King, "The Art Union of London: 1837–1912" (Ph.D. dissertation, University of Minnesota, 1982). Roger Smith has examined the Art Union in terms of photographic patronage in "Selling Photography: Aspects of Photographic Patronage in Nineteenth-Century Britain," *History of Photography* 12/4 (October–December 1988): 317–26.

19. Smith, "Selling Photography," 319.

20. Allen Staley, Introduction, in Allen Staley et al. *The Post-Pre-Raphaelite Print: Etching, Illustration, Reproductive Engraving, and Photography in England in and around the 1860s* (New York: Miriam and Ira D. Wallach Art Gallery, Columbia University [distributed by University of Washington Press], 1995), 8.

21. As quoted in Smith, "Selling Photography," 324.

22. Ibid.

23. See, for example, Sarah Holdsworth and Joan Crossley, *Innocence and Experience: Images of Childhood in British Art from 1600 to the Present* (Manchester: Manchester City Art Gallery, 1992); and E. D. H. Johnson, *Paintings of the British Social Scene: From Hogarth to Sickert* (London: Weidenfeld and Nicholson, 1986).

24. John E. Mayall, as quoted in "High Art Photography: In Search of an Ideal," in Mark Haworth-Booth, ed., *The Golden Age of British Photography 1839–1900* (New York: Aperture, 1984), 94.

25. *British Journal of Photography* (15 August 1862): 317. I am indebted to the knowledge and generosity of Roger Taylor for information about Mayall and this image.

26. See Haworth-Booth, *Golden Age;* and Staley, *Post-Pre-Raphaelite Print,* for example.

27. Staley, *Post-Pre-Raphaelite Print,* 9.

28. For a discussion of this issue, see Tim Barringer, *The Pre-Raphaelites: Reading the Image* (London: Weidenfeld and Nicholson, c. 1998).

29. For additional possible readings of this image, see Sylvia Wolf, *Julia Margaret Cameron's Women,* with contributions by Stephanie Lipscomb, Debra N. Mancoff, and Phyllis Rose (Chicago: Art Institute of Chicago; New Haven: Yale University Press, 1998). Wolf notes the association of women with birds and birdcages, commented upon at length in Elaine Shefer, *Birds, Cages, and Women in Victorian and Pre-Raphaelite Art* (New York: P. Lang, c. 1990).

30. See Naomi Rosenblum, *A History of Women Photographers* (New York: Abbeville Press, 1994); and Bernard V. and Pauline F. Heathcote, "The Feminine Influence: Aspects of the Role of Women in the Evolution of Photography in the British Isles," *History of Photography* 12/3 (July–September 1988): 259–73.

31. As stated in letter to Sir John Herschel, reproduced in Helmut Gernsheim, *Julia Margaret Cameron: Her Life and Photographic Work* (Millterton, N.Y.: Aperture, 1975), 14; and as quoted in Mary Warner Marien, *Photography and Its Critics: A Cultural History, 1839–1900* (Cambridge: Cambridge University Press, 1997), 99.

32. George Frederic Watts lived with the family of Cameron's sister, Sara Prinsep, at their London home, known as Little Holland House. Cameron and Watts were enthusiastic in their praise of each other's work. See Joanne Lukitsch, *Cameron: Her Career and Work* (Rochester, N.Y.: International Museum of Photography, 1986).

33. Mike Weaver has commented at length on the religious content of Cameron's work, most notably in "Julia Margaret Cameron: Christian Pictorialist," in Haworth-Booth, *Golden Age;* and "Julia Margaret Cameron: The Stamp of Divinity," in Mike Weaver, ed., *British Photography in the Nineteenth Century: The Fine Art Tradition* (Cambridge: Cambridge University Press, 1989).

34. Julia Margaret Cameron, "The Annals of My Glass House" (1874), reproduced in Beaumont Newhall, *Photography: Essays and Images* (New York: Museum of Modern Art, 1980), 136; and Marien, *Photography,* 191.

35. Cameron also illustrated Tennyson's *Idylls of the King.* See Carol Armstrong, "Cupid's Pencil of Light: Julia Margaret Cameron and the Maternalization of Photography," *October* 76 (spring 1996).

36. *Encyclopedia Britannica,* entries "binary star"; and "Herschel, Sir John (Frederick William), 1st Baronet."

37. Armstrong, "Cupid's Pencil of Light," 140. Armstrong also discusses the eroticism of the image. Smith, *Politics of Focus,* discusses Cameron's photography in terms of gender, specifically the relationship between lack of focus and patriarchy.

38. As quoted in Marien, *Photography,* 100.

39. As quoted in Malcolm Daniel, "'Men Great thro' Genius . . . Women thro' Love': Portraits by Julia Margaret Cameron," in Daniel, *Inventing the New Art,* 36.

40. As quoted in Marien, *Photography,* 100.

41. As quoted in Kathleen Stewart Howe, "Excursions along the Nile: The Photographic Discovery of Ancient Egypt," in Kathleen Stewart Howe, ed., *Excursions along the Nile: The Photographic Discovery of Ancient Egypt* (Santa Barbara: Santa Barbara Museum of Art, 1993), 22.

42. James Buzard, *The Beaten Track: European Tourism, Literature, and the Ways to Culture, 1800–1918* (Oxford: Clarendon Press, 1993).

43. See Andrew Wilton and Ilaria Bignamini, *Grand Tour: The Lure of Italy in the Eighteenth Century* (London: Tate Gallery Publishing, 1996).

44. As quoted in Buzard, *Beaten Track,* 168.

45. As quoted in Buzard, *Beaten Track,* 65.

46. As quoted in Andrew Szegedy-Maszak, "Roman Views," in *Six Exposures: Essays in Celebration of the Opening of the Harrison D. Horblit Collection of Early Photography* (Cambridge: Harvard University, Houghton Library, 1999), 93.

47. In 1867, however, Macpherson and the publishers at Murray's would exchange heated letters over mistakes in publication that included listing Macpherson as "Canadian." This argument is given treatment in Piero Becchetti, *Robert Macpherson: Fotografo inglese a Roma* (Rome: Edizione Quasar, 1987).

48. Information about Macpherson from "Robert Macpherson 1811–1872," in Richard Pare, Catherine Evans Insbusch, Phyllis Lambert, and Marjorie Munsterberg, *Photography and Architecture: 1839–1939* (Montreal: Centre Canadien d'Architecture, 1982); Szegedy-Maszak, "Roman Views."

49. Beato trained Japanese studio assistants and was in this sense a "founding member" of the group known as the "Yokohama Photographers." See Melissa Banta and Susan Taylor, eds., *A Timely Encounter: Nineteenth-Century Photographs of Japan* (Cambridge, Mass.: Peabody Museum Press, 1988).

50. "Egypt and Palestine," *Art Journal* (August 1858): 229.

51. As quoted in "Exploring the Empire" in Haworth-Booth, *Golden Age,* 121.

52. Buzard, *Beaten Track,* 322.

53. John Murray, *Handbook for Travelers in Northern Italy Comprising Piedmont, Liguria, Lombardy, Venetia, Parma, Modena, and Romagna* (London: John Murray, 1866), 363.

54. As quoted in James Ryan, *Picturing Empire* (London: Reaktion, 1997), 214.

55. As quoted in Ryan, *Picturing Empire,* 148.

56. As quoted in Andrew Topsfield, "Eugene Impey at Mount Abu and Jodhpur," *History of Photography* 14/3 (July–September 1990): 256. I am greatly indebted to Dr. Topsfield for his assistance in attributing the images in the Scholz Collection.

57. I am grateful to Dr. Andrew Topsfield for this information. For further information, see Rosemary Crill, *Marwar Painting: A History of the Jodhpur Style* (Bombay: India Book House Ltd., 1999).

58. As quoted in Marien, *Photography,* 59.

Bibliography

General Reading on Nineteenth-Century Photography

Apraxine, Pierre. *Photographs from the Collection of the Gilman Paper Company.* New York: White Oak Press, 1985.

Baldwin, Gordon. *Looking at Photographs: A Guide to Technical Terms.* Los Angeles: J. Paul Getty Museum, 1991.

Barthes, Roland. *Camera Lucida.* London: Jonathan Cape, 1981.

Batchen, Geoffrey. *Burning with Desire: The Conception of Photography.* Cambridge: MIT Press, 1997.

Benjamin, Walter. "The Work of Art in the Age of Mechanical Reproduction," in *Illuminations.* New York: Schocken, 1969.

Bernard, Bruce, with Valerie Lloyd. *Photodiscovery: Masterworks of Photography 1840–1940.* New York: Harry N. Abrams, Inc., 1980.

Bertell, Richard, with Roy Flukinger, Nancy Keeler, and Sydney Kiglor. *Paper and Light: The Calotype in Great Britain and France, 1839–1870.* Boston: 1974.

Bolton, Richard, ed. *The Contest of Meaning: Critical Histories of Photography.* Cambridge: MIT Press, 1989.

Borcoman, James. *Magicians of Light: Photographs from the Collection of the National Gallery of Canada.* Ottawa: National Gallery of Canada, 1993.

Buckland, Gail. *First Photographs: People, Places, and Phenomena as Captured for the First Time by the Camera.* New York: Macmillan, 1980.

Clarke, Graham. *The Photograph.* Oxford: Oxford University Press, 1997.

Coe, Brian. *The Birth of Photography: The Story of the Formative Years 1800–1900.* New York: Taplinger, 1976.

——. *Cameras: From Daguerreotypes to Instant Pictures.* New York: Crown Publishers, 1978.

Coke, Van Deren. *The Painter and the Photograph, from Delacroix to Warhohl.* Rev. ed. Albuquerque: University of New Mexico Press, 1972.

Collins, Kathleen. *Shadow and Substance: Essays on the History of Photography.* Bloomfield Hills, Mich: Amorphous Institute Press, 1990.

Crawford, William. *Keepers of Light: A History and Working Guide to Early Photographic Processes.* Dobbs Ferry, N.Y.: Morgan and Morgan, 1979.

Daniel, Malcolm, R. *Inventing a New Art: Early Photography from the Rubel Collection in the Metropolitan Museum of Art. Metropolitan Museum of Art Bulletin* (spring 1999). New York: Metropolitan Museum of Art, 1999.

Edwards, Elizabeth, ed. *Anthropology and Photography: 1860–1920.* New Haven: Yale University Press, 1992.

Fraenkel Gallery. *The Kiss of Apollo: Photography and Sculpture 1845 to the Present.* Essay by Eugenia Parry Janis. San Francisco: Bedford Arts, c. 1991.

Freund, Gisele. *Photography and Society.* Boston: David R. Godine, 1980.

Frizot, Michel, ed. *A New History of Photography.* Cologne: Könemann Verlagsgesellschaft, 1998.

Galassi, Peter. *Before Photography: Painting and the Invention of Photography.* New York: Museum of Modern Art, 1991.

Gernsheim, Helmut. *A Concise History of Photography.* 3d ed. New York: Dover, 1986.

——. *The History of Photography from the Earliest Use of the Camera Obscura . . . up to 1914.* Oxford: Oxford University Press, 1955. Rev. ed., published as *The History of Photography from the Camera Obscura to the Modern Era.* London: Thames and Hudson; New York: McGraw Hill, 1969. 3d rev. ed., published in 2 vols. Vol. 1: *The Origins of Photography.* London: Thames and Hudson, 1982. Vol. 2: *The Rise of Photography: 1850–1880, the Age of Collodion.* London: Thames and Hudson, 1988.

Greenough, Sarah, and Joel Snyder, David Travis, and Colin Westerbeck. *The Art of Fixing a Shadow.* Washington, D.C.: National Gallery of Art, 1989.

Hambourg, Maria Morris, et al. *The Waking Dream: Photography's First Century: Selections from the Gilman Paper Company Collection.* New York: Metropolitan Museum of Art, 1993.

Haworth-Booth, Mark, and Anne McCauley. *The Museum and the Photograph: Collecting Photography at the Victoria and Albert Museum, 1853–1900.* Williamstown, Mass.: Clark Art Institute, 1998.

Jacobson, Ken, and Jenny Jacobson. *'Etude d'après nature': Nineteenth-Century Photographs in Relation to Art.* Petches Bridge, Essex: Ken and Jenny Jacobson, 1996.

Jay, Bill. *Cyanide and Spirits: An Inside-Out View of Early Photography.* Munich: Nazrali Press, 1991.

Jeffrey, Ian. *Revisions: An Alternative History of Photography.* Bradford, England: National Museum of Photography, Film, and Television, 1999.

Johnson, William. *Nineteenth-Century Photography: An Annotated Bibliography, 1839–1879.* Boston: G. K. Hall, 1990.

J. Paul Getty Museum. *Masterpieces of the J. Paul Getty Museum: Photographs.* Los Angeles: J. Paul Getty Museum, 1999.

Lewinski, Jorge. *The Naked and the Nude: A History of Nude Photography.* New York: Crown Publishers, 1987.

Marien, Mary Warner. *Photography and Its Critics: A Cultural History, 1839–1900.* New York: Cambridge University Press, 1997.

McCauley, Elizabeth Anne. *Likenesses: Portrait Photography in Europe 1850–1870.* Albuquerque: University of New Mexico Art Museum, 1980.

Museum of Modern Art. *A Personal View: Photography in the Collection of Paul F. Walter.* New York: Museum of Modern Art, 1985.

Newhall, Beaumont. *History of Photography from 1839 to the Present.* Rev. ed. New York: Museum of Modern Art, 1982.

Pare, Richard, Catherine Evans Inbusch, Phyllis Lambert, and Marjorie Munsterberg. *Photography and Architecture: 1839–1939.* Montreal: Centre Canadien d'Architecture, 1982.

Pulz, John. *The Body and the Lens: Photography 1839 to the Present.* New York: Harry N. Abrams, 1995.

Rosenblum, Naomi. *A History of Women Photographers.* New York: Abbeville Press, 1994.

———. *A World History of Photography.* New York: Abbeville Press, 1984.

Scharf, Aaron. *Art and Photography.* Harmondsworth: Penguin Books, 1974.

———. *Pioneers of Photography: An Album of Pictures and Words.* New York: H. N. Abrams, 1976.

Sobieszek, Robert A. *Masterpieces of Photography from the George Eastman House Collections.* New York: Abbeville Press, 1985.

Solomon-Godeau, Abigail. *Photography at the Dock: Essays on Photographic Histories, Institutions, and Practices.* Minneapolis: University of Minnesota Press, 1991.

Szarkowski, John. *Looking at Photographs: 100 Pictures from the Collection of the Museum of Modern Art.* New York: Museum of Modern Art, 1973.

———. *The Photographer's Eye.* New York: Museum of Modern Art, 1966

———. *Photography until Now.* New York: Museum of Modern Art, 1989.

Thomas, Alan. *Time in a Frame: Photography and the Nineteenth-Century Mind.* New York: Schocken, 1977.

Turner, Peter. *History of Photography.* New York: Exeter Books, 1987.

Wade, John. *The Camera from the Eleventh Century to the Present Day.* Leicester: Jessop, 1990.

Wagstaff, Samuel J., Jr. *A Book of Photographs from the Collection of Sam Wagstaff.* [New York?]: Gray Press, 1978.

Weaver, Mike, ed., et al. *The Art of Photography, 1839–1939.* New Haven: Yale University Press, 1989.

Wells, Liz. *Photography: A Critical Introduction.* New York: Routledge, 1997.

Nineteenth-Century French Photography

Bibliothèque Nationale. *Une invention du XIXe siècle: La photographie.* Paris: Bibliothèque Nationale, 1976.

Borcoman, James. *Charles Nègre, 1820–1880.* Ottawa: National Gallery of Canada, 1976.

Buerger, Janet E. *The Era of the French Calotype.* Rochester, N.Y.: International Museum of Photography at the George Eastman House, 1982.

———. *French Daguerreotypes.* Chicago: University of Chicago Press, 1989.

Daniel, Malcolm R. *Baldus.* New York: Metropolitan Museum of Art, 1997.

Gernsheim, Helmut, and Alison Gernsheim. *L. J. M. Daguerre: The History of the Diorama and the Daguerreotype.* New York: Dover Press, 1968.

Gosling, Nigel. *Nadar.* New York: Alfred A. Knopf, 1976.

Hambourg, Maria Morris, Françoise Heilbrun, and Philippe Néagu, et al. *Nadar.* New York: Metropolitan Museum of Art, 1995.

Haworth-Booth, Mark. *Camille Silvy: "River Scene, France."* Malibu, Calif.: Getty Museum Studies on Art, 1992.

Hough, Richard. *Images on Paper: Mid–Nineteenth-Century French Photography.* Edinburgh: Scottish Photography Group, 1979.

Jammes, André, and Eugenia Parry Janis. *The Art of the French Calotype with a Critical Dictionary of Photographers, 1845–1870.* Princeton: Princeton University Press, 1983.

Jammes, André, and Robert Sobieszek. *French Primitive Photography.* Introduction by Minor White. Millerton, N.Y.: Aperture, 1969.

Jammes, Isabelle. *Blanquart-Evrard et les origines de l'édition photographique française: Catalogue raisonné des albums photographiques édités, 1851–1855.* Geneva and Paris: Librairie Droz, 1981.

Janis, Eugenia Parry. *The Photography of Gustave Le Gray.* Chicago: Art Institute of Chicago, 1987.

Marbot, Bernard. *After Daguerre: Masterworks of French Photography (1848–1900) from the Bibliothèque Nationale.* New York: Metropolitan Museum of Art, 1980.

Marville, Charles. *Charles Marville: Photographe de Paris de 1851 à 1879.* Paris: Bibliothèque de la Ville de Paris, 1981.

McCauley, Elizabeth Ann. *Industrial Madness: Commercial Photography in Paris 1848–1871.* New Haven: Yale University Press, 1994.

Szarkowski, John, and Maria Morris Hambourg. *The Work of Atget.* 4 vols. New York: Museum of Modern Art, 1981–1985.

Travis, David. *The First Century of Photography, Niépce to Atget: From the Collection of André Jammes.* Chicago: Art Institute of Chicago, 1977.

Victorian British Photography

Arnold, H. J. P. *William Henry Fox Talbot: Pioneer of Photography and Man of Science.* London: Hutchinson Benham, 1977.

Baldwin, Gordon. *Roger Fenton: Pasha and Bayadere.* Los Angeles: J. Paul Getty Museum of Art, 1995.

Bartram, Michael. *Pre-Raphaelite Camera: Aspects of Victorian Photography.* London: Weidenfeld Nicolson, 1985.

Briggs, Asa. *Victorian Things.* Chicago: University of Chicago Press, 1988.

Buckland, Gail. *Fox Talbot and the Invention of Photography.* Boston: D. R. Godine, 1980.

Cameron, Julia Margaret. *Annals of My Glass House: Photographs by Julia Margaret Cameron.* Text by Violet Hamilton. Claremont, Calif.: Ruth Chandler Williamson Gallery (distributed by University of Washington Press, Seattle), c. 1996.

———. *For My Best Beloved Sister, Mia: An Album of Photographs.* Albuquerque: University of New Mexico Art Museum, 1994.

———. *Julia Margaret Cameron: Photographs from the J. Paul Getty Museum.* Los Angeles: J. Paul Getty Museum, 1995.

Cohen, Morton N. *Lewis Carroll: A Biography.* New York: Knopf, 1995.

———. *Reflections in a Looking Glass: A Centennial Celebration of Lewis Carroll, Photographer.* New York: Aperture, 1998.

Dimond, Frances, and Roger Taylor. *Crown and Camera: The Royal Family and Photography, 1842-1910.* Harmondsworth: Penguin, 1987.

Flukinger, Roy. *The Formative Decades: Photography in Great Britain, 1839-1920.* Austin: University of Texas Press, 1985.

Ford, Colin, ed., with essay by Roy Strong. *An Early Victorian Album: The Photographic Masterpieces (1843-1847) of David Octavius Hill and Robert Adamson.* New York: Alfred A. Knopf, 1976.

Gernsheim, Helmut, ed. *Lewis Carroll, Photographer.* New York: Dover, 1979.

Haworth-Booth, Mark, and Anne McCauley. *The Museum and the Photograph: Collecting Photography at the Victoria and Albert Museum, 1853-1900.* Williamstown, Mass.: Clark Art Institute, 1998.

Haworth-Booth, Mark, ed., *The Golden Age of British Photography 1839-1900.* New York: Aperture, 1984.

Heyett, Elizabeth. *The Glass-House Years: Victorian Portrait Photography 1839-1870.* Montclair and London: Allanheld and Schram/George Piror, 1979.

Hopkinson, Tom. *Treasures of the Royal Photographic Society 1839-1919.* Bath: Focal Press, Inc., 1980.

Linkman, Audrey. *The Victorians: Photographic Portraits.* London and New York: Tauris Parke, 1993.

Lloyd, Valerie. *Roger Fenton: Photographer of the 1850s.* London: South Bank Board, 1988.

Pal, P., and V. Dehejia. *From Merchants to Emperors: British Artists and India 1757-1900.* Ithaca: Cornell University Press, 1986.

Schaaf, Larry J. *The Photographic Art of William Henry Fox Talbot.* Princeton: Princeton University Press, 2000.

Scharf, Aaron. *Art and Photography.* Harmondsworth, England: Penguin Books, 1974.

Seiberling, Grace. *Amateurs, Photography, and the Mid-Victorian Imagination.* Chicago: University of Chicago Press, 1986.

Sobieszek, Robert A., ed. *British Masters of the Albumen Print: A Selection of Mid-Nineteenth-Century Victorian Photography.* Chicago: University of Chicago Press, 1976.

Stevenson, Sara. *Hill and Adamson's "The Fishermen and Women of the Firth of Forth."* Edinburgh: National Galleries of Scotland, 1990.

Talbot, William Henry Fox. *The Pencil of Nature.* Facsimile ed. New York: Da Capo Press, 1961.

Ward, John, and Sara Stevenson. *Printed Light: The Scientific Art of William Henry Fox Talbot and David Octavius Hill with Robert Adamson.* Edinburgh: Scottish National Portrait Gallery, 1986.

Weaver, Mike, ed. *British Photography in the Nineteenth Century: The Fine Art Tradition.* Cambridge: Cambridge University Press, 1989.

Weaver, Mike, ed., et al. *The Art of Photography, 1839-1939.* New Haven: Yale University Press, 1989.

Wolf, Sylvia, et al. *Julia Margaret Cameron's Women.* New Haven: Yale University Press, 1998.

Worswick, Clark, and Ainslie Embree. *The Last Empire: Photography in British India, 1855-1911.* Millerton, N.Y.: Aperture, 1976.

Nineteenth-Century
Travel Photography

See also British Photography, *entries for* P. Pal and V. Dehejia; Clark Worswick and Ainslie Embree.

Banta, Melissa, and Susan Taylor, eds. *A Timely Encounter: Nineteenth-Century Photographs of Japan.* Cambridge, Mass.: Peabody Museum Press, 1988.

Bull, Deborah, and Donald Lorimer. *Up the Nile: A Photographic Excursion: Egypt 1839-1898.* New York: Clarkson N. Potter, Inc., 1979.

Çingen, Engin. *Photography in the Ottoman Empire 1839-1919.* Istanbul: Ha et Kitabevei, 1987.

Ferrez, Gilberto, and Weston J. Naef. *Pioneer Photographers of Brazil, 1840-1920.* New York: Center for Inter-American Relations, 1976.

Fontanella, Lee. *Photography in Spain in the Nineteenth Century.* San Francisco and Dallas: Fraenkel Gallery, 1983.

Howe, Kathleen Stewart, ed. *Excursions along the Nile: The Photographic Discovery of Ancient Egypt.* Santa Barbara: Santa Barbara Museum of Art, 1993.

———. *Revealing the Holy Land: The Photographic Exploration of Palestine.* Santa Barbara: Santa Barbara Museum of Art, 1997.

Nir, Yeshayahu. *The Bible and the Image: The History of Photography in the Holy Land, 1839-1899.* Philadelphia: University of Pennsylvania Press, 1985.

Onne, Eyal. *The Photographic Heritage of the Holy Land, 1839-1914.* Manchester: Manchester Polytechnic, 1980.

Perez, Nissan N. *Focus East: Early Photography in the Near East, 1839-1885.* New York: Harry N. Abrams, 1988.

Watson, Wendy. *Images of Italy: Photography in the Nineteenth Century.* South Hadley, Mass.: Mount Holyoke College Art Museum, 1980.

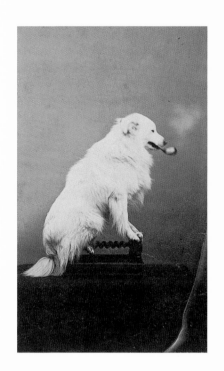

J. TOURTIN *Dog Smoking a Pipe* c. 1860s albumen print from wet collodion negative

Acknowledgments

Ten years ago I began looking through the boxes of photographs that housed the Scholz collection, and I quickly realized three things: that these were wonderful photographs that deserved to be seen; that I knew little about them; and that I would need help to begin understanding their history and their significance. Fortunately, over the years many people have contributed to the study of these images. One of the first was Lee Marks, who used her expertise acquired at the Gilman Paper Company Collection to evaluate the importance of the Notre Dame holdings. More recently, Eugenia Parry shared her informed opinions while patiently examining many hundreds of prints. Alain Paviot of the Galerie Octant in Paris has supplied a number of important new attributions. Information regarding individual photographs was supplied by Julian Cox of the J. Paul Getty Museum, Malcolm Daniel at the Metropolitan Museum of Art, Andy Eskind and Joe Struble at the George Eastman House, Mark Haworth-Booth of the Victoria and Albert Museum, and Sara Stevenson of the National Galleries of Scotland. Others whom I consulted include Charles Isaacs, Hans Kraus, and Richard Pare. I would especially like to thank Larry Schaaf, who generously shared his extensive knowledge of the photographs of William Henry Fox Talbot.

A number of Notre Dame student interns have worked in the photography department, and I would especially like to thank Sarah Jacobs for her work early in the project and Anna Searle for doing much last-minute preparation for the exhibition. Jill Deupi produced some important research while serving as a summer volunteer before entering graduate school. Morna O'Neill began studying the collection as an undergraduate and soon developed into co-author and scholar in her own right, due to her intelligent curiosity and instinctive understanding of the material.

Director Charles Loving and Associate Director Ann Knoll of the Snite Museum have been steadfast in their support of the project. Susan Fitzpatrick and Anne T. Mills ably prepared label and text copy; Gina Costa was responsible for publicity. Notre Dame's Institute for Scholarship in the Liberal Arts made it possible for me to travel to the George Eastman House in Rochester, New York, to study nineteenth-century photographic processes.

My wife Kathleen has patiently encouraged and supported me in this project, as always.

Finally, I would like to thank Rev. Edward Sorin, c.s.c., founder of the University of Notre Dame and the probable source of Nadar and Adrien Tournachon's photograph of the mime Deburau as *Pierrot the Thief* (page viii). Sorin returned to his beloved France on many trips and regularly brought back mementos to Indiana, *Pierrot* perhaps one of the most valuable of them. This image was the first important nineteenth-century photograph to be accessed into the collection of the Snite Museum of Art. STEPHEN ROGER MORIARTY